D1282792

Mark Elling Rosheim

Leonardo's Lost Robots

Mark Elling Rosheim

Leonardo's
Lost Robots

With 203 Images

 Springer

9-19-2006
WW
$ 39.95

Author

Mark Elling Rosheim

President
Ross-Hime Designs Inc.
1313 5th Street S.E.
Minneapolis, MN 55414
USA
web: www.anthrobot.com

Library of Congress Control Number: 2005934414

ISBN-10 3-540-28440-0 **Springer Berlin Heidelberg New York**
ISBN-13 978-3-540-28440-6 **Springer Berlin Heidelberg New York**

Springer is a part of Springer Science+Business Media
springer.com
© Springer-Verlag Berlin Heidelberg 2006
Printed in Germany

The use of general descriptive names, registered names, trademarks, etc. in this publication does not imply, even in the absence of a specific statement, that such names are exempt from the relevant protective laws and regulations and therefore free for general use.

Cover design: Erich Kirchner, Heidelberg
Typesetting and layout: Büro Stasch · Bayreuth (stasch@stasch.com)
Production: Almas Schimmel
Printing and binding: Stürtz AG, Würzburg

Printed on acid-free paper 89/3141/as – 5 4 3 2 1

[… You know what they say. In Italy for thirty years under the Borgias they had warfare, terror, murder, bloodshed; and they produced Michelangelo, Leonardo da Vinci, and the Renaissance. In Switzerland they had brotherly love, five hundred years of democracy and peace. And what did they produce? The cuckoo clock …]

Orson Welles in *The Third Man*. Directed by Carol Reed, 1949

Foreword

As this book is bound to be hailed by the academic world as one of the most significant and original contributions to scholarship, and this in spite of its being by a non-academic author, the general reader should welcome it as a refreshing change of pace in the outpouring of banalities and commonplace accounts of Leonardo da Vinci's art and science as well as technology, not to mention the groundless interpretations of his unfathomable mind, personality and character, including his sexuality and even his views on religion, ever so often taking him out of historical and cultural context with dangerously astute fabrications that may show at best how very few are the discriminating readers left.

As is well known, any scholarly work has autobiographical connotations. For Mark Rosheim, they are a necessity, and he is not shy to make them obvious. But it is not only for the sake of clarifying the nature and complexities of a problem of technological interpretation that he would take time to explain how he got to the solution of that problem. It is above all for the urge to share with others the uplifting, exhilarating experience of establishing a direct contact with one of the greatest minds that ever existed. In order to do so, he has gathered all possible reference tools pertaining to the study of Leonardo and his time, sparing no effort to acquire every facsimile and critical edition of his manuscripts and drawings, from the earliest to the latest, as if he were to compete with the most prestigious, comparable collections in long-established public institutions. He turns to such tools with scientific humility, in fact with a sense of great respect for the scholarship that generated them, ever ready to indulge in moments of innocent delight, as collectors normally do, at the beauty and fascination of masterpieces in book production. One would hardly expect this from a young man well grounded in the reality of a demanding if not ruthless world of business and professional achievement that seldom allows for intellectual leisure. And yet his scientific and technological visions are well cast into the future, to which he is contributing with relentless dedication and unfailing expertise. His numerous patents in the field of robotics are eloquent proof of this. It is a field that he keeps approaching historically. His two books on the subject of robotics show that he is indeed in the privileged position of turning to his fellow engineers of the past, notably but not exclusively Leonardo da Vinci, and understanding immediately the working of their minds. As a skillful draftsman, he shows a sort of elective affinity with Leonardo's way of conveying an idea by drawing. And then, determined to go beyond this, he has set himself to learning Italian so as to follow him carefully in his explanatory notes and even in the complexities of his theoretical writings as well. Having to deal with Leonardo's technological conceptions of which, very often, only a preliminary, fragmentary phase is left, he is now prepared to fill the gaps, so to speak, by figuring out what is missing—just like an archaeologist who recreates a lost masterpiece. And so, for the first time, he can tell the fascinating story of Leonardo's lost robots.

This is an extraordinary book that, to an old and lonely wolf the like of myself, brings joy with gratification. It is a book that answers so many questions that I have raised in the course of half a century, questions which I have long thought that only the improbable, though not impossible, discovery of Leonardo's missing manuscripts

or comparable documents could have answered. I would never have thought that a brilliant young man, so far from the fervor and tradition of Leonardo research, could possibly come my way to follow in my footsteps with all the power of his Yankee ingenuity and with the pristine candor and generosity of a fellow American. Now more than ever I could tell myself that I always wanted to be the teacher I never had and to have the student I never was. Mark is that student.

Carlo Pedretti, Fall 2005

Preface

Milan, Italy, 1495. Leonardo da Vinci designed and possibly built the first articulated humanoid robot in the history of western civilization. This armored Robot Knight was designed to sit up, wave its arms, and move its head by means of a flexible neck, while opening and closing its anatomically correct jaw. Quite possibly it emitted sounds to the accompaniment of automated musical instruments such as drums. Leonardo's robot outwardly appeared as a German-Italian suit of armor of the late fifteenth century. It was made of wood with parts of leather and brass or bronze and was cable-operated. It may have been built for a grotto, similar to those built at a later date in France.

Madrid, Spain, Winter 1965. Leonardo's *Book of Mechanics* circa 1495, known to scholars as Madrid MS I, and its companion volume, Madrid MS II, are discovered in the National Library of Madrid by André Corbeau. Bound in red Moroccan leather, Madrid MS I originally consisted of 382 pages. Sixteen of Madrid MS I pages are missing. Was the missing material removed at the time of discovery? Interviews are conducted, no one is blamed, and the case is closed. But what was on the missing pages?

Tama, Iowa, Christmas Day, 1965. A red-headed tyke of five years is tearing the wrapping paper off a box and clawing open the flaps held by copper staples. Inside is the red and blue *Lost in Space* Remco toy robot from the Sears Christmas Catalog he had asked Santa for. How vividly he had imagined its every life-like move: the huge reach of the thing, its powerful yet dexterous claws, its rolling gait, its many victories against hostile aliens and, most importantly, its role as the constant companion and guardian of Will Robinson, the youngest member of the TV show's space family. He crawls on the floor with the robot's body flashing, his eyes shining as he watches the robot roll along its preset path. But its arms don't move. The boy stares in disappointment. "What's wrong with it, Dad?" "Nothing, Mark. You can move the arms yourself by squeezing the levers in its back." "But it's a robot. They're supposed to move on their own."

He spends the next years obsessed with building robots out of TinkerToys and cardboard boxes. And the year after that, too. It is not only his toy robot that is flawed. They are all flawed. No modern robot has ever moved the way a human being moves because most of them are made up of joints that are little more than strong hinges swinging stiffly in one dimension, or are driven by simple motors held together with brackets—joints that jam and lock up.

In 1972, he watches the multi-part *Life of Leonardo* sponsored by Alitalia Airlines. With dramatic music, authentic settings and a superb supporting cast, the film intrigues him with the successes and failures of the ultimate Renaissance man. Although he does not know it, he is also introduced to the research of Carlo Pedretti who, decades later, would become his mentor. Towards the end of the 1970s, the boy, now a young man, begins to assemble a small library of Leonardo books.

In search of an understanding of human motion, he studies the anatomical drawings of Leonardo da Vinci. He learns how muscles are located *close to*, but not *on*, the joints they move—a feature that gives them both lightness and power. He learns how our most flexible joints move in two or even three dimensions at once, stabilized by

tendons and ligaments. By the early 1990s his research, funded by NASA, leads him to build the Robotic Surrogate, the first humanoid robot with a torso and fully functioning shoulder, elbow, wrist and finger joints.

While researching the first, historical, chapter on robots for his second book, he learns of Carlo Pedretti's pioneering studies of Leonardo's robots. He seeks the master scholar, who inspires him to begin his own research that would lead him on an odyssey around the world.

I was that boy. I am that man. My quest to build a robot with human-like capability—an anthrobot—has taken me on a journey that started with the ancient human urge to build a creature in man's own image. I followed in Leonardo's footsteps, and they led me not only to the solution to the mystery of the eight missing folios (sixteen pages) of Madrid MS I, but also to my reconstruction of Leonardo's Robot Knight. This book tells the story of its reconstruction and those of two other of Leonardo's automata: the programmable cart that may have transported a lion *rampant,* and a "digital," hydraulically powered clock that told the hours.

St. Paul, 2005
M. E. R.

Acknowledgments

I wish to thank the close friends who assisted in this undertaking. Without Carlo Pedretti's generous spirit and support, my work on Leonardo would never have gone as far as it has. It is to Carlo that this book is dedicated. Thanks to my editor, Mary Ann "the other half of my brain" Cincotta, without whose shaping, chopping, pruning, and nurturing, this book would also not exist. I would also like to thank the staff of the Florence Science Museum and Sforza Castle in Milan, the Biblioteca Leonardiana in Vinci, the University of Minnesota Library rare books department, British Library, Dr. Gerald Sauter for his wonderful and well thought-out electronic analog of Leonardo's Bell Ringer, Jack William Smith for transforming my detailed photographs and sketches into the classic illustrations you see here, John Kivisto for the splendid CAD renderings, last but not least Springer's layout artist Armin Stasch extraordinaire. Tom Ditzinger my Editor at Springer whose rare talent for technical and literary insight made this book a reality. *Per aspera ad astra.*

St. Paul, 2005
M. E. R.

Contents

List of Figures

Beginnings

When I set myself to the task of writing a historical introductory chapter to my second book, *Robot Evolution,* in the early 1990s, I had learned about Leonardo's Robot Knight from Carlo Pedretti's magnificent *Leonardo Architect.*[1] I had seen the book in a book store, but it was in Italian and very expensive. Later I found a copy of it used and in English. After digesting it I leapt at the opportunity to delve into Leonardo's Robot Knight, which was described near the end of the book. Taking a leap of faith that enough material had survived to reconstruct the robot, I made my way to the University of Minnesota's Rare Books Collection on the top floor of Wilson Library. There, an elderly librarian, tasked with wheeling up from the stacks the twelve elephant folios of the Codex Atlanticus, nearly collapsed his cart beneath the volumes, which weighed several hundred pounds. From this awkward beginning I traced the faint fragments one by one, perhaps even discovering an overlapping figure that had been overlooked by Pedretti, and was able to make a road map of the design and publish the fragments. My book, *Robot Evolution*, which contained the Leonardo material, was well underway but not yet published by the winter of 1994.

While in Los Angeles in February that year, where I had gone to recover from another of my bouts of chronic bronchitis brought on by the harsh and unyielding climate of Minnesota, I found myself with little to do. On a whim, I decided to contact Pedretti himself. I called and left a message at the UCLA Arts Library on Hilgard Avenue. He returned the call to my Santa Monica budget hotel room and after a lengthy conversation, I proposed sitting in on his lecture. Suggesting that for "people like you" it would be best if I came to his house for an in-person discussion, he graciously invited me to his home in Westwood.

Driving down the endless car dealerships, restaurants, and other commercial establishments on Santa Monica Boulevard, I passed under Interstate 405 and continued on past the sprawl of Kinko's and Subway sandwich shops. As I turned off I entered a tree-lined, peaceful neighborhood whose beauty is favored by artists, educators and scholars. Walking up the sidewalk to his beautiful Spanish Colonial home with its shady, well groomed yard, the "Armed Response" security sign in front and notes to deliver packages to the neighbor across the street, I began to wonder if I would find the great man at home.

I shouldn't have worried. Carlo Pedretti opened the door and invited me to "Come on in!" I was met by a gracefully aging energetic man with inquisitive brown eyes and an Italian accent. He led me along a narrow hall lined with paintings and prints, and I realized that I had entered the world of a great scholar.

Author of a shelf of books and editor of several "Monumental Leonardo Works in Facsimile" for Giunti, Carlo Pedretti seems to embody the word "Scholar." Professor Emeritus of the UCLA Art History Department, he is better known in Europe, where he maintains a second home in Vinci, Italy, the birthplace of Leonardo.

[1] Carlo Pedretti, *Leonardo Architect.* New York, Rizzoli International Publications, 1985.

Born in Bologna in 1928, Carlo began his professional life as an artist and journalist. In nearly sixty years of research he has produced a shelf of books the backbone of modern Leonardo scholarship. His most recent and spectacular achievement was the discovery of a previously unknown terracotta angel by Leonardo at San Gennaro near Vinci. The Angel's face is a self portrait of Leonardo himself.[2]

His Westwood living room was filled with antique furniture, an ornate marble fireplace, and a bookcase so large that the front windows of the house had to be removed to bring it into the house! Peering through the ornate grating of that bookcase, I spied a fortune in Renaissance first editions. Pedretti ushered me to the right, into his spacious, book lined office painted in water green with plaster filigree encircling the ceiling. The overhead light was very Leonardo: a geometric sphere design. In a corner stood an ornate scale, the only piece to survive from a 1952 exhibition. On top of a book case a renaissance bronze lamp sat with implements dangling on chains to service the wick.

We discussed his rare books collection, including early editions of Vitruvius. I mentioned I had bought a copy of Vitruvius' *Architecture* and he asked what edition, to which I innocently replied "Dover"—the celebrated budget publisher. This to the man who had (in multiple copies) some of the rarest editions of Vitruvius in existence. Saying it was time to "bring me up to date," he began, with the enthusiasm of a twenty-year old and not a whiff of condescension, to educate me about the various editions of Leonardo facsimiles. He showed me the Giunti facsimiles of the Codex Hammer which he had edited (the original had been purchased by Bill Gates for 30 million dollars). One funny thing that happened was when he was showing me a very rare, early printed book he accidentally tore the page and then rubbed the two pieces together as if they would miraculously heal. Then he brought out the Codex Hammer sixteen-page facsimile notebook from a massive brown leather Solander box, exclaiming in his wonderful, flamboyant Italian way: "Look at this! Magnificent!"

The manuscript, and many like it, had been admired centuries before, while Leonardo was still alive. Antonio de Beatis, who accompanied the Cardinal Luigi of Aragon on his visit to Leonardo's retirement chateau at Cloux, France on October 10, 1517, was astounded to see an "infinity of volumes" pertaining to machinery, hydraulics, anatomy, and of other fields of study.[3]

Leonardo's student and eventual heir, Francesco Melzi, held the collection together and worked towards publishing his book of paintings. Unfortunately, upon Melzi's death, his son Orazio saw little value in the old papers and their dispersion around the world began. Many came into the possession of the Spanish court sculptor and pupil of Michelangelo, Pompeo Leoni. He is responsible for mutilating a great deal of material in the course of creating thematic albums now known to the world as the codices of Leonardo.

In the intervening centuries, many of the codices would be bought and sold and if lucky deposited into libraries around the world by far seeing benefactors. Often named for their owners or the country where they finally came to rest, they bear names such as Codex Atlanticus (so named for its oceanic size); Codex Forster, named for John Forster, who in 1873, donated them to the Victoria and Albert Museum in London. In 1796 Napoleon looted the Ambrosian Library while in Milan, declaring "All men of genius ... are French."[4]

The legacy currently consists of over 7 000 pages of notes, some in fairly coherent notebooks much as Leonardo left them. Most of this legacy has been published twice

[2] Carlo Pedretti, "Un angelo di Leonardo giovane," in the Sunday Cultural Supplement of *Il Sole 24 Ore*, April 19, 1998, no. 106, p. 21.

[3] Antonio de Beatis (1905) Die Reise des Kardinals Luigi d' Aragona durch Deutschland, die Niederlande, Frankreich und Oberitalien, 1517–1518. In: Pastor, Ludwig (ed) Erläuterungen und Ergänzungen zu Janssens Geschichte des deutschen Volkes, vol. 4. Herder, Freiburg.

[4] Kate Steinitz, *Manuscripts of Leonardo da Vinci*, Los Angeles, Ward Ritchie Press, 1948, p. 12.

in facsimile form around the turn of the last two centuries. My first impression upon learning this was to marvel at the large quantity of material. But later, after study, I mourn how much has been lost. The addition of the two Madrid manuscripts, discovered in 1965, added by twenty percent to the known material. The most beautiful of which was also the most vulnerable.

On our way to visit Carlo's magnificent white stucco library, which is housed above his custom-built garage with its red tiled roof, we climbed up some exterior side steps leading to the door. Turning about, I looked up at the ceiling corners and behind me to gauge proportions and recognized Leonardo's proportions: a perfectly square floor plan and a Renaissance style pitched ceiling. Gratified that I had understood the geometry of Leonardo in practical application, Carlo told me that he had driven the contractor mad by insisting on geometrical proportions.

I asked for his comments on the Leonardo material I was working on for *Robot Evolution* (he loved the traced fragments and exclaimed that all the drawings should be done that way). I asked him to review the manuscript and he thanked me for making reference to his work. Plying me with gifts of offprints and books, he asked me to write a paper for his journal, *Achademia Leonardi Vinci*. The subsequent paper was reported in the press and led to my first BBC appearance on their *Tomorrow's Worlds* program.[5]

<div align="center">❖</div>

What can be said when the perfect pairing of teacher and pupil meets? The pupil assimilates the teacher's life experience, not only saving an enormous amount of trial and error, but time. One does not exactly absorb all his detailed knowledge, but perhaps more importantly, his "feel" for his subject. Meeting Carlo enabled me to leapfrog past the usual need for academic training in art history and immediately begin using my knowledge of mechanical design to reinterpret Leonardo's legacy.

Likewise, building on an ancient heritage, Leonardo's training and research provided him with the skills to construct automata, the term used in the Renaissance for robots. His own teacher, Andrea del Verrocchio (1435–1488), was known in Florence as the premier armorer of the second half of the fifteenth century, and some of Leonardo's early drawings reflect this aspect of Verrocchio's workshop activity. Verrocchio also designed and built an automaton clock in the "New Market" (destroyed and now replaced by unremarkable nineteenth-century architecture) which was regarded at the time as a beautiful and whimsical thing.[6]

Illegitimate, Leonardo had little if any contact with his mother and was sent to Verrocchio's bottega, a form of arts and crafts boarding school, as a teenager. Although details of Leonardo's and Verrochio's interaction are undocumented, it is known that Verrocchio loved geometry just as well as art. From him, Leonardo learned drawing, geometry, grinding pigments, painting, sculpture, carpentry, and metal working. Even before Verrochio's tutelage, the young Leonardo showed early promise in his fields. Commissioned to paint a circular panel, he collected snakes and other creepy crawlies and produced a Medusa so detailed and lifelike that it scared his neighbor. Knowing a good thing, his father Ser Piero sold it in the city for a tidy sum and gave a much more mundane shield painted with a heart pierced by an arrow for his peasant tenant.[7]

[5] BBC, "Tomorow's World." August 12, 1998, producer: Lucy Dudman.

[6] Cf. C. P., "Leonardo's Robot," in *Achademia Leonardi Vinci*, X, 1997, pp. 273–274, quoting Vasari, III. 375, as first noted by Simona Cremante, who suggests a relation with Leonardo's later project for a bell ringer (Windsor, RL 12716 and 12688): "È anco di mano del medesimo [Verrocchio] il putto dell' oriuolo di Mercato Nuovo, che ha le braccia schiodate in modo che, alzandole, suona l'ore con un martello che tiene in mano: il che fu tenuto in que' tempi cosa molto bella e capricciosa."

[7] Giorgio Vasari, Lives of Seventy of the Most Eminent Painters, Sculptors and Architects by Giorgio Vasari. Edited and Annotated in the Light of Recent Discoveries by E. H. and E. W. Blashfield and A. A. Hopkins. Vol. II. Charles Scribner's and Sons, New York, 1986, p. 377–379.

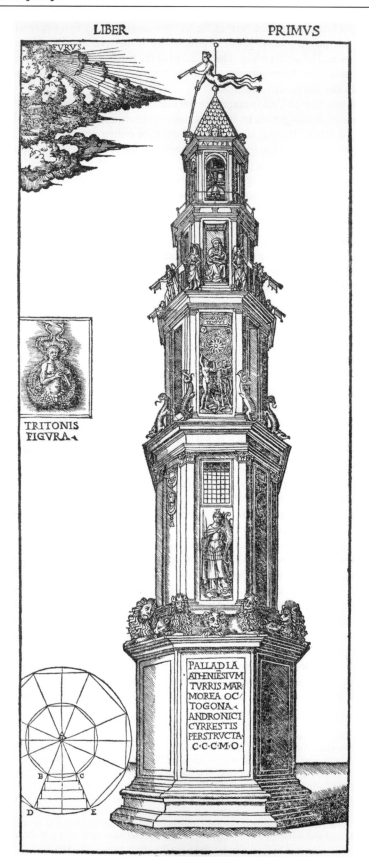

Fig. 1.1.
The Tower of Winds from the 1521 Como edition of De Architectura by Vitruvius

Other practical skills developed during and after his apprenticeship with Verrocchio would have been profitably applied. In Milan, after 1482, he also came in contact with German craftsmen with expertise in armor construction. Using the knowledge he acquired from dissecting corpses, Leonardo built mechanical models of the muscles and joints. His numerous arm-like designs for ornithopters attest to his full understanding of the mechanics of human and animal bodies.

Leonardo's initial impetus to develop robot technology probably came from his exposure to ancient Greek texts as interpreted by the humanists. One example is the well-known account of the mechanical dove made by Archita of Taranto in the fourth century B.C. According to Aulus Gellius, it was made of wood on the basis of "certain mechanical principles," so that "the dove actually flew, so delicately balanced was it with weights, and propelled by a current of air enclosed and concealed within it."[8] Indeed, this seems to be what Leonardo himself is said to have done while in Rome about 1515: "Forming a paste of a certain kind of wax, as he walked he shaped animals very thin and full of wind, and, by blowing into them, made them fly through the air, but when the wind ceased they fell to the ground."[9]

Something that should be kept in mind is that Leonardo had access to ancient texts and perhaps to oral traditions that are undocumented and unknown to us. As Reti writes regarding Leonardo's personal library listing of *Libro di Filone De Acque*, "This is a remarkable entry. The title can refer only to the *Pneumatics* of Philon of Byzantium, who is believed to have flourished about the end of the second century. It is surprising to find such an early trace of an Arabic text which became known to Western scholars only in our twentieth century."[10]

A compelling use of automation for political purposes occurred in ancient Roman times following the assassination of Julius Caesar. This has come down to us from the Roman historian Appian (A.D. 95?–A.D. 165?). A Latin translation by Petrus Candidus, private secretary to Pope Nicholas V, was published the year of Leonardo's birth in 1452 and therefore would have been available to him. Appian tells us that Marc Antony was to deliver the funeral oration for Caesar, with the goal of gaining popular support for punishing the conspirators. An unendurable anguish weighed upon the maddening crowd. The tension was at a fever pitch. The potentially dangerous mob was now struck with a vision of horror:

> While they were in this temper and were already near to violence, somebody raised above the bier an image of Caesar himself made of wax. The body itself, as it lay on its back on the couch, could not be seen. The image was turned around and round by a mechanical device, showing the twenty three wounds in all parts of the body and on the face, that had been dealt to him so brutally. The people could no longer bear the pitiful sight presented to them [...][11]

Antony's use of this robotic simulacrum of Caesar was a success in stirring the crowd to action, producing one of the greatest civil war in history.

Although unlikely, it is even conceivable that fragments of ancient prototypes could have been unearthed during Leonardo's lifetime. One wonders, for example, why the Renaissance 1521 Como edition of *De Architectura* by Vitruvius the illustration of the Tower of Winds is festooned with automata when the building has been gutted for centuries (Fig. 1.1).[12] Nero's *Domus Aurea* (golden house)—which was built between A.D. 64 and A.D. 68 on real estate reclaimed from the fire that consumed the downtown of first-century Rome and later replaced by, among other things, the Coliseum—was accidentally discovered in 1480 when a tavern owner excavating for a cellar accidentally dug through to the ancient dwelling. Artists of the day, carrying torches and sketch-

[8] Vasari, *Lives*, IV. 46.

[9] *Attic Nights*, X. 12, viii.

[10] Leonardo da Vinci: *The Madrid Codices*, vol. 3. Commentary p. 106, McGraw Hill, New York.

[11] Appian, *Roman History: The Civil Wars*, Book II 147, p. 499. New York, Macmillan Co.

[12] Vitruvius, *De Architectura*. F. XXIII verso, Bronx: Blom, 1968.

books, made their way into the palace and copied the innumerable fresco paintings that covered the vaults, finding in them the source of inspiration for their decorations of palaces, chapels and villas. Raphael, master of the Vatican Stanze, was inspired by the buried frescoes and, along with Giovanni da Udine, launched a new artistic style. The *Domus*, which was buried in order to build the Baths of Titus, was built into the Oppian Hill and contained grottos and a dining room featuring a rotating ceiling that may have depicted the movements of the heavens. Leonardo was a young man at the time the *Domus* was discovered.

The Laocoön, discovered in 1506 in the Dumas's apsidal hall and identified by Michelangelo, which with its tortured, dramatic figures transformed the Renaissance conception of classical sculpture. Leonardo was working in Milan at this time.

About 1508, as he was staging a play at the residence of the French governor of Milan, Charles d' Amboise, Leonardo devised a mechanical bird[13] that could flap its wings by means of a double crank mechanism as it descended along a cable (Fig. 1.2). A comparable device was sold as a toy in the late nineteenth century (Fig. 1.3), and there is of course the antecedent of Villar de Honnecourt in the first half of the thirteenth century (Fig.1.2).

Another bit of evidence supporting the idea that Leonardo had not only the ambition but the knowledge needed to build automata is the Codex Huygens. Recently confirmed to be copies of several folios of lost Leonardo notes, the Codex Huygens is a late sixteenth-century manuscript based on Leonardo's lost original of about the same date (Fig. 1.4). Named for its owner, brother of the famous Christian Huygens, who was credited with the invention of the pendulum clock, the manuscript resides in the Pierpont Morgan Library in New York.[14] It contains history's earliest kinesiology diagrams. As kinesiology deals with the range of motion and degrees of freedom of human joints, the knowledge of it is vital to the conception and generation of anthropomorphic robots.

Fig. 1.2. *Top:* Leonardo, CA, f. 231 v-a [629ii v]. *Bottom:* Villar de Honnecourt, sketchbook, f. 58 r, Paris, National Library

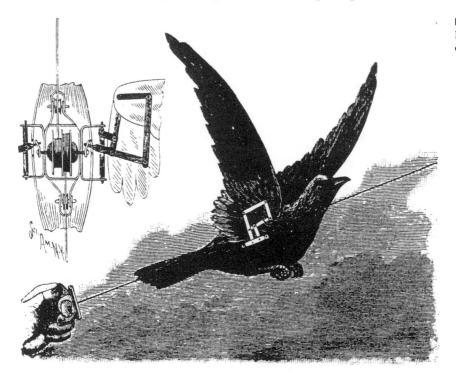

Fig. 1.3.
Nineteenth century version of Leonardo's bird

[13] CA, f. 630 v, [231 v-c], 1508, given in the Richter Commentary, note to §703 (with full bibliography).
[14] Erwin Panofsky, *The Codex Huygens and Leonardo da Vinci's Art Theory*, London, The Warburg Institute, 1940.

Fig. 1.4. ▶
Codex Huygens, f. 7 and 29

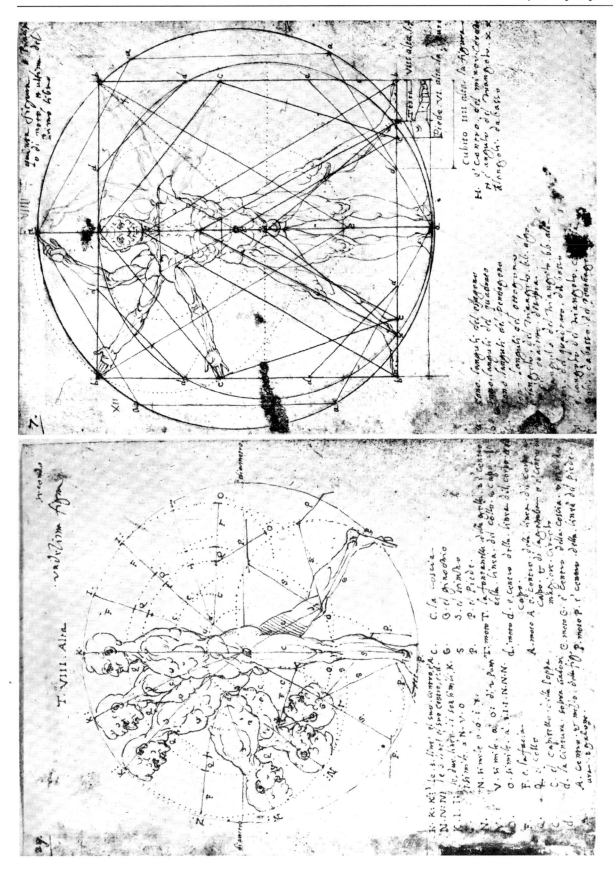

Leonardo's kinesiology diagrams not only provided him with ready reference for his art but also would have enabled him to determine at a glance the range of human limb motion. I know this from my own experience as a designer of robotic joints—much of my early work in joint technology was guided by reproductions of Leonardo's drawings in this codex. Folios 7 and 29, for example, provide a good illustration of the range of motion for legs and arms in a way that is very useful in the design of automata.

My first design for an anthrobot, which formed the cover art of my first book, *Robot Wrist Actuators*,[15] was as much an exercise in art as mechanical design, was inspired by Leonardo's "Proportions of Man." This was based on the ancient Vitruvian canon of proportions (Fig. 1.5). I sought to depict the essential element of an anthrobot by focusing on broad concepts of proportions and kinematics. I applied ball-and-socket joints throughout, but to my surprise, the resultant limbs did not fit the geometrical proportions of the circle and square seen in Leonardo's drawing; I had to "fudge" the limbs to make them fit. I learned two things from this. First, that Leonardo's drawings are very accurate, and may have been drawn with the aid of a *camera obscura* or other optical aid. Perhaps the model stood with his back to a white wall inscribed with a circle and square. Second, I learned that the human shoulder is far more complex than a simple ball and socket—the geometry suggested a compound joint. This would set my direction—study kinesiology to set goals for the robot's performance. And never, never, underestimate Leonardo da Vinci.

Fig. 1.5.
Proportions of Robot

[15] Mark E. Rosheim, *Robot Wrist Actuators*, New York, Wiley, 1989. Dust Jacket illustration and p. 248–249.

One area, almost a subculture, which I entered through my interest in Leonardo is the world of rare books, their stores, and colorful dealers. I became so interested in it that I started taking night classes at the Minnesota Center for Book Arts in Renaissance bookbinding classes from a local master binder in order to produce my own vintage notebooks sewn on cords.

My addiction started innocently enough with the local bookstores in Minneapolis and Saint Paul, Minnesota. On the other hand, maybe it's something deeper than a simple addiction. I always find myself in the darkest recesses of antique and book stores on the most esoteric behind the scene tours. It seems I'm the last to leave or the only one in some obscure or unlikely exhibit.

Book stores were already familiar to me from years of searching for technical books in my robotics studies. As always, I began by raiding the local stores—Midway Books, Jim Lowry's, The Book House by the University of Minnesota, and later moved on to infiltrating surrounding areas. Constantly I consulted the bibliographies of my ever-growing collection to determine what the standard texts were. And I already had a long history of antique hunting and country auctions going back to my childhood in Tama, Iowa, where for a few dollars I could come home with baskets of silk-covered wire, Model T ignition coils and other wonderful turn of the century technical junk. I would also hunt with my father, who is a collector of rare Horatio Alger books.

Being a rare book addict has its own rhythm and rituals. Hunting down the book, the thrill of discovery and, in this era of the World Wide Web, the tension of ordering, making sure it is still available. Then the joy of receiving the book, with its strange foreign stamps and insurance markings from far away. Stealing off to my little office space nook. Unwrapping the parcel, unpacking the books from the padding—at last reaching the books themselves in their last layer of buff blue colored paper. All alone, delicately removing this sheath to reveal a lost fragment of the past in its impossibly impractical vellum binding. Behold, my new treasure: a piece of history intercepted by me in its travel through time. I have done this countless times, as I amassed my Leonardo manuscripts and facsimiles, down, at last, to the five volumes of the Codex Forster first edition, which nearly completes my collection.

One of my first rare books adventures took place in Berkeley, California, on Telegraph Avenue to the rare books room on the top floor of Moe's Books, then run by the legendary Moe himself. A tubercular man with long gray hair, he was beet red when I first saw him, yelling and screaming about an employee's unproductive behavior. He would be dead of a heart attack a few years later. My first set of Leonardo facsimiles was the Madrid Codices, which I had eyed in a dark hardwood cabinet with double glass doors at Moe's. I sold my Reagan era Stainless Steel Rolex Submariner watch to finance the $300 acquisition and went home well pleased.

Another character in the world of book collecting is Jeremy Norman, the son of the major collector Haskel Norman, a New York psychiatrist who, having passed away to the big library in the sky, no doubt rolled in his grave when his collection was recently sold in three Christie's auctions. The first auction alone netted over six million dollars. Jeremy had an elegant downtown San Francisco suite of offices at 720 Market Street where stockbrokers and lawyers drop 100K on a single purchase. On my visits there I would get his employees in stitches with my impersonation of his nasal voice.

Once I met the French collector Michel Boviar at the Los Angeles book fair and purchased some of the French Leonardo facsimiles from him. When I asked what he liked the most about collecting, he said it was exploring attics of old French estates and finding rare incunabula (books printed before 1500) forgotten there by owners centuries before.

One of the palaces of rare book collecting is the vast and formidable Strand bookstore, named after the famous publishers' street in London. Located at Broadway and Twelfth Street in New York, it boasts five floors and acres of books in addition to its own side entrance rare bookstore, where I picked up a set of turn of the nineteenth-century Leonardo volumes with tipped-in reproductions of his horse drawings.

Passing through the narrow, alley-like streets of Florence, I found Gonnelli, located near the Duomo on Via de' Servi. The bay window is filled with literary treasures flaunting their engraved plates, the artists challenging the centuries. In contrast are the employees, whose perpetual frowns no amount of purchase—even a six-million dollar sale—can reverse into a smile. One employee, thinking that I would not want a broken set, mentioned in passing that they had two volumes from separate sets of Leonardo's Codex Arundel. The employee, surprised that I was interested in such sorry remnants, headed off to the warehouse to locate them. To cut costs I became a connoisseur of the broken set, having faith that someday it will be made whole once more.

One interesting phenomenon of the rare book world is that, not withstanding the value of the objects, dealers are willing to accept checks from anyplace in the world. In the case of the Codex Arundel, my fractured credit card was not up to the job, but by dropping a few well placed names I walked out with the broken set on the strength of my promises to send a check. I guess they figured they knew how to find me. Another learning experience occurred when the State of Minnesota sent me a bill for unpaid customs duties—they too knew how to find me!

Once, in the pre-Web days of Christie's, I stayed up until four in the morning to purchase my first set of the Codex Atlanticus. I had received the notice via "Lot Finder" only a few days previously. I fell asleep by the phone and was woken up by the London auctioneer's call. As the adrenaline pumped through my sleepy head, the hammer went down at only $1 200, and I heard the female auction house representative saying in a firm British voice, "you own it." I wasn't too upset with the price because new copies can retail for over $40 000. Carlo commented that it was meant to be. After purchasing a "mint in box" set I later sold them on eBay to a person who thought he had an original Leonardo painting that he purchased in a flea market. I hope he's right about the painting.

As I amassed my army of facsimiles, storage became a problem. The Codex Atlanticus alone weighed several hundred pounds and took a cubic yard of space. I bought two armoires from Pier One Imports and painted them to resemble school cabinets. I subsequently painted Leonardo's Knight on the wooden panes of one and his lion on the wooden panels of the other.

One day in 1999, Jeremy Norman's rare book catalog "Classics of Science and Medicine" arrived in my mailbox. With my usual sense of anticipation I thumbed through the catalogue, looking for facsimiles of Leonardo manuscripts, and noticed a first edition of *De Motu Animaliam* by Giovanni Alfonso Borelli, a seventeenth-century mathematician, a follower of the great Galileo. The catalogue showed one of his leg diagrams, which I immediately recognized as the same as one in Leonardo's Madrid Manuscript I. Not possessing $7 500 to purchase the first edition, I located a cheap reprint in English with reproductions and commentary. As I was studying the Borelli reproduction, the staggering thought occurred to me that I was not simply looking at drawings that reflected Leonardo's interests and style: *I was looking at the missing section from Madrid MS I.* Could I have located the missing material that had eluded professional scholars for decades? Strangely, the facsimile plates were almost exactly the same size as the Madrid MS I—so you could slip them into the red leather bound facsimile as if they belonged there.

❖

Giovanni Alfonso Borelli was an important mathematician of his time who became interested, as did Leonardo before him, in modeling the movements of animals. Born in Naples on 28 January 1608, he was the son of a Spanish infantryman and his Italian wife. In 1635, through Castelli's recommendation, Borelli obtained the public lectureship in mathematics in Messina, Sicily, then ruled by Spain. In 1658 he accepted the chair of mathematics at Pisa. Malpighi is credited with sparking Borelli's interest in the movements of living creatures. Around 1675, Borelli created *De motu animalium*

in hopes of being received and accepted into the Academie Royale de Science, which had been newly established by Louis XIV in Paris.[16]

The similarities between the work of Borelli and Leonardo have not gone unnoticed by modern researchers. V. P. Zubov makes the general conclusion that Borelli over simplifies.[17] This may be true in some cases but in many other cases he is now viewed as being highly advanced for his time, anticipating technology that did not occur until well into the twentieth century.[18] Zubov also criticizes either the absence or incorrectness of Leonardo's theories of flight. And yet, as shown by Madrid MS I, Leonardo's theories were adequate to design in 1495 a hang-glider capable of lifting a man. This has been proven through modern reconstructions.[19]

Only a very few of the scholars who have dealt with Leonardo's scientific and technological endeavors have called attention to Borelli's work for possible reflections of Leonardo's ideas. None has ever raised the question whether such ideas could have reached Borelli directly or through the mediation of those who had access to Leonardo's manuscripts following his death in 1519.

Those manuscripts were brought back to Italy from France by Francesco Melzi after Leonardo's death. Other books, of course, could have already circulated when Leonardo was still alive, and there is evidence that an autograph manuscript on the movements of the human body analyzed geometrically—a subject extensively treated by

[16] The best account of Borelli's work, in particular his innovative studies on the flight of birds, is still the one in Giuseppe Boffito, *Il Volo in Italia*, Florence, 1921, pp. 137–142 (with full bibliography). For a comparable account, see Galileo Venturini, S. J., *Da Icaro a Mongolfier*, Rome, Parte Prima, 1928, pp. 243–245, which concludes with a reference to Leonardo: "Nella pare che riguarda il volo, chi volesse fare un accurato confronto, troverebbe le stesse lines maestre, tracciate da Leonardo da Vinci: con questa differenza pero', che mentre Leonardo ci da' (ne' poteva essere altrimenti) un ingegnoso trattatello, dove non se sa se piu' ammirare la intuizione o la succosa brevita' del poderoso autodidatta, il Borelli, che ha potuto far tesoro delle osservazioni sagaci di tanti predecessori, e che in quella materia se sente appieno in casa sua, ci presenta un completo trattato scientifico."

See also the preface to Paul Maquet's English edition of Borelli's *De motu animalium* (*On the Movement of Animals*), Berlin, 1989, pp. v–ix.

Borelli was one of Galileo's most prominent followers, not only as a member of the celebrated Accademia dell Cimento in Florence and as a friend and a colleague of Evangelista Torricelli, but above all as a pupil of Benedetto Castelli, whose treatise *Della misura dell'acque correnti* (1628) was at one time believed to have been based in part on Leonardo's writings on the subject. Cf. Filippo Arredi, "Intorno al trattato 'Della misura dell' acque correnti' di Benedetto Castelli", in *Annali dei Lavori Pubblici*, 1933, fasc. 2, pp. 1–24, and *L'idraulica di Galileo e della sua scuola*, Rome, 1942, in particular p. 16. Borelli's writings on hydraulics are included in the *Raccolta d'autori italiani che trattano del moto delle acque*, Bologna, 1822, vol. III, pp. 289–336. One of his treatises, a report on the Pisa and Livorno swamps ("Stagno di Pisa"), is yet to be examined in connection with Leonardo's previous studies on the subject. Cf. Siro Taviani, *Il moto umano in Lionardo da Vinci*, Florence, 1942, pp. I–LXIV, in particular p. VI for the reference to Leonardo as having recognized before Borelli the general physiological laws of the muscular system.

[17] V. P. Zubov, *Leonardo da Vinci*, Cambridge, Mass., Tr. David H. Kraus, 1968, pp. 184–185. A comparable, modern assessment of Borelli's work comes from Clifford A. Truesdell, the author of a perceptive and well informed essay on "The mechanics of Leonardo da Vinci," in his *Essays in the History of Mechanics*, New York, Springer-Verlag, 1968, pp. 324–325: "In the seventeenth century, statics was a well developed subject, and it was applied in a way then acceptable to many persons in many cases where any modern engineer would require laws of motion, then unknown. For example, we may cite Borelli's book, *On the Motion of Animals* (1685), where the parallelogram of forces seems to be the only quantitative basis for two volumes on the subject named, and where, despite the title, we look in vain for any laws of motion. I do not mean at all to ridicule the book; it is not only truly scientific but also ingenious in many places; I adduce it as an example to show the work both intelligent and extensive can be done on a wobbly foundation, and that the existence of serious literature in a domain, leading to some measure of success, does not necessarily imply that the structure is sound."

[18] Paul Maquet, as cited in note 16 above.

[19] See Michael Pidock, "The Hang Glider," in *Achademia Leonardi Vinci*, VI, Firenze, Giunti, 1993, pp. 222–225, with an editorial introductory note and reproductions, figures 1 and 2, of photographs of a first test flight of the reconstructed hang glider (Sussex Downs, England, 20 October 1993). A version more faithful to Leonardo's drawings has recently been built at Sigillo in Umbria by a local association of hang glider pilots. See Carlo Pedretti, *Leonardo. The Machines*, Firenze, Giunti, 1999, p. 29.

Fig. 1.6.
Borelli's table XIIII, fig. 8

Borelli—was seen by Federico Zuccaro either in Rome or in Turin at the end of the sixteenth century.[20] And since a mechanical lion made for Francis I is now confirmed to have been a Medici commission on which Leonardo worked, either in Florence or in Rome about 1515, he very well may have gathered all the pertinent information in a book left to his patrons and then lost, as was the case with a book of unspecified contents given to Battista dell' Aquila, steward-in-waiting to the Pope—"cameriere segreto del Papa."[21] Leonardo's invention of diver devices and his studies for the submarine were shown by Mario Baratta in 1903 as part of a vast historical context that includes Borelli's comparable studies.[22] Indeed, the diver devices shown in fig. 8 from table XIIII seems to be lifted directly from Leonardo (Fig. 1.6). Borelli might be the source of

[20] Federico Zuccari's account of the lost Leonardo manuscript of the Codex Huygens type of kinesiology studies is given in his *Idea*, Turin, 1607, p. 31, as fully discussed and reproduced in Leonardo da Vinci, *Libro di pittura. Edizione in facsimile del Codice Urbinate lat. 1270 nella Biblioteca Apostolica Vaticana a cura di* Carlo Pedretti. *Trascrizione critica* di Carlo Vecce, Florence, Giunti, 1995, pp. 42–43.

[21] Leonardo's memorandum in CA, f. 287 r-a780 r [780 r], c. 1514–1515, used to be quoted, as Richter does, §7A, with the addition of the words "de vocie" (On Acoustics) taken to be the title of Leonardo's book, when they are, instead, Leonardo's "label" to an adjacent diagram. This is explained by Carlo Pedretti in his *Commentary* to the Richter anthology (Oxford, Phaidon 1977), vol. I, p. 107.

[22] Mario Baratta, *Curiositá Vinciane*, Turin, 1905, pp. 179–184. See also Francesco Savorgnan di Brazzá, *Da Leonardo a Marconi. Invenzioni e scoperte italiane*, Milan, 1941, pp. 78–79, for the mention of Borelli's project of a submarine as well.

Fig. 1.7.
Borelli's table XIIII, fig. 9

other lost Leonardo drawings. The summary of Madrid MS I discusses how to salvage sunken ships; pages which are now missing may have been discussed and illustrated in folios 37–42 and 55 and 56. It is interesting that Borelli's illustration 9 from table XIIII (Fig. 1.7) seems to illustrate with its leather floats and boarded-up hull just that, albeit with some oars placed through openings.

Borelli's studies on the flight of birds were first mentioned by Gustavo Uzielli in 1884 in connection with Leonardo's Codex on the Flight of Birds, in particular for a note on f. 7 r (and again on f. 10 r), in which Leonardo, long before Borelli, formulated the theory that the wind acts as a wedge in lifting the bird: "il vento fa ofitio di cuneo."[23] Scholars such as Giuseppe Boffito in 1919 and Raffaele Giacomelli in 1935 systematically approached Leonardo's and Borelli's studies on the flight of birds on a comparative basis, and this is also the subject of a paper published by G. Pezzi in 1972.[24]

It is indeed surprising that recent scholars such as Martin Kemp (1982), Kenneth Keele (1983) and Kim H. Veltman (1986), who have greatly contributed to place Leonardo's scientific studies in their historical context, make no reference to Borelli. However, in the Keele-Pedretti edition of the Corpus of Leonardo's Anatomical Studies at Windsor

[23] Gustavo Uzielli, *Ricerche intorno a Leonardo da Vinci*. Rome, Serie seconda, 1884, p. 403.

[24] The importance and originality of Borelli's studies on the flight of birds were first recognized by E. J. Marey, *La machine animale*, Paris, Librairie Germer Baillière, Bibliothèque Scientifique Internationale, 1873, and again, in a context that includes Leonardo's comparable studies, in roman *Le vol des oiseaux*, Paris, 1890, pp. 234–235, a classic on the subject which is not recorded in Verga's *Bibliografia vinciana* (1931). See also Modestino Del Caizo, *Studi di Giovanni Alfonso Borelli sulla pressione atmosferica*, Naples, 1886, and, by the same author, *Giovanni Alfonso Borelli e la sua opera "De motu animalium*," Naples, 1908. Raffaello Caverni, *Storia del metodo sperimentale in Italia*, Florence, 1891–1900, 6 vols., in particular vol. III, p. 402; Giuseppe Boffito, *Il volo in Italia*, cit. (as in note 11 above), pp. 137–142 (in comparison with Leonardo); Raffaele Giacomelli, *Gli scritti di Leonardo da Vinci sul volo*, Rome, 1935, pp. 206–207, and, by the same author, "Il *De volatu* di Borelli," in *L'Aeronautica*, XIV, fasc. 3, 1934, pp. 1–15. For the wedge theory in both Leonardo and Borelli, cf. G. B. De Toni, *Le piante egli animali in Leonardo da Vinci*, Bologna, 1922, p. 137. In 1900 G. B. De Toni ("Osservazioni di Leonardo intorno si fenomeni di capillaritá," in *Frammenti Vinciani, I–IV*, Padua, 1900, pp. 53–61) had already mentioned Borelli in connection with Leonardo's experiments on capillarity. G. Pezzi, "La meccanica del volo nell'opera di Leonardo da Vinci e nel *De motu animalium* de Gian Alfonso Borelli", in *Minerva medica*, LXIII, 1972, pp. 2184–2188, and *Annali di medicina navale e coloniale*, LXXVI, 1971, pp. 2750–2782. And finally: Useful information on the life and work of Borelli is still to be found in Giammaria Mazzuchelli, *Gli scrittori d' Italia*, Brescia, Giambatista Bossini, 1762, vol. II, part III, pp. 1709–1714. See also Pietro Riccardi, *Biblioteca matematica italiana*, Modena, 1970, *sub voce*, and *Le opere dei discepoli di Galileo Galilei*. Volume Primo. *L' Accademia del Cimento*. Parte Prima, ed. Pietro Pagnini, Florence, Giunti, 1942, pp. 21–22.

Fig. 1.8.
Borelli's table V, fig. 11

(1980), Keele points out[25] that the complex mechanism of the woodpecker's tongue, on which Leonardo intended to write,[26] is first explained by Ulisse Aldrovandi and again by Lorenzo Bellini and by Borelli, who gives a beautiful illustration of it in plate V, fig. 11 (Fig. 1.8).[27] Finally, Leonardo's extensive and innovative studies on mechanics

[25] Kenneth D. Keele and Carlo Pedretti, 1979/80, *Corpus of the Anatomical Studies in the Collection of Her Majesty the Queen at Windsor Castle*, London and New York, Johnson Reprint Corporation (3 vols.), vol. I, p. 362. For other aspects of Borelli's biological studies in relation Leonardo's, see F. S. Bodenheimer, "Leonard de Vinci, biologiste", in *Lènard de Vinci et l'espèience scientifique aux XVIe siècle*, Paris, Presses Universitaires de France, 1953, pp. 172–188, in particular p. 175 (flight of birds), 179 (Leonardo's studies on animal locomotion as compared with Borelli's principles of "iatophysics", i.e. the application of physics to medicine), 182 (Leonardo as precursor of Malpighi, Redi and Borelli). Cf. in the same volume the "Rapport final" by Alexandre Koyrè (p. 244).

[26] Cfr. Windsor, RL 19070 v: "scrivi la lingua del pichio." See also Windsor, RL 19115 r: "fa il moto della lingua del picchio."

[27] Cfr. Guglielmo Bilancioni, "Leonardo da Vinci e la lingua del picchio," in *Rivista di storia delle scienze mediche e naturali*, XVII, 1926, pp. 1–12. Bilancioni does not mention Borelli, but for the explanation of the mechanism of the woodpecker's tongue he gives full credit to Borelli's pupil Lorenzo Bellini. The illustration in pl. V, fig. 11 (Fig. 9) is not based on that given by Ulisse Aldrovandi, *Ornithologiae …*, Bolgna, 1599, p. 838. According to Carlo Pedretti (oral communication), the way the complex mechanism of the bird's tongue is shown in an overall view of the bird's head, as seen three quarters to the right from above, is well in keeping with the type and character of Leonardo's anatomical illustrations of c. 1510 (e.g. the sheet with studies of the palate, tongue and larynx, and hyoid bone, in Windsor, RL 19002 r (A. 3)).

Fig. 1.9.
Borelli reference letters on table III, fig. 2, H, C, and A

Fig. 1.10.
Codex Urbinas, f. 120 v

Fig. 1.11. Madrid MS I, f. 36 r

are shown by Roberto Marcolongo in 1939 to find reflections only in Borelli's work of nearly two centuries later.[28] Unfortunately, this interesting pointer was not followed-up by Arturo Uccelli (1940) in his monumental edition of those studies.[29]

Of the eighteen plates in Borelli's *De motu animalium,* almost every one offers a figure that is similar in theme or style to Leonardo's. This is the case not only with drawings; coincidentally, several reference letters match. For example, the Borelli reference letters on plate III, fig. 2, H, C, and A (Fig. 1.9) match those of Codex Urbinas, f. 120 v (Fig. 1.10). Interestingly, Borelli appears to follow the sequence of illustrations in Madrid MS I: he starts with a figure that has elements in common with the page

[28] Roberto Marcolongo, *Leonardo artista-scienziato*, Milan, Hoepli, 1939, pp. 197 and 294.

[29] Leonardo da Vinci, *I libri di meccanica nella ricostruzione ordinate da* Arturo Uccelli, Hoepli, Milan, 1940.

Fig. 1.12.
Borelli's table I, fig. 1

Fig. 1.13.
Borelli's table I, fig. 3

before the first section of missing pages in Madrid MS I. On Madrid MS I, f. 36 r (Fig. 1.11), Leonardo shows a block-and-tackle design with seventeen pulleys the same number as the number of muscle fibers in Borelli's first illustration on plate I, fig. 1 (Fig. 1.12). Plate I, fig. 3 (Fig. 1.13), has thirtyfour muscle fibers the same as the number of cable convolutions in Madrid MS I, f. 36 r. Indeed, the number seventeen shows up throughout the machine design folios of Madrid MS I in the number of pulleys and gear teeth. Is Leonardo trying to tell us something? Is he carefully maintaining analogs to his lost human muscle diagrams?

Fig. 1.14.
CA, f. 349 r-b [966 r].
Studies of forces

Leonardo's biomechanics can be interpreted through the comparative study of Borelli. Because of the great similarity of theme and organization, Borelli may have used it as an aid in interpreting drawings such as CA, f. 349 r-b [966 r] (Fig. 1.14), which represent the human body schematically, and are similar to the diagrams in Borelli's plate V, fig. 1 (Fig. 1.15). Madrid MS I, f. 90 r-v (Fig. 1.16) bears a striking resemblance to Borelli's plate V, fig. 6 (Fig. 1.17). This relates to the leg's lifting capacity

Fig. 1.15.
Borelli's table V, fig. 1

Fig. 1.16.
Madrid MS I, f. 90 v. Leg study

Fig. 1.17.
Borelli's table V, fig. 6
▼

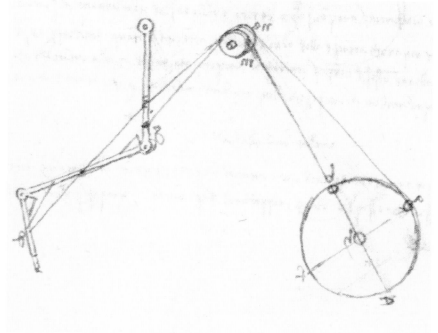

Fig. 1.18. Borelli's table XII, fig. 4 **Fig. 1.19.** Leonardo's MS L, f. 28 v **Fig. 1.20.** CA, f. 164 r-a [444 r]

in retraction. Also in Borelli's plate XII, fig. 4 (Fig. 1.18), we see a graphic similarity to
Leonardo's MS L, f. 28 v (Fig. 1.19), and CA, f. 164 r-a [444 r] (Fig. 1.20), showing a
centerline though the body's limbs. In Paris MS L and CA, f. 164 r-a [444 r], are com-
parable diagrams of the forces involved in pulling a weight uphill which show a leg
extending and retracting. This notation may date from 1497–1500. See Chapter III for
Leonardo's Robot Knight's leg which may be the practical demonstrate piece based
directly on these theoretical studies.

The seed of Leonardo's biomechanics was to come to full fruition nearly two centu-
ries later with Giovanni Borelli's *De motu animalium.* Zubov appropriately refers to
Leonardo as Borelli's "spiritual father."[30] Curiously, Pierre Duhem, a fervent advocate
of the theory that much of Leonardo's legacy was indeed available and taken advan-
tage of, by his successors, never mentions Borelli.[31] That Borelli learned from Leonar-
do may never be proved. But it seemed too much of a coincidence that his approach to
biomechanics should be so strikingly similar to Leonardo's.

Rushing to my phone, I called Carlo Pedretti in the evening, and excitedly explained
my theory.

[30] Zubov, op. cit. (as in note 17 above), p. 184.

[31] Pierre Duhem, *Ètudes sur Leonard de Vinci. Ceux qu' it a lus et ceux qui l'ont lu*, Paris, A. Hermann,
1906, 1909 and 1913, 3 vols.

Leonardo's Programmable Automaton and Lion

These schemes [i.e. blue-prints] which have provided the basis for our reconstruction of Leonardo's car, along with the hypotheses that one may speculate about, confirm our conviction that this vehicle could never function the way it was designed by Leonardo.

Giovanni Canestrini, *Leonardo costruttore di macchine e di veicoli*, Roma-Milano, Tumminelli & C. Editori 1939, p. 128

My discovery that one of the leg diagrams in Giovanni Alfonso Borelli's *De Motu Animaliam* was the same as in Madrid MS I had Carlo Pedretti diving into his library as the realization set in that perhaps the missing material had been discovered at last. There had been a controversy when Madrid MS I was discovered in the 1960s about when the missing material may have been removed. Interviews were made and the case closed.[1]

And then if Leonardo's Book of Mechanics featured the similarity of man to machine, it is logical that he took it one step further—to automata that mimic the very motion and movement of life itself.

Leonardo developed a means of locomotion and control for automata which would later become common in the festivals and court masques of the sixteenth and seventeenth centuries. In 1478, while under the patronage of the Medici, he designed a programmable, mechanical computer-controlled automaton. This automaton was a precursor to mobile robots and was perhaps the earliest "computer" in western civilization. By reinterpreting material form Leonardo's notebooks, as well as the work of Japanese artisans of the eighteenth century, I was able to reconstruct Leonardo's intentions for the programmable automaton. This basic design may have been recycled by Leonardo in France some thirty-six years later for use as a platform for a self-propelled mechanical lion, again under a commission from the Medici. This has been ascertained only recently by Carlo Pedretti. Michelangelo Buonarroti the Younger, nephew of Leonardo's great rival, recorded the spectacle he witnessed at the wedding in 1600 of Maria de' Medici, Queen of France and Navarre, to Henry IV son of Antoine de Bourbon and Jeanne d' Albret. He was the first of the Bourbon Kings of France. In a booklet published in Florence in 1600, Michelangelo the Younger mentions an automaton that was presented at a banquet: a mechanical lion that walked a few steps and then rose on its hindquarters, opening its breast to show that it was full of fleurs-de-lis, a concept, concludes the younger Michelangelo, "similar to that which Leonardo da Vinci realized for the Florentine Nation on the occasion of Francis I's triumphal entry into Lyons" in 1515.[2]

[1] See the section on "News and Notes" in *Renaissance Quarterly*, New York, Renaissance Society of America, XXIV, no. 3, autumn 1971, pp. 430–431, for the "Notice" signed by the members of a committee—Theodore S. Beardsley, Jr. (Hispanic Society of America), Carlo Pedretti (UCLA), and Paul Oskar Kristeller (Columbia U), Chairman—charged by the Renaissance Society of America "to investigate the circumstances under which two Leonardo manuscripts entitled *Tratados de fortificación, mecanica y geometria* had been recently discovered in the Biblioteca Nacional in Madrid".

[2] Nothing is left of Leonardo's project for the mechanical lion and what used to be known of it was only through the mentions by Vasari and Lomazzo, who did not indicate the precise occasion of the event nor its symbolism. The missing information is supplied by the *Descrizione delle felicissime nozze della Cristianissima Maesta' di Madama Maria Medici Regina di Francia e di Navarra* by Michelangelo Buonarroti the Younger (Florence, Giorgio Marescotti, 1600), p. 10, as first discussed and reproduced by Pedretti, *Leonardo architetto*, cit., p. 322. See also, by the same author, "Leonardo at Lyon," in *Raccolta Vinciana*, XIX, 1962, pp. 267–272, and *Leonardo. A Study in Chronology and Style*, London, Thames & Hudson, *and* Berkeley and Los Angeles, University of California Press, 1973 (second edition, New York, Johnson Reprint Corporation, 1982), p. 172.

The occasion of the earlier spectacle was described in Lomazzo's 1584 retrospective account of the allegory of friendship between the Medici and Francis I, which occurred at the latter's accession to the throne of France. Lomazzo writes that "once in front of Francis I, King of France, [Leonardo] caused a lion, constructed with marvelous artifice, to walk from its place in a room and then stop, opening its breast which was full of lilies and different flowers."[3] The Lion was an old symbol of Florence, and the lilies referred to the *fleur-de-lis* that Louis XI of France had given to Florence as a token of friendship. The two powerful families were combined symbolically in a dramatic presentation by one fantastic machine. Figure 2.1 shows my recreation utilizing the automaton presented in this chapter with a Lion shell over it.

Scholars offered no explanation for how Leonardo's lion walked. Carlo Pedretti felt that it would have been an anatomically correct approach. However, supplying the power required for actually walking, even in the twenty-first century, is a daunting task. In general, Renaissance Italian scholars have tended to under-rate the abilities of the court "special effects" people of the fifteenth to sixteenth centuries, perhaps, in part, because they tend to be non-technical, but also because it challenges the idea that Renaissance engineers were not as sophisticated as we.

There have been a number of books claiming to collect Leonardo's mechanical studies.[4] All have missed the overriding patterns, to say nothing of the complex devices. They concentrate on the clearly illustrated mechanical elements which are often reproduced in museums. The pulleys, bearings and gears along with some locks, weight lifting devices and other components or simple machines that would have been considered unremarkable by Leonardo's contemporaries. What is being reconstructed here is a much broader richer tapestry with far more complex mechanisms than previously known.

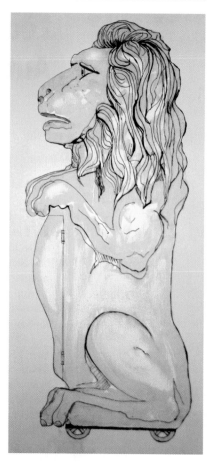

Fig. 2.1. Leonardo's Lion

Pieces of the Puzzle

My reconstruction of Leonardo's programmable cart began in 1999 when I was invited to give the keynote speech at the 40th annual *Biblioteca Leonardiana* in Vinci, Italy, the town of Leonardo's birth. An honor usually bestowed on professors and scholars, the invitation came with a serious drawback: I would be asked to deliver the speech in Italian. Thus forewarned, I began a crash course in Italian at Hamline University. My first university class in perhaps 15 years started at 8:00 A.M. (very early for this night owl) and met three times a week. There I found myself sitting with teens and early twenty-somethings, a few of whom would show up for class in their pajamas.

Meanwhile, I had to think of a topic for the lecture, a problem that, compared to the prospect of carrying on in Italian for hours on end, seemed a bit more manageable. Codex Atlanticus,[5] f. 296 v-a [812 r] (Fig. 2.2) shows the formation of a technological idea as early as c. 1478, when Leonardo was about twenty-six years old. Since 1929, when it was first recognized by Guido Semenza as a self-propelled vehicle, the machine represented there has convinced all interpreters that the arbalest springs

[3] Carlo Pedretti, *Leonardo architetto*, cit., p. 209, and, by the same author, "Leonardo at Lyon," in *Raccolta Vinciana*, XIX, 1962, pp. 267–272.

[4] Ivor B. Hart, The Mechanical Investigations of Leonardo da Vinci, London, Chapman & Hall, 1925. Arturo Uccelli, Leonardo da Vinci's Libri di Meccanica, Milan, Hoepli, 1940. Zur Mechanik Leonardo da Vincis (Hebelgesetz, Rolle, Tragfähigkeit von Ständern und Trägern). Inaugural Dissertation Fritz Schuster. Germany, K. B. Hof- und Univ.-Buchdruckerei von Junge & Sohn, 1915.

[5] Henceforth cited as CA.

Fig. 2.2. ▶
CA, f. 296 v-a [812 r]

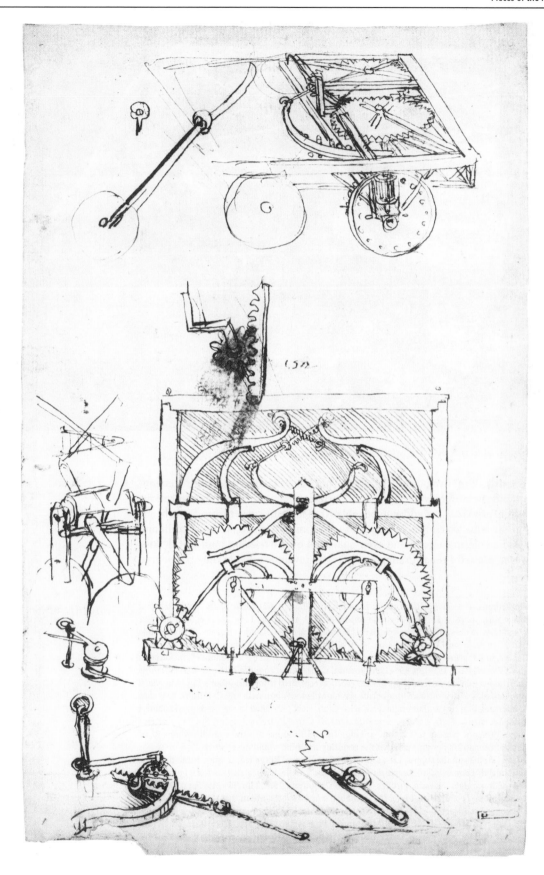

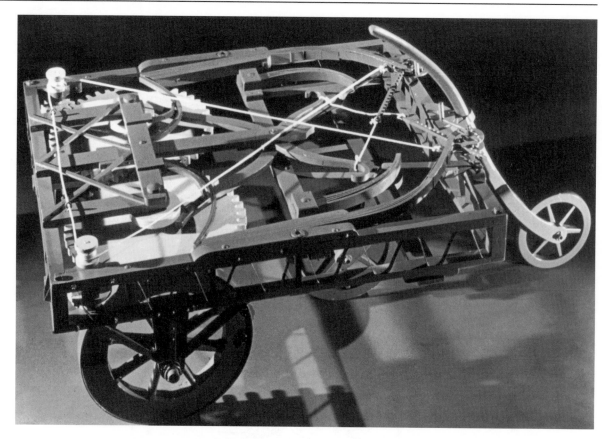

Fig. 2.3. Traditional reconstruction of Leonardo automaton

were the source of motive power (Fig. 2.3).[6] This way of reading Leonardo's techno-
logical graphic notation involved, of course, arbitrary alterations and modifications
of his design, primarily the addition of cables transmitting power from the arbalest
springs to the large gears. Scholars such as Giovanni Canestrini, Arturo Uccelli and
Jotti da Badia Polesine argued and even quarreled over irrelevant points of details.
All, however, praised Leonardo's ingenuity as the inventor of what they considered

[6] Cf. Carlo Pedretti, *The Codex Atlanticus of Leonardo da Vinci. A Catalogue of Its Newly Restored
Sheets*, New York, Johnson Reprint Corporation, 1978–1979, vol. II, pp. 125–126, new folio number
812 r. The studies on the subject are as follows (in chronological order): Guido Semenza, "L' automobile
di Leonardo", in *Archeion*, IX, no. 1, 1928, pp. 98–104; Arturo Uccelli, "L' automobile a molle e Leonar-
do da Vinci", in *La lettura*, no. 3, March 1936, pp. 7–8; Id., "Leonardo e l' automobile", in *Raccolta
Vinciana, XV–XVI*, 1935–1939, pp. 191–199; Giovanni Canestrini, *Leonardo costruttore di macchine
e di veicoli*, Rome, 1939, in particular pp. 67–129 (section reprinted from the author's *L'automobile: il
contributo italiano all' avvento dell' autoveicolo*, Roma-Milano, Tumminelli and C. Editori, 1939. See
also the interpretation by another engineer, Enrico Gigli, later published in the book by Marialuisa
Angiolillo, *Leonardo. Feste e teatri. Presentazione di Carlo Pedretti*, Naples, Società Editrice
Napoletana, 1979, one page of text accompanying pl. 6. This too has arbitrary modifications to, or
distortions of Leonardo's design, such that the resulting machine would never work.

The latest studies on the subject are as follows: Mario Loria, "Ruota trascinata e ruota motrice:
L' "automobile' di Leonardo," in *Leonardo nella scienza e nella tecnica. Atti del Simposio inter-
nazionale di Storia della Scienza*, Firenze-Vinci, 23–26 giugno 1969, Florence, 1975, pp. 101–103;
Augusto Marinoni, *Leonardo da Vinci: L' automobile e la bicicletta*, Milan, 1981, and, by the same
author, "Leonardo's Impossible Machines," in *Leonardo da Vinci Engineer and Architect*. Edited
by Paolo Galluzzi, Montreal, Montreal Museum of Fine Arts, 1987, pp. 111–130, in particular
pp. 124–125. See finally my paper "Leonardo's Lost Robot," in Achademia Leonardi Vinci, IX, 1996
for the Appendix on pp. 109–110: "Leonardo's 'Automobile' and Hans Burgkmair's 'Gala Carriages'."

the first example of a differential gear.[7] It did not matter, therefore, whether the machine, as reconstructed by them for the Leonardo exhibition of 1939, would work or not. Like Leonardo's helicopter, this so-called "automobile" was just another idea for modern interpreters to integrate and develop. So did Canestrini as he prepared a set of blue-prints for the model presented in the 1939 exhibition. Inexplicably, he concluded that what he had so painstakingly reconstructed could never work:

> These schemes [i.e. blue-prints] which have provided the basis for our reconstruction of Leonardo's car, along with the hypotheses that one may speculate about, confirm our conviction that this vehicle could never function the way it was designed by Leonardo.[8]

In 1975 Carlo Pedretti became the first to recognize this drawing of "Leonardo's so-called automobile" in the *Codex Atlanticus* for what it is—an automaton—and theorized that the first major subsystem was a pair of large coil springs for propulsion.[9] My work built on this fundamental discovery. I would later discover that the automaton had nothing less than front-wheel drive and rack-and-pinion control. But it would require my reconstruction of several major missing subsystems, including the steering, programming, and escapement or "clock," to make a full reconstruction possible. Reinterpreted by me as representing a programmable automaton, this mechanism was to have a great impact on Leonardo's future views, ranging from biomechanics all the way to his achievements with the famous and now less enigmatic mechanical lion of about forty years later.

I had left in my last paper on Leonardo some tantalizing notes about this "car," and the hint had been picked up by Romano Nanni, director of the Biblioteca Leonardiana in Vinci, Italy, the birthplace of Leonardo. This was why I found myself invited to the 40th annual *Celebrazioni Leonardiae*. I chose the process of reconstructing the programmable automaton as my thesis.

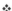

My struggle to learn Italian began with a sleepless night before the first class. Wishing very much for any other chore other than attending class at 8 A.M., I was happily surprised to find my teacher, Alessandra Matthys, to be a highly intelligent, attractive, bright eyed brunette from Rome. I would be learning from a native. In the course of the class, I also became friends with a Chinese music professor, Yalli Yu, who was taking the class to better serve her students for music study in Italy. Yalli and I became good friends and studied together at her office and over pizza. Loaded with books, flash cards, tapes, notebooks, and homemade index card notes held together with key rings, I would study day and night in coffee shops, restaurants and at my girlfriend's apartment. When studying with the audio tapes, I would occasionally give a hoot of joy when I got all my answers right. In spite of doing all the homework, I still had difficulty with tests (if only they would give me the entire day). But I gamely pressed on, offering some help from my worldly travels to my fellow students but in one embarrassing incident offering completely incorrect grammatical advice.

[7] The interpretation of Leonardo's drawings as showing a differential gear is unfounded. A differential gear is a complex bevel gear mechanism designed to permit differential motion of a pair of drive wheels in order to accommodate fewer revolutions of the inside wheel versus the outside wheel during turning. The two front wheels of the platform for automaton rotate together at a constant velocity.

[8] Canestrini, p. 128.

[9] Carlo Pedretti, "Eccetera: perchè la minestra si fredda" (Codice Arundel, fol. 245 recto). XV *Lettura Vinciana* ..., Firenze, Giunti, 1975, p. 13, note 9, where the so-called "automobile" represented in CA, f. 296 v-a [812 r], is considered more likely "a cart for festivals moved by springs and planned to cover brief tracts as from one side of a piazza to another" ("non era altro che un carro per feste azionato da molle e destinato a percorrere brevi tragitti come da un punto a un altro di una piazza"). In his *Leonardo architetto* (Milan, 1978), pp. 319–322, the interpretation is further elaborated and the Leonardo drawings shown in relation to other early studies in the Codex Atlanticus at the Uffizi.

As the text of the paper would be prepared in Italian, I hired my teacher to translate the paper with Carlo's supervision. Iteration after iteration, I would pick up the latest draft from her mailbox and correct it, watching it slowly take shape. As my pronunciation improved, I would also practice the entire speech, complete with slide presentation, for a captive audience of friends, relatives and party guests at a class pot luck to which I brought my very un-Italian beef stew. The party was at my Italian teacher's house, a nineteenth-century brick home on the outskirts of downtown St. Paul where, to the consternation of my fellow students, I joined in to a rendition of "Volare" in which we were accompanied on the piano by the teaching assistant. The damage inflicted on those within earshot must have been devastating.

At this stage of my development as a book collector/addict, I was hunting mostly on the Web using search terms like "rare book dealer." This led to some interesting consequences. With the advent of the Web almost anyone with a basement full of books may become a rare book dealer. One benefit to the consumer is that sellers may be ignorant of the true value of the merchandise, as was the case with a Belgian dealer from whom I purchased the facsimiles of Leonardo's anatomical studies. The down side of dealing with those who don't know how to price is that they also don't know how to pack! In spite of instructions to double box, insure, etc., this individual sent my massive three volume set in a simple cardboard box, with predictable damage. This required a visit to the book binder Dennis Rude, my former book arts instructor, whose amusing asides, encyclopedic knowledge and passion for book restoration know no bounds. In a month he had the bumped and torn corners repaired, and I was able to insert them in the two armoires that house my collection of Leonardiana.

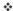

Although they at first told me that delivering the paper in Italian was simply "how it was done," Carlo and his lovely wife Rossana began to sense my difficulty as the year went on. The enormity of mastering Italian in so short a time would have been difficult, even for a person gifted at languages, which I am not. My reading timed out at 45 minutes – painful even in my native language. My battle plan consisted of having my Italian teacher tape record the entire text in Italian so I could practice to my heart's content. As a further aid, I would then rewrite the entire text phonetically in Italian! Perhaps it was my numerous phone calls to Carlo and Rossana begging for help with my pronunciation that led to the final solution. They eventually took pity on me and pulled some strings so that I could give the paper in English with simultaneous translation. Cleverly, they gave the excuse that Italy, in joining the European Union, should reach out to non-Italians. And of course there was the new millennium, a great reason to extend mercy to poor Anglophones such as myself. It was only later that I learned that the Italian of a certain famous British Leonardo scholar was so poor that not a single person understood him! What a relief!

As we've seen, automata of various descriptions were very much on Leonardo's mind up to and during the design of the programmable cart. However, the *Codex Atlanticus* and Uffizi drawings, which are the surviving record of the design, do not show Leonardo's complete intentions for the automaton. I would have to reconstruct it by reinterpreting other materials from Leonardo's oeuvre.

Armed with the critical guidance of Carlo that I was facing an automaton and not an unworkable anticipation of the modern automobile, I looked to robotic designs of subsequent centuries and diverse cultures to form my design and operation hypotheses for Leonardo's automaton. I then reinterpreted the fragments based on these hypotheses. My guess was that traces of the programmable automaton would be found in Renaissance accounts of ancient automata as well as in later designs by inventors who may have had access to Leonardo's oeuvre. This information would aid in inter-

preting and reconstructing the nuts and bolts of Leonardo's design as well as its performance characteristics and application. At the same time, I drew upon my lifelong experience as a student of Leonardo's legacy.

Although there are now no longer any complete designs for automata in Madrid MS I, that manuscript contains numerous examples of potential components, such as compact spring drives with imaginative integral fusee mechanisms that could have powered them. A fusee is a spiral-shaped drive device that compensates for a springs winding down. The typical fusee has a spiral groove wrapped with a chain or gut cord which is driven by the spring. As the spring winds down, the chain or gut drives the increasingly larger diameter fusee, thus compensating for the loss of torque. Leonardo's fusees are mounted on a drum, often referred to as the going barrel or tambour, in which is contained a spring. They are a unique geared design in which the fusees are mounted on the top of the barrel, which rotates and automatically compensates for the loss of torque as the spring unwinds. Various means are used to transfer the power from the moving fusee to a stationary rotating power output shaft. They have no specific designation as to application, and could well have been employed in mobile automata, where weight and size need to be optimal. These could have been used as power sources for successors of the programmable automaton.

Folio 4 recto of Madrid MS I shows the first of a series of ingenious, lightweight, compact fusee-regulated power supplies (Fig. 2.4, p. 28). Spiral arrays of driver pins connected to the barrel form the fusee. A sliding lantern gear transfers the barrel's rotation to the output. These gears allow greater amounts of torque to be transmitted than do conventional cables and chains. Madrid MS I, f. 16 r (Fig. 2.5, p. 29) shows a conical lantern gear to compensate for the difference between the pinion path and the fusee pins.

One of the things that makes it challenging to interpret Leonardo's drawings is that the pages in the Codices are not always bound in a way that allows the reader to make sense of them easily. Whether Leonardo did this deliberately, as he did with his famous mirror-writing, or if this is the result of the pages' being bundled together as he roughly organized his notes into books, or of their being assembled arbitrarily from files by later, less caring hands, the result has been to mislead and confuse investigators for hundreds of years and to create work for scholars who want to "get back to zero" when the notes were complete and made more sense. For example, the often-reproduced design on Madrid MS I, f. 45 r (Fig. 2.6, p. 30) has usually been interpreted as a power supply for a clock. But if the design is laid on its side, it could be read as constituting a drive element for an automaton. The disk of the output appears to be a drive wheel. All of these designs feature a significant gear ratio increase that would be useful for propulsion.

Several theoretical studies comparing the various spring morphologies for use as a power source appear in Madrid MS I, f. 85 r (Fig. 2.7, p. 31). The upper left corner of the page shows a "T"-shaped key used for winding. It is possible that a key like this was used to wind the programmable automaton. The depth of Leonardo's interest in springs is apparent: he even shows manufacturing techniques illustrating automated drawing machines for strips of steel in MS G, f. 70 v (Fig. 2.8, p. 32).[10]

Numerous gear studies, ranging from low-cost sheet metal gears to elaborate helical and involute gear forms, appear on these pages. Theoretical studies of gear geometry are also present. Cams in a myriad of forms are shown, beginning on Madrid MS I, f. 1 v and 24 r (Figs. 2.9 and 2.10, pp. 33 and 34) Leonardo engages the curved surfaces on the inside and outside, and mixes gears with cams to produce hybrids.

One would expect that such detailed studies would appear with other drawings showing the practical demonstrations of their use in sophisticated automata. But with the exception of an astronomical clock, such drawings do not appear in Madrid MS I.

[10] See Ladislao Reti (ed.), *The Unknown Leonardo,* New York, Abradale Press, 1974, in particular the chapter by Silvio A. Bedini and Ladislao Reti, "Horology," pp. 240–263, with various kinds of springs discussed on pp. 250–253.

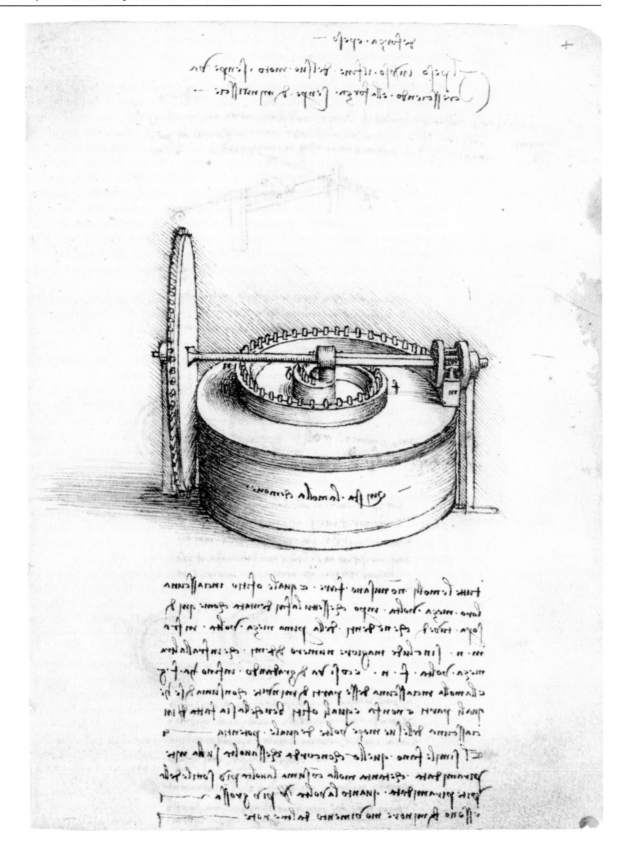

Fig. 2.4. Madrid MS I, f. 4 r

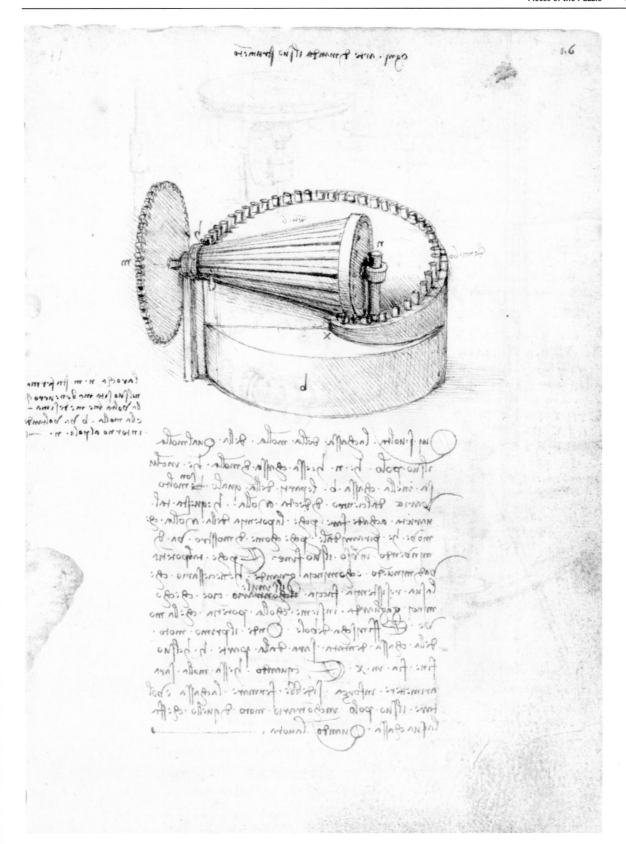

Fig. 2.5. Madrid MS I, f. 16 r

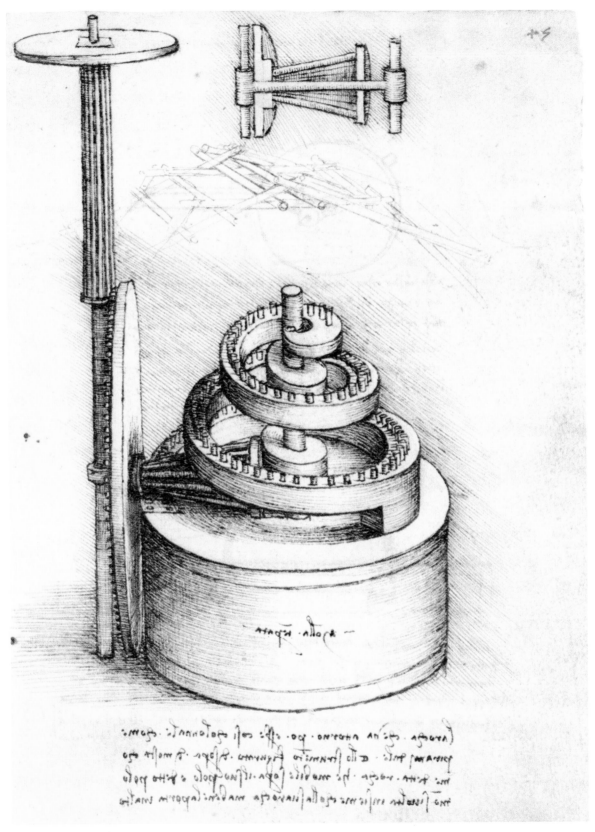

Fig. 2.6. Madrid MS I, f. 45 r

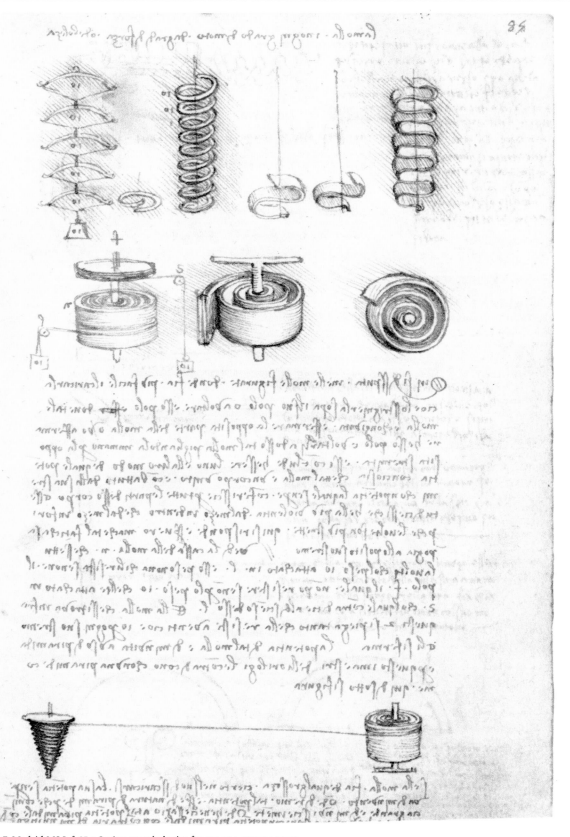

Fig. 2.7. Madrid MS I, f. 85 r. Spring morphologies for use as a power source

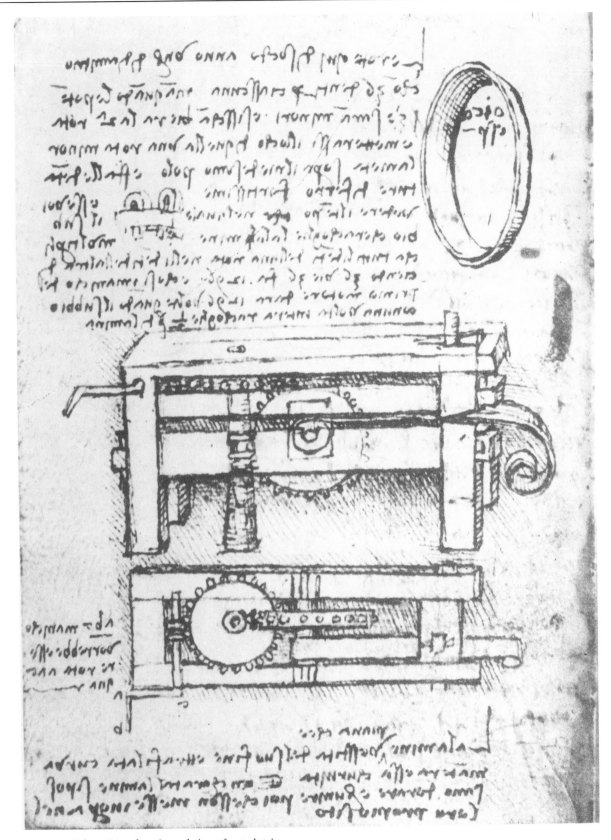

Fig. 2.8. MS G, f. 70 v. Manufacturing techniques for steel strips

Fig. 2.9. Madrid MS I, f. 1 v

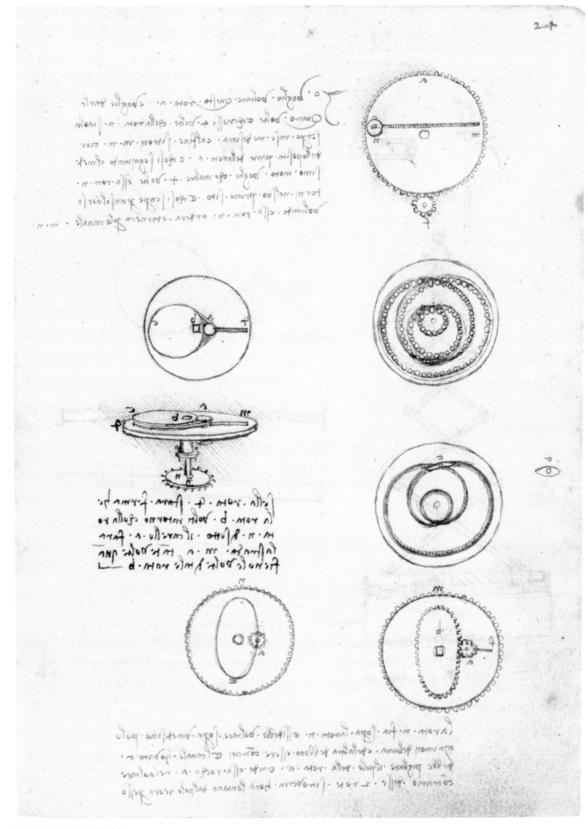

Fig. 2.10. Madrid MS I, f. 24 r

Fig. 2.11. Leonardo's family coat of arms

I suspect drawings showing complex automata were once part of the eight folios that were removed at some point in time before the Madrid codices were published. As shown in the Reti edition, they are ff. 37–42 and 55–56.[11]

If this is indeed the mechanism that supported the fabulous Robot Lion, the beast, which would have been supported by the base mechanism, may have been based on Leonardo's family coat of arms—an upright lion (Fig. 2.11).

The significance to Leonardo of seeing his name in heraldic form could hardly be understated. With his penchant for secret writing and similar arcana, I think Leonardo could hardly resist the opportunity to make a pun by employing an element of his name in his legendary Robot Lion.

Several seemingly unrelated pieces of evidence, when reinterpreted, reveal the intended working of Leonardo's programmable automaton, the first of which was the Robot Lion. The trail I followed began, strangely enough, with a late eighteenth-century Japanese "Karakuri," or tea carrier,[12] known to me from previous research. In this design, separated by several centuries and two continents from Leonardo, I found an autonomous mobile robot of equal complexity, construction, materials and performance characteristics as those of the lion that delivered flowers to Francis I.

The fourteen inch tall (35.56 cm) Tea Carrier (Fig. 2.12) has a cherry wood frame, and composite gears of laminated oak and Japanese cedar for strength held together by wooden pins. The only metal components are in the governor, which regulates a coiled baleen (whale-bone) spring and is steered by means of programmable cams mounted on the spring's hub. A cam follower actuates the front steering wheel.

Cams are revolving mechanical components, such as a wheel, so shaped as to impart a preprogrammed motion in another piece engaging it. By changing the shape of the cam, one changes the "program," the motion that is imparted to another piece engaging it. Seeing programmable cams in the Japanese design, I reexamined Leonardo's programmable automaton and saw that they were present there as well. I had discovered the programming system, the second major subsystem of Leonardo's cart.

But the Karakuri was not likely a native Japanese design, as attested to by the surviving Renaissance-era mobile automata that bear a striking resemblance to the Karakuri. These are the "Monk" and the "Cittern" Player. Both are propelled by wheels, are spring wound and have simulated feet that "walk," powered by the action of the clockwork. The Monk is programmed to move in a two foot wide square. Some scholars think the Monk could have been built by Juanelo Turriano, master watchmaker in the service of Charles V. But how did such a design find its way to eighteenth-century Japan, and how might it be connected to Leonardo's Madrid Codices? Although I had a perfect model for how Leonardo's automaton worked, I would not be able to connect it to the master unless I could establish the path it took to reach Japan.

Given the growing trade between Japan and the West during this period, I hypothesized that the Tea Carrier's programmable cams were modeled on Spanish designs—designs that themselves may have been inspired by Leonardo's Madrid Codices, for Madrid MS I and MS II were kept in Spain since their transfer to the royal library in

[11] Leonardo da Vinci, *The Madrid Codices*, vol. III, Commentary by Ladislao Reti, New York, McGraw-Hill, 1974, pp. 23–26. According to Carlo Pedretti, cit. in Chapter I, note 1, p. 322, those missing sheets could well have contained "most accurate and spectacular studies for the robot."

[12] This is fully discussed and illustrated in my book *Robot Evolution: The Development of Anthrobotics*, New York, Wiley, 1994, pp. 27–29.

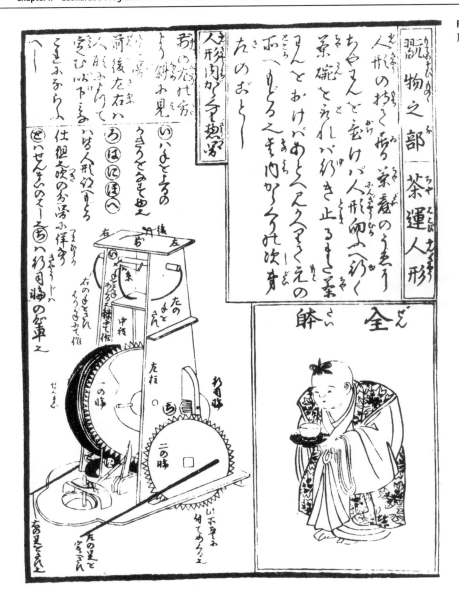

Fig. 2.12.
Japanese tea carrier

1642. The missing section of the first manuscript, unknown to us today, could itself have disseminated Leonardo's ideas. Autonomous robot designs do appear in Spain at this time in the work of Juanelo Torriano. Such designs became increasingly common in the eighteenth century, with the development of water-powered grottos and spring-driven dining table servers. The design for the Tea-Carrier closely resembles that of the "Monk" (c. 1560), an automaton figure which is programmed to move in a square and which is attributed to South Germany or Spain.[13] This technology may have been transferred to Japan by Spanish Jesuit missionaries during the eighteenth century, where it was reinterpreted as a geisha. I reasoned this from my research into early automata for my book *Robot Evolution*. I saw the similarity and noted that one way the Jesuits won favors (and converts) was to gift foreign leaders with clocks, novel devices that were highly prized. This is how one of the Jacquet Droz draftsmen got to be located in China.[14]

[13] Maurice and Mayr, *Clockwork Universe*, New York, Smithsonian, 1980, p. 170.

[14] Alfred Chapuis and Edmond Droz, *Automata a Historical and Technological Study*, London, B. T. Batsford Ltd., 1958, pp. 300–302.

Another piece of the puzzle, the escapement, came from part of an early sixteenth century copy of Leonardo drawings, Uffizi, GDS, no. 4085 A r (Fig. 2.13). This is a large sheet of technological drawings, including manufacturing.[15]

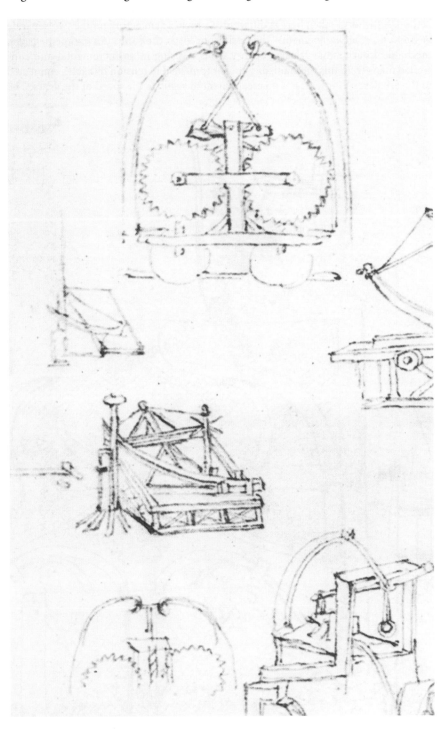

[15] Reproduced in facsimile in *I Disegni di Leonardo da Vinci e della sua Cerchia nel Gabinetto dei Disegni e Stampe della Galleria degli Uffizi a Firenze ordinati e presentati da* Carlo Pedretti. *Catalogo di* Gigetta Dalli Regoli, Florence, Giunti 1985, pp. 92–93, no. 43 [4084A]. See also my paper on "Leonardo's Lost Robot," (as in note 6 above), p. 109, fig. 32.

The top and bottom far left figures clearly show a similarity to the plan view of CA, f. 296 v-a [812 r] (Fig. 2.14)—that is, they are of a mechanism having two large gears and arbalest springs. An arbalest spring is simply a strip of metal, wood, horn or other springy material that can be bent to store and release mechanical energy. Although the form taken here is different—a rocker arm acting on the two separate gears to form an escapement—the basic concept is the same. An escapement is a mechanical device that releases energy from a spring in an incremental and controlled manner. In this mechanism, a rocker arm, held in tension by cables connected to the arbalest springs, creates an escapement to regulate the speed of the gears. The

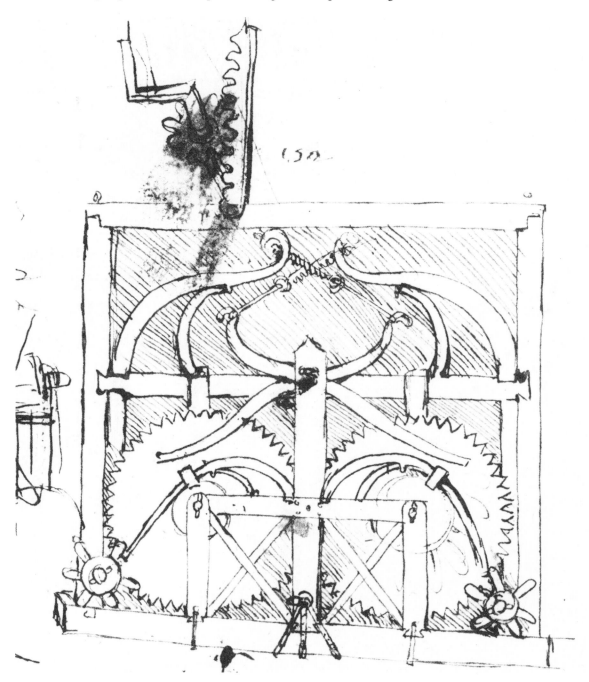

Fig. 2.14. Plan view of CA, f. 296 v-a [812 r]

rocker oscillates back and forth like a teeter-totter alternatively engaging and disengaging the gear teeth. Two wheels located on the bottom of the machine could be for locomotion, although it is difficult to interpret them at this time.

It was this element, the escapement acting on the barrel gears, which confirmed what I had already suspected—that the arbalest springs engaging the cogs comprised an escapement mechanism. And if this were indeed an escapement mechanism, all the cables, differentials and details imagined by scholars would fall away, revealing not Leonardo's primitive striving toward an automobile but rather his fully developed design for a working automaton. I was on the road to discovering the third major subsystem of the Leonardo cart—the escapement or "clock."

Only recently have I discovered that the above machine is also related to the top perspective figure of CA, 296 v-a [812 r] (Fig. 2.15). My reinterpretation is shown in Fig. 2.16.

Fig. 2.15. CA, f. 296 v-a [812 r]. First generation automaton

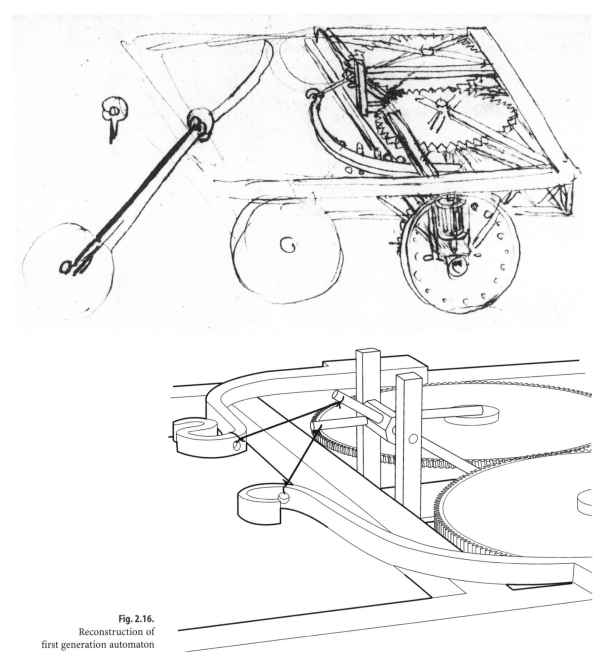

Fig. 2.16.
Reconstruction of
first generation automaton

Indeed, this reinterpretation and the Uffizi sheets show how critical to Leonardo the escapement was. I now see this figure as a distinct, different design than the one shown below in plan view. It's main focus being the escapement the drivetrains most critical component.

Also, in a recent reinterpretation, I discovered that the left of center detail of CA, f. 296 v-a [812 r] (Fig. 2.17) relates to an escapement mechanism similar to the one depicted in the Uffizi GDS, no. 4085 sheet. Figure 2.18 illustrates my reconstruction. A split (to adjust phasing) pair of pallets on a common pivot alternatively engage and disengage the pair of large gears.

But it was far from clear to me how the escapement worked in the plan view. Was it completely shown in CA, f. 296 v-a [812 r], or was part of it shown in the Uffizi GDS, no. 446 E-r drawing? I explored using the Uffizi escapement combined with the plan view and made some pretty drawings—but were they correct? How did it connect to the drive wheel and how were they connected to the springs? I was missing bottom and side views and had only a plan view and fragments to work with. However, I had at least a theory of the two basic subsystems: Carlo's coil springs and my computer-like cam system.

I was ready to begin the reconstruction.

Fig. 2.17. CA, f. 296 v-a [812 r]. Escapement mechanism detail

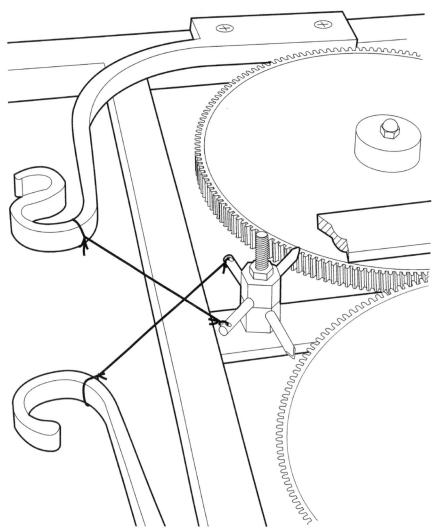

Fig. 2.18.
Escapement reconstruction

Reconstruction

The programmable automaton as depicted in the *Codex Atlanticus* consists of a square mortised and dovetailed wooden frame approximately 20 by 20 inches (50.8 by 50.8 cm). I base these dimensions on several measurements taken from the *Codex Atlanticus* drawings, which I believe are full-size preliminary fabrication drawings,[16] not scaled drawings. In other words, in Leonardo's time, standardized measurements small enough for mechanisms did not exist. Producing full-sized drawings provided a simple, accurate and direct guide for the craftsman who would build the mechanism. The craftsman would transfer the design directly form the drawings to the workpiece. If we assume that the dimensions of the automaton are full-size, we discover that they provide a perfect stage on which to mount a figure such as a life-sized lion seated in an upright posture, but would seem small for a lion walking on all fours, as would have been necessary for the revelation of the flowers at Francis I's entry into Lyons in 1515.

The frames contain two interdependent subsystems for propulsion and guidance. Leonardo also went to pains to secure the joints with fasteners, no doubt for increased ruggedness. In the top perspective view, a second, lower frame is attached to the top via angled brackets.

Using the plan figure as a guide, I concluded that the right side is for steering. This is indicated by the presence of several cams drawn on the barrel gear of the right side unit. The left-hand unit cam follower return spring has a screw which may be tightened with a nut, as shown in CA, f. 320 v-a [878 v] (Fig. 2.19).

This arrangement suggests the left-side unit is for propulsion. Controlling the tension of the cam followers is the means of controlling their speed. It seemed to be supported by Leonardo's choice to illustrate the left side of the automaton in his perspective sketch in CA, f. 296 v-a [812 r] (Fig. 2.15) which I thought at the time showed a rough idea for propulsion.

The two large barrel gears mesh together doubling the available power (Fig. 2.14). The interaction of the two corner cogs form a complete escapement that enables speed regulation of the large springs and hence the large gears. The gear ratio from the springs to the spoked drive wheels increases the springs' revolutions per minute to maximize the travel of the programmable automaton.

Petal-like cams located on the top surface of the large gears drive the two scissors-like cam followers, which are kept in contact with the cams via the arbalest return springs. These springs have traditionally been mistaken for a power source, but I now saw they are actually return springs for the cam followers, and probably would have been fashioned out of bent wood, bamboo, horn, or even bone perhaps ribs. This material is likely because large amounts of force are not needed to keep the cam followers in contact with the cams. Too much force would create friction and drain the springs' power.

The top perspective sketch CA, f. 296 v-a [812 r] is a separate distinct design as mentioned above, and Leonardo seems to be exploring two steering options. The

[16] A scale drawing, or at least a drawing begun as such and then turned into a rough sketch, is shown on CA, f. 320 v-a [878 r], c. 1478, which I consider as part of the studies for the programmable automaton. As in other sheets (e.g. CA, f. 347 r-b [956 r]), the wheels are shown with a 4.2-inch (106 mm) radius. Leonardo's drafting procedures are shown by the draft of a letter to his patron Giuliano de' Medici with which, about 1515, he was to complain about the behavior of one of his two German assistants, who was apparently prepared to steal his inventions. See CA, f. 247 v-b [671 r], Richter, §1315: "Afterwards he wanted to have the models made in wood, just as they were to be in iron, and wished to take them away to his own country. But this I refused him, telling him that I would give him, in drawing, the breadth, length, height, and form of what he had to do; and so we remained in ill will." Cf. Carlo Pedretti, Introduction to *Leonardo da Vinci Engineer and Architect*, (as in note 6), pp. 12–13, and *Achademia Leonardi Vinci, VI*. Firenze, Giunti, 1993, p. 184.

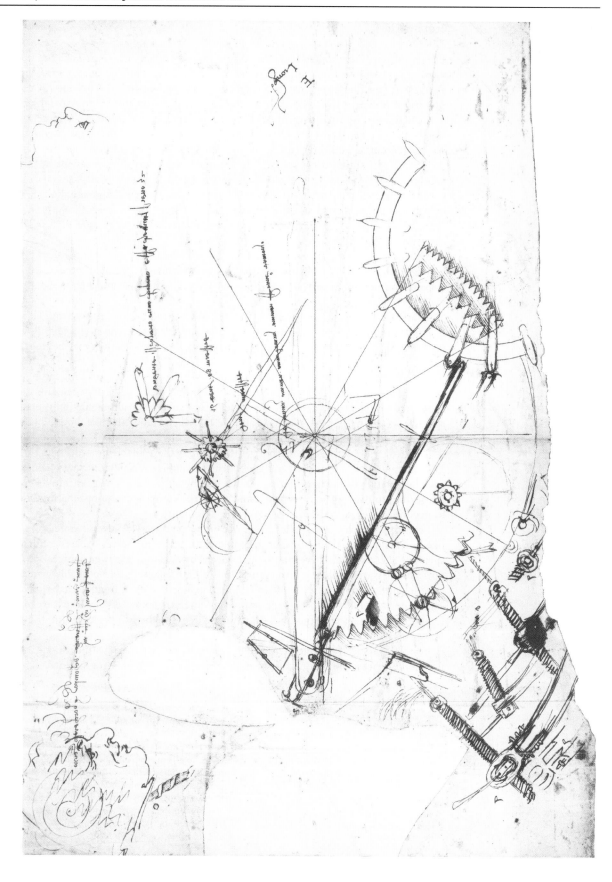

◄ Fig. 2.19.
CA, f. 320 v-a [878 v].
Tension adjusting screws

first looks like a tiller connected to the wheel with the opposite end driven by the linkage. Leonardo has a design dilemma with the escapement mechanism in the way it's difficult to attach a steering linkage to the tiller. The second seems to be a wheel mounted directly underneath the platform, with the fork's shaft passing up into the automaton mechanism. Mounting the steering wheel there solves the problem of interference with the escapement mechanism. This gave me clue that the steering wheel could connect to the upper cam follower arm.

The bottom three figures of CA, f. 296 v-a [812 r] relate to an additional control mechanisms (Fig. 2.2). The most detailed is a rack-and-pinion control mechanism (Fig. 2.20). In the center of CA, f. 296 v-a [812 r] directly above the main plan view, is a rack-and-pinion mechanism with the pinion axle terminating in a crank (Fig. 2.21). A rack is a toothed bar usually made of brass or steel. A pinion is a simple spur (toothed) gear. In this case, the teeth of the pinion mesh with those of the rack. This, I believe, is the pinion mounted in the left return spring shown in the bottom left hand corner of the folio. The spool and cable version above it is a simpler lower-cost alternative embodiment. The spool (Fig. 2.22) would clip into the cam follower, re-

Fig. 2.20.
CA, f. 296 v-a [812 r].
Rack-and-pinion control

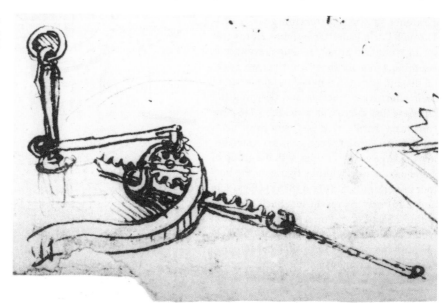

Fig. 2.21.
CA, f. 296 v-a [812 r].
Rack-and-pinion with crank

Fig. 2.22. CA, f. 296 v-a [812 r]. Spool with cable

placing the gear (Fig. 2.23). Based on the lower left figure, this subassembly is mounted on the upper left return spring. This is the reverse location of the rack in the top view which is near the right return spring. Two functions could be accomplished with this arrangement. First, the automaton could be slowed as it encountered resistance of a dedicated cam. Secondly, upon slowing, the rack-and-pinion mechanism could trigger a special effect, such as opening a door.

Following the action of the escapement and drive train I could see it has front-wheel drive! Both spoked wheels are driven under power; this interpretation is based on the escapement arbalest springs bias in relationship to the corner cogs caused by the gear hubs creating a ratchet (a single direction gear-train). Through Carlo Pedretti's insight that the leaf springs could not produce enough revolutions per minute to make the platform move a useful distance albeit that he did not understand their alternative function and by using the Japanese Tea Carrier as a model, I am now convinced that Pedretti was right in suspecting that there are large coil springs located below the large gears.[17] I suggest that a group of slight arcs, shown within a figure on the bottom center of CA, f. 320 r-a [878 r] (Figs. 2.24 and 2.25) may represent just such a spring within a barrel gear. Power for the automaton would have come from winding it up like a giant toy, perhaps by one of the corner cogs, so as to take advantage of the gear reduction. The force generated by these springs would be substantial, perhaps in the fractional horsepower range.

A second level of gearing of the going barrel gear appears on both the lower right of CA, f. 320 r-a [878 r] and CA, f. 320 v-a [878 v] (Figs. 2.19 and 2.24). This second level of gearing may represent an alternative and possibly earlier embodiment. In addition, there is a parallelogram linkage shown in smaller preliminary sketches at the center left of CA, f. 320 r-a [878 r]. This folio also provides an important reconstruction detail—the right corner cog and its smaller pinion gear meshing with the large barrel gear. I then reasoned that the lantern gear shown in the top of CA, f. 296 v-a [812 r] must be attached to the same vertical shaft powering the drive wheel pegs. This provided me with the vital clue to see below the plan view and solve the mystery of the drivetrain.

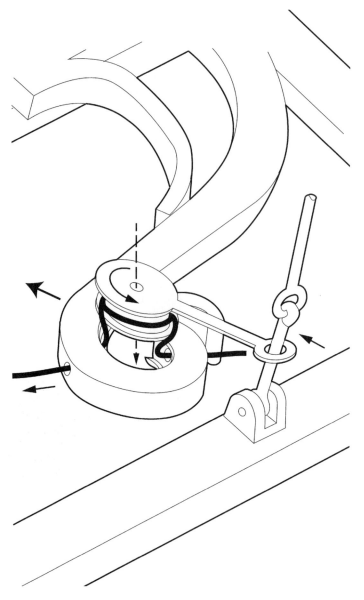

Fig. 2.23. Reconstruction of spool and cable

Fig. 2.24. ▶
CA, f. 320 r-a [878 r].
Sketch of spring in barrel

[17] This was already discussed in the Appendix to my paper "Leonardo's Lost Robot," (as in note 6 above), p. 109, note 7. Carlo Pedretti has shown that a comparable application of a coil spring is found in Leonardo's so-called "helicopter" sketch. See his *Studi Vinciani*, Geneva, Droz, 1957, pp. 125–129, and his *Leonardo. The Machines*, (as in note 14 above), pp. 8–10 and 29. See also Giovanni P. Galdi, "Leonardo's Helicopter and Archimedes' Screw. The Principle of Action and Reaction," in *Achademia Leonardi Vinci*, IV, Firenze, Giunti, 1991, pp. 193–195.

Fig. 2.25.
CA, f. 320 r-a [878 r].
Detail of spring

Fig. 2.26.
Uffizi, GDS, no. 446 E-r
▼

Near the cut-out section of Uffizi, GDS, no. 446 E-r (Fig. 2.26) is another parallelo-gram mechanism similar to the one above it. These linkages may be indexing or escapement concepts. Finally, yet another secondary level of gearing is also shown on CA, f. 339 r-a [926 r] (Fig. 2.27) and CA, f. 347 r-b [956 r] (Fig. 2.28). I dismissed all of these as surplus in the search for the basic mechanism.

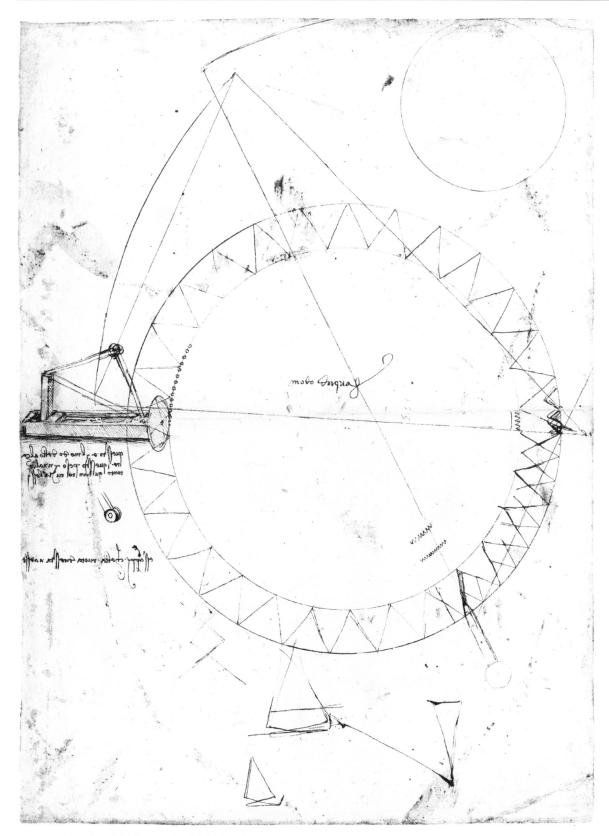

Fig. 2.27. CA, f. 339 r-a [926 r]. Secondary level of gearing

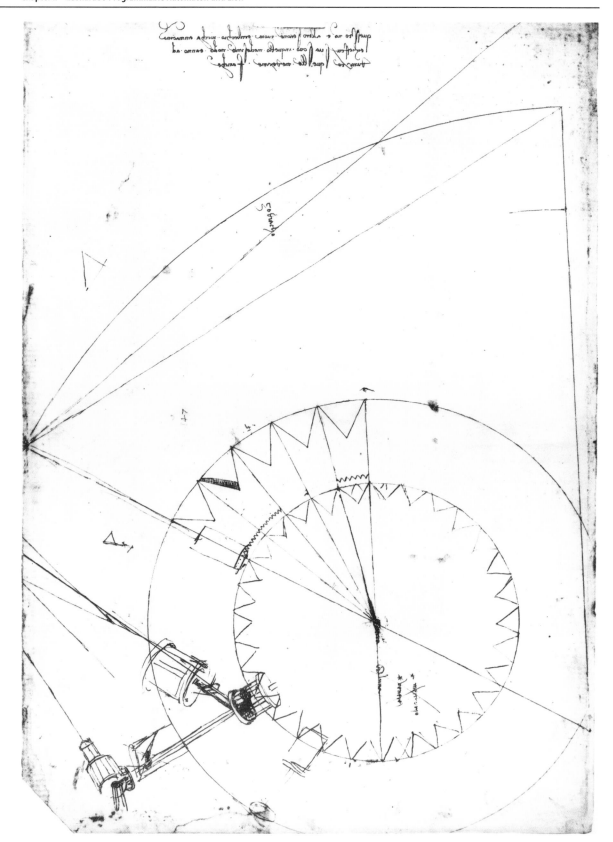

Fig. 2.28. CA, f. 347 r-b [956 r]. Secondary level of gearing

Fig. 2.29. CA, f. 347 r-b [956 r]. Multi-grooved sinusoidal cam

Codex Atlanticus f. 347 r-b [956 r] (Fig. 2.29) is interesting as it shows elements in other drawings such as the multi-grooved sinusoidal cam mechanism shown in "A Draped Figure and Studies of Machinery," 447 E Uffizi r (Fig. 2.30). There is also the

Fig. 2.30.
447 E Uffizi r. Draped figure and studies of machinery

Fig. 2.31.
447 E Uffizi v. Preliminary
studies for automaton

verso of the same Uffizi sheet (Fig. 2.31) for very early fragmentary studies of the automaton. In *Ashmolean Museum* P. 18 (VII), (Fig. 2.32) some of the small sketches may be predecessors of those shown at the bottom of CA, f. 296 v-a [812 r] (Fig. 2.20).

Fig. 2.32. Ashmolean Museum P. 18 (VII). Preliminary studies for automaton

The triggering mechanism shown in CA, f. 296 v-a [812 r] (Fig. 2.33) is mounted underneath the center beam of the frame locking the two going barrel gears. A cord attached to the trigger plug when pulled, releases the gears and starts the machine (Fig. 2.34).

Although the above may simply represent early iterations, they may also represent additional or alternative drive trains. Perhaps rotating vertical shafts went up to power doors or other devices for various theatrical effects, such as rearing of the lion on its hindquarters and upon opening its breast, revealing its heart full of Florentine lilies.

Fig. 2.33.
Triggering mechanism
for automaton

Fig. 2.34.
Reconstruction of triggering
mechanism for automaton

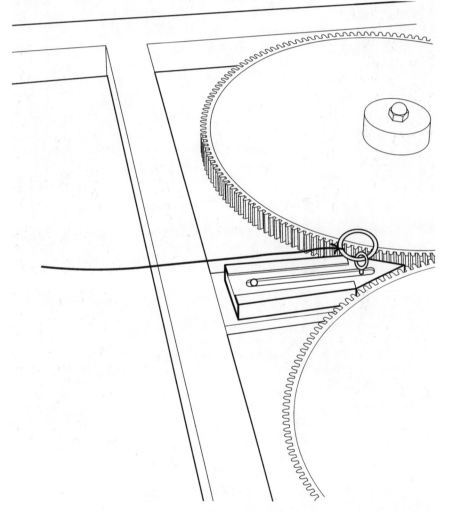

Once I had put the pieces together, I needed to figure out if the automaton could indeed work. It's one thing to reconstruct how the automaton was made, but if I left it there I felt I would only have succeeded in putting together a mock-up of some elaborate bit of sculpture. I took some encouragement from Lomazzo, who wrote that Leonardo had found the way "to have lions move by the power of wheels" (*andar i'leoni per forza di ruote*). Surely, this meant the automaton had indeed worked as planned.

Operation

To understand how the mechanism worked, I began with Carlo's insight that the impetus for the system comes from the two springs below the large gears (Fig. 2.35). I reasoned the springs are directly connected to the large gears which drive the smaller pinion gears attached to the corner cog arbors. These same shafts drive the lantern gears and thus the mating spoked wheels for forward motion (Fig. 2.36).

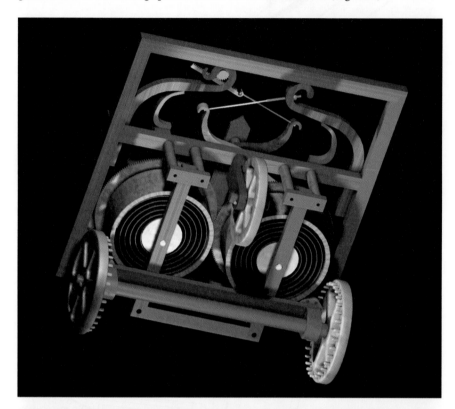

Fig. 2.35.
Impetus for the system comes from the springs housed within their barrels

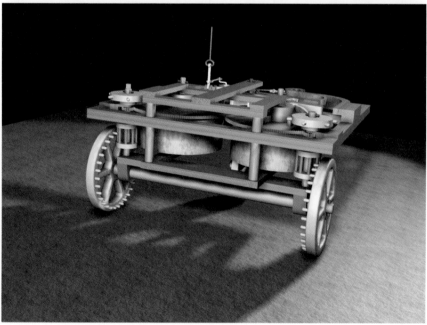

Fig. 2.36.
Front view of automaton

The coil springs mounted within the going barrels are regulated by a unique verge-and-crown wheel clocklike escapement mechanism based on the classic design (Fig. 2.37). Indeed, Leonardo would show a design using a verge and crown in CA, f. 314 r-b [863 r] (Fig. 2.38) which was reconstructed by Alberto Gorla (Fig. 2.39).

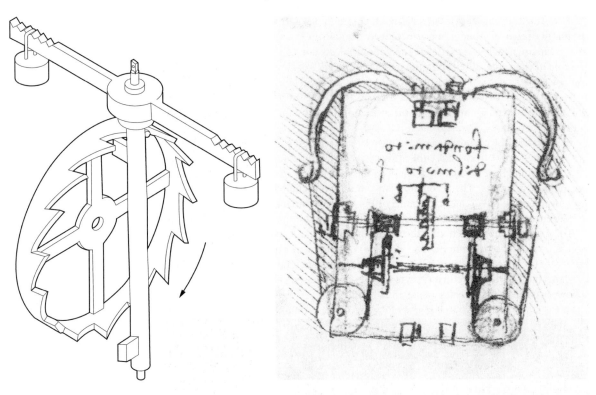

Fig. 2.37. Verge-and-crown escapement

Fig. 2.38. CA, f. 314 r-b [863 r]

Fig. 2.39.
Reconstruction by
Alberto Gorla

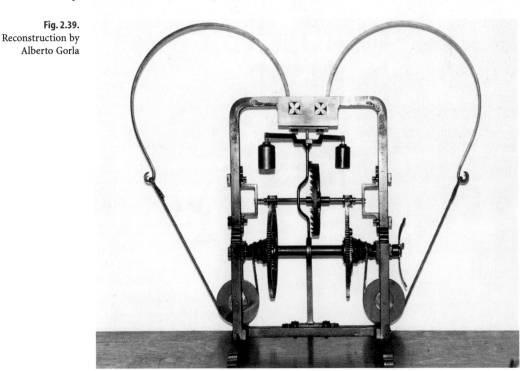

The crown, like its royal counterpart, is a ring of metal with teeth on the top edge. The verge is a bar of metal with paddles on both sides. Perpendicular to the verge is the foliot with adjustable hanging weights. Those paddles engage the crown teeth oscillating back and forth alternatively engaging and disengaging the crown teeth thereby regulating its rotation.

The crown (in this case a pair) forms the corner cogs and the verge is a toothlike oscillating member. Regulation is achieved through interaction of the corner cogs and escapement arbalests. The escapement arbalests correspond to and function in the role of the verge, albeit split, the pallets of the verge being the arbalest tips. The pair of corner cogs equate to the crown wheel, although this function is also split between the two. Drive wheels and their respective drive trains equate to the foliot or mass of the system. Dampening of the system is aided by the springiness of the escapement arbalests (Fig. 2.40).

In operation, the corner cogs rotate toward their arbalest springs, which are phased one-half step apart from each other (Figs. 2.41, 2.42 and 2.43). As the system oscillates, one would hear a "click click click" as the corner cogs incrementally release the escapement arbalests. The automaton is wound by a corner cog in a clockwise motion, overcoming the greater resistance of the biased escapement arbalests. Perhaps it too generated a loud "clack clack clack" as it was wound up.

The array of cams attached to the top of the large barrel gears controls the direction and velocity of the automaton (Fig. 2.44). As the cams rotate together as a unit, they force the scissors-like cam followers to pivot. The cam followers are forced against the cams by the arbalest return springs via the criss-crossed cables. The steering cam follower connects the steering wheel thus turning it.

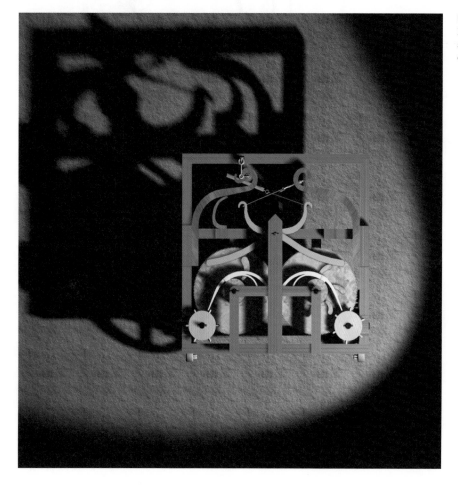

Fig. 2.40.
Dampening is aided by the springingness of the escapement arbalests

Fig. 2.41.
Corner cog/arbalest escapement

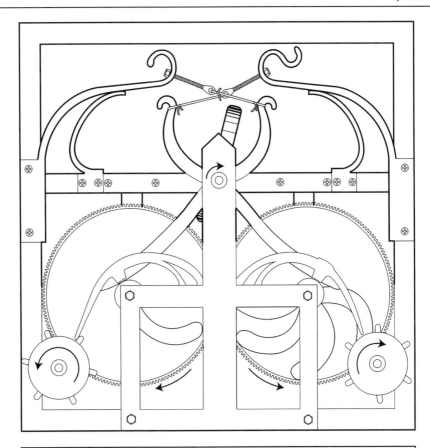

Fig. 2.41.
Corner cog/arbalest escapement

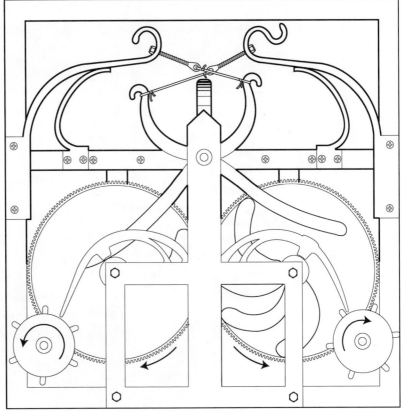

Fig. 2.42.
Corner cog/arbalest escapement

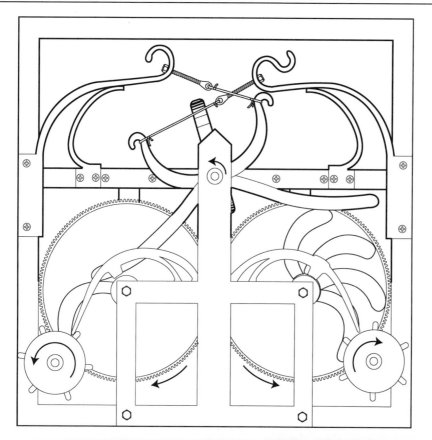

Fig. 2.43.
Corner cog/arbalest escapement

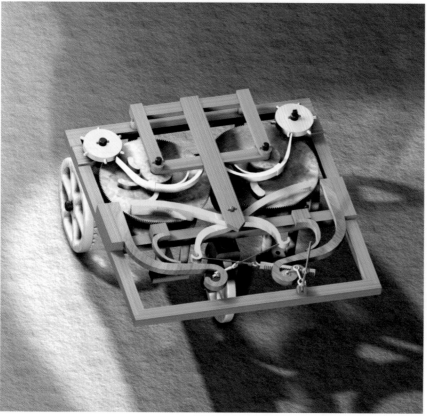

Fig. 2.44.
Array of cams attached to the top of the large barrel gears controls the direction and velocity of the automaton

Because Leonardo seems to indicate one "petal" or cam by the position of the cam follower, I reasoned that the propulsion cam on the left-side large gear control speed rather than direction, perhaps even stopping the automaton briefly. The gear's basic operation is similar to the stackfreeds used to regulate the earliest spring clocks. In a stackfreed (Fig. 2.45), a cam attached to the top of the barrel has a spring-loaded arm pressing against it—the resistance matches the torque as the spring unwinds. Perhaps a few petal-shaped cams were used to slow or momentarily stop the automaton. The propulsion cam follower could also drive the rack-and-pinion subassembly. As the return spring pivots, the pinion moves up-and-down the rack, perhaps triggering a mechanism for ancillary devices such as a door (Fig. 2.46).

Fig. 2.45.
Stackfreed

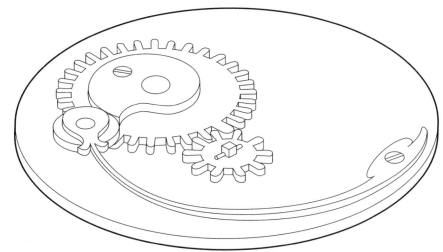

Fig. 2.46.
The pinion moves up-and-down the rack, perhaps triggering a mechanism for ancillary devices such as a door

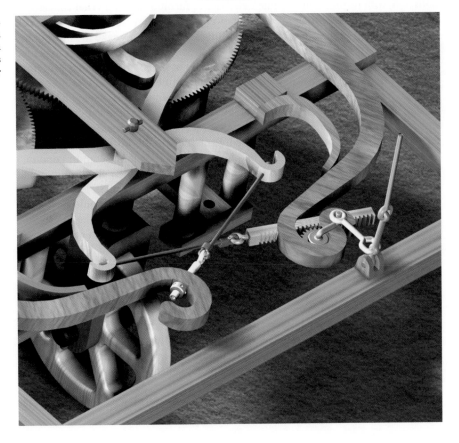

Thus propelled, the automaton was capable of performing a variety of pre-determined movements that could be varied depending on the desired choreography and available space. Starting from a home position, the automaton begins to move forward and follows a preprogrammed course, stopping and starting, turning left and right. Special effects at any point could be introduced. The particular program is determined by the number, shape and location of cams on top of the two large cam gears. Each cam represents an individual instruction, or "line of code." The "program" is latent in these cams and is predetermined by the programmer, who might "debug" or modify his "program" with a file!

I arrived at Rome's Fiumicino airport five days prior to the day of the lecture. Unlike previous trips to Italy, when I had spoken no Italian, I was now able to open my mouth and speak a few terrified words to my hosts. After riding the Metro from Fiumicio to the Stazione Centrale in downtown Rome, I was met by Rosie Fontanna, a free-lance publicist hired by the Biblioteca Leonardiana. Successful, self employed, and as it seemed with every Italian women I would meet on this journey, very beautiful, she was suffering from a cold in the April weather that was not much better than my native Minnesota. Pumping her inhaler while negotiating the mad traffic of Rome, Rosie drove me to my hotel. Thus began an almost Beatles-like odyssey of newspaper and magazine interviews. Prior to this little experience with fame, I had never understood why celebrities complained. Now I know: being "on" continuously, being shuttled from one interview to the next, just wears you out. And what I experienced must be the mild low-cal version. As the Beatles said regarding Beatlemania, "If it had continued we would have gone insane" now makes sense.

Thanks to *Cheap Sleeps in Italy*, I stayed at the charming little red tile roofed Hotel Coliseum, with its pieces of genuine Renaissance furniture and paternal concierges. After the long jet ride I took my ritual shower and quick lay-down on my little cot. But sleep was out of the question. I was in Rome! And I had to make the most of my one free day in the city that all roads lead to. Rallying, I asked the manager to get me a cab. A overweight, loud, dressed in American tourist shorts and tee shirts American family also asked for a cab. They attempted to steal mine when it came and the manager ran out and rescued me, from the American father, who was saying his tourist version of grazie, which came out as "grazy." My first stop was the Vatican Museum, which I had missed on my last stay. Fighting the jet lag that was making any horizontal surface attractive as an emergency bed, I entered into the world of ancient Rome and the Renaissance. Even though I had been in the National Museum in London, I was not prepared for the vast quantity of ancient statues with their sightless gaze and corridor upon corridor of marble. I found Leonardo's painting of St. Jerome tucked away in a small room and covered with a piece of Plexiglas that could have been purchased at the local hardware store. As I wound my way through the treasures, I stopped to photograph the *Laocoön* and to marvel at the titanic fragments of ancient statues, including a Roman head of Emperor Constantine the size of a VW Bug. Following the halls, corridors, and courtyards, I at last entered the Sistine Chapel, with its recently restored frescoes by Michelangelo. Like everyone except the babies in their recumbent strollers, I strained my neck to view one of the great wonders of the world. Every now and then the growing noise would be interrupted by a "shush" from the guards. After a long but blissful afternoon I called a cab, returned to my hotel and then headed out for dinner. Well fed by a waiter who only wanted to communicate to me in English, I returned at last to go to sleep, only to be awakened early by my alarm.

The publicist, who arrived downstairs late, complained about someone screaming in the night. We were chauffeured in a black Mercedes sedan to a studio in Rome, where I was scheduled to appear on the national Italian morning talk show for RAI 1,

"Uno Mattina." As is common in Rome, where armed guards stand outside of banks and high-security diplomatic convoys watched over by men in black sporting ear buds are a daily occurrence, there was a big security check at the studio's gatehouse. My passport was scanned, checked and entered into a database before I could enter. We were ushered into the complex, and I passed a heavyset, bearded gentleman who had just been interviewed. He could have been Pavarotti as far as I knew. Luca Giurato, the show host, is middle aged, tall, with salt and pepper hair and glasses. Very affable, he met me before we went on the air, and was kind enough to be impressed by my little Italian. In the dressing area, very young and pretty make-up girls sprawled in make-up chairs intended for arriving guests—no doubt done in from late night partying. The expensive art Deco set was very impressive with a large video monitor display playing my videos accompanied by music, and I couldn't help but feel intimidated by the big studio cameras. Luca helped me by telling me to look at him, not at the cameras.

Fortunately, I was given an earpiece and the translator who had lived in the Midwest simultaneously translated Italian into English for me and vice a versa for the broadcast. I expressed my gratitude at the honor of speaking at the birthday party of Italy's greatest artist and described my work, which was propped up on a stand. I had brought along my latest wrist design, the Omni-Wrist III, and demonstrated it for the television audience. Probably the scariest moment was when the host asked me to speak some Italian. I leaned forward and, squeezing my thumb and finger together tightly, replied, "il mio italiano è poco"—my Italian is little—a short phrase taught to me by Rossana Pedretti. This got a big response from our host, who said, "your Italian is perfect."

The morning went on with more interviews and then an appearance on a young people's television program, Tech 4 U. The show host, who started as a LA street performer, moved to Italy and parlayed his charm into his own television program. After the filming I was dead tired, but there was more to come. My next stop was Florence, so I boarded a train North to Vinci for a photo shoot with the famous paparazzo photographer Maximo. I was picked up by the wife of the Director and driven to Vinci by the Bibliteca chauffeur, but not before I hit one of my favorite rare book stores and purchased a rare first edition of Leonardo's Codex Trivulziano. Maximo was the last to photograph Princess Diana before she died. Though I had my doubts about my appearance by that time, my publicist said I "looked beautiful" and had the make-up adjusted for the shoot. I posed with various Leonardo models and when I finally got a Xerox of the article, I saw the hilarious results of my on-the-fly makeover: with my matted hair I looked like a freak. But I was beautiful—or so said my agent. The final event of the evening was a late night practice reading of my paper with the Biblioteca director's wife.

The day of the lecture I woke up early and took advantage of my limited free time to make a pilgrimage to Leonardo's birthplace. As I followed the winding medieval streets, I passed the church where Leonardo was baptized centuries before and felt a growing sense of wonder that I could be walking on cobblestones that held his footsteps from so long ago. Continuing on, I left town and started on a path to the birthplace, as signs of civilization started to fall behind me. Telephone poles and powerlines faded away, and older and older buildings came into view. When I arrived at his red tiled house, a two roomed, one story stone structure with a substantial stone outbuilding, I was immediately struck by the Vinci coat of arms: a lion wearing a knight's helmet—an heraldic representation of his name and a merger of his two robotic projects!

Reading this as a sign from God, I returned to Vinci with more than a little relief, and gave my lecture in English with simultaneous Italian translation. After the applause died down, I gave interviews to local newspapers with the usual questions about the evil potential of robots. Significantly, I was also asked by Monica Taddei

(Dr. Nanni's wife) if I would give Paolo Galluzzi an advance copy of my paper complete with illustrations. As I had worked with him in the past I granted that request. He now had all the technical information necessary to build a working model.[18]

The event was arranged almost like a pageant, thanks to the wonderful sense for drama and spectacle so close to the Italian heart. I was delighted to meet the beautiful blond haired, blue eyed and accomplished young Leonardo scholar, Simona Cremante, who accompanied me to several newspaper interview and photograph opportunity with the mayor of Vinci. We were then chauffeured in the Biblioteca's car to a villa in the wine country where the celebration was held. There I met up with my publicist and her assistant and posed for yet more photographs. Then two ranks of guests formed in front of the nineteenth-century villa entryway. They lined up behind me and, with Mayor Faenzi leading the procession, we walked inside, where we were first to partake of a beautiful buffet of Italian delicacies. Feeling quite at home, I loaded up my plate like it was Christmas at the folks'. But when I sat down I learned my mistake—everyone else had taken small portions of the first course only. Simona explained that you were supposed to go back for each successive course, so I unloaded food onto her plate and was amused to see her devour it all without my Yankee sense of shame. Then a very warm, huge Italian shook my hand, and although he couldn't express it in English, it was apparent he simply loved me for my work. Upon leaving, I also met the chef who was responsible for the feast and praised his effort, after which we went back to Leonardo's birthplace and wrote our names in the visitor's log book.

I went back to Firenze on the train with Simona, and we talked about Orson Welles' movies all the way. I then got a train to Rome, and by the time it arrived it was too late for me to catch the last train to the airport Holiday Inn. At the station I was met by a serious-looking, dark-haired heavyset man who, except for his clipboard, would have fit well in any of the Godfather films. He sent me on my way in an unmarked cab. Once inside, I began to wonder if I was being taken for a ride in a rogue taxi. After a long search in which the driver, in spite of stopping at restaurants for directions, couldn't find the hotel, we realized that the hotel was actually a few miles outside of the airport. But the driver had tried so hard I still tipped him. At last, in my American hotel, I could take a bath and shower and sleep on a bed with box springs!

Leonardo's programmable automaton is the first record of a programmable analog computer in the history of civilization. We see in it Leonardo's first design effort in planning automata culminating in his fabulous Robot Knight,[19] of about 1495, a practical entertainment piece based on his pioneering study of biomechanics.

Leonardo's sophisticated use of mechanisms at a very early age further highlights his talent in producing a design that simultaneously combines marvelous compact packaging, complex guidance and control.

Postscript: Building Leonardo's Programmable Automaton

After several years of fruitless efforts to raise funds to build Leonardo's programmable automaton, including a near miss with Britain's ITN for a program on Leonardo,[20] I decided to build a prototype myself in August of 2004.

Utilizing the computer aided design (CAD) model shown above as blue prints, I headed to my shop. I followed the above design without any "updates." The most

[18] Vanderbilt Tom, "The Real da Vinci Code," *Wired*, November 2004, pp. 210–229.

[19] The Uffizi and Oxford sheets contain studies for an *Adoration of the Shepherds* on which Leonardo was working in 1478, thus confirming the proposed date for the programmable automaton. Cf. A. E. Popham, *The Drawings of Leonardo da Vinci*, New York, Reynal & Hitchcock, 1945, plates 50 and 51.

[20] *Leonardo's Dream Machines*, Airdate: 25 Febraury 2003, ITN Factual, London, producer: Paul Sapin.

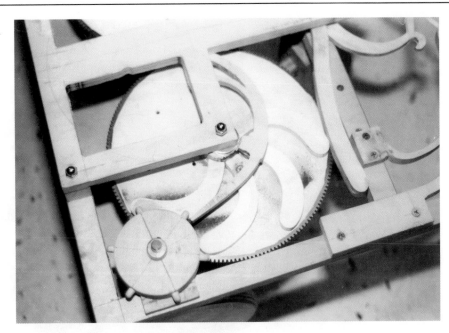

Fig. 2.47.
Working model of programmable automaton under construction

tedious task was the wooden cogs and lantern gears because they required a large number of accurately spaced holes for the pegs. Firing up my vintage WWII Sheldon lathe, I set up a miniature peg factory. I purchased stock steel gears (I was not going to subject myself to cutting my own gear teeth).

The question of whether Leonardo would have used wood or metal for these gears and their pinions is an interesting one. Considering how small the teeth are, as well as the torque and abuse the cart would have to endure, I would argue that metal (although not necessarily iron or steel) would be probable. Any clock maker of the time could have fabricated gears for him, but considering this early stage of his career and the lightness of his pocketbook, he may well have used punch and file himself. The stock metal gears that I bought were amazingly close in pitch, diameter and tooth profile to those of Leonardo (Fig. 2.47). I took this as a good sign.

Another challenge was the arbalest springs for the cam returns. Although Leonardo may have made these from bent wood, he also may have considered horn or even bone as contemporary plastic like materials. I was willing to settle for model airplane grade plywood so that I could easily cut the intricate curvilinear shapes with my saber saw. As Leonardo would have, I used bronze bushings with integral flanges for all the bearings, which I purchased at the local hardware store. Cost effective and elegantly simple, they reduced the cart's friction to a minimum.

Actually building made Leonardo's intentions even clearer (Figs. 2.48–2.50). We can see from the top perspective figure of CA, f. 296 v-a [812 r] (Fig. 2.15) that Leonardo is after compactness in overall height as well as in width and breadth. This he accomplished by locating (as is the case in almost all previous reconstructions) the pair of drive wheels as high as possible. Because the drive wheel pegs are near their outside diameter, the lantern gears are mounted near them to enable them to mesh successfully. Consequently, this relationship defines the framing system, with the lantern gear dividing the upper and lower frame. Because of the lantern gear and the wheel meshing it is not possible for the famous zigzag bracing to be located on the inside of the lantern gear where it would collide with the coil springs. Therefore it is more likely that it would hang from the upper frame and could extend all the way down and tie into the lower frame for maximum support partially covering the wheels. However, this is not what Leonardo shows in the upper figure of CA, f. 296 v-a [812 r]. Instead, he seems content to have the upper frame extend down a short distance,

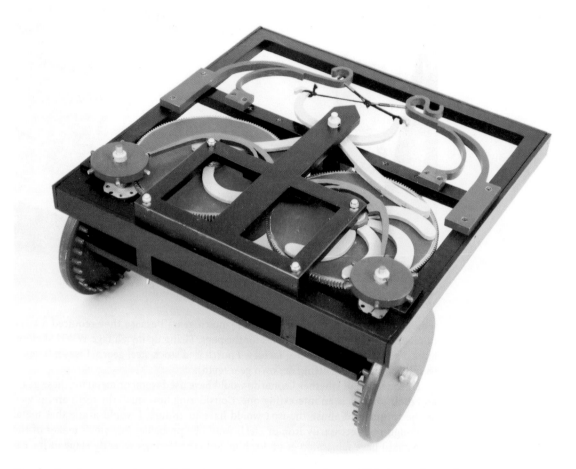

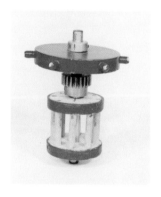

Fig. 2.48a. Working model of programmable automaton

Fig. 2.48b. Corner cog/latern gear/pinion assembly

terminating in a separate and distinct complementary lower frame. This is another reason that I have connected the steering wheel to the upper frame only. Also, building the model made it clear to me that the combination of the arrow-like top frame, in conjunction with the main frame below, is adequate for supporting the steering wheel shaft.

It should be also noted that the area where the framing, lantern gear and drive wheel mesh is one of the most critical and confusing portions of the upper drawing of CA, f. 296 v-a [812 r]. (This also occurs again in the Chapter IV the Bell Ringer with CA, f. 5 r-b [20 r] in the helix area of the "Bottini.") Leonardo tends to keep overlaying critical elements in the area that interests him until their relationship to one another becomes almost indecipherable.

The switch to start the cart identified above was most likely a plug wedged between the two large gears and pulled out by a cord. It would be ridiculous to assume that the cart would travel with the cord trailing behind it. Pulling the plug, literally, would do the opposite of stopping the cart and would actually start it moving. The remote control feature would facilitate the illusion of autonomous action—leaving the cart free to go on its mission.

The escapement mechanism is perhaps the most critical and difficult to adjust. Unlike the verge and crown, the arbalest springs have no swinging mass connected to them. In an actual verge and crown, the acceleration and deceleration of the swinging mass dampens the engagement of the verge teeth with the crown. Although there is the mass of the cart's drive train, it is critical that it be tuned to the tension of the arbalest springs to slow the escapement corner cogs. The above comments about materials for the cam return springs also apply here. Leonardo may have resorted to

Fig. 2.49.
Working model of
programmable automaton

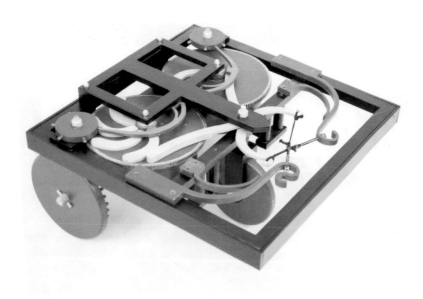

Fig. 2.50.
Working model of
programmable automaton

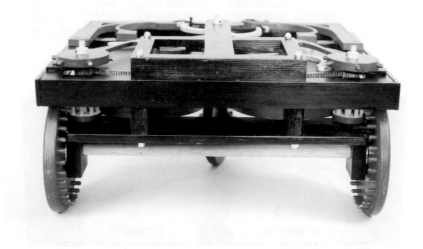

exotic material for the arbalest springs, perhaps using horn or bone, using their capacity for fine detail to make minute adjustments to their engagement with the escapement corner cogs. Too much stiffness and the escapement mechanism is locked and the cart is static; too little and the escapement runs wild, propelling the cart out of control. A balance must be struck between friction and pressure on the upper corner cogs to simulate the inertial effects of the verge and foliate. Spring torque, friction and compliance of the springs all must be balanced.

Perhaps the most important validation that this model provides is the proof that the cam "program" makes the cart capable of turning left, right, or running straight. Indeed, what Leonardo shows in the center top view of CA, f. 296 v-a [812 r] is half a dozen cams on the right side of the right large gear. On the opposite side of the same gear there are none. This produces a left/right turning of the steering wheel—the two extremes (Figs. 2.51 and 2.52). This is assuming that Leonardo intended full-length cams. A medium-length cam would result in the cart's going in a straight line (Fig. 2.53) or, in other words, no rotation of the steering wheel from centerline. The

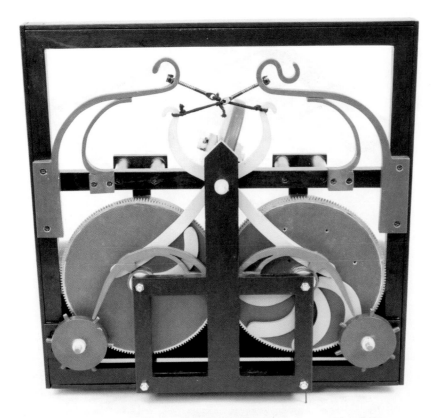

Fig. 2.51.
Left turn produced by no cam

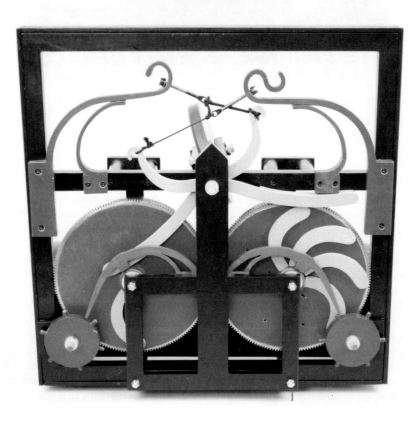

Fig. 2.52.
Right turn produced by full cam

Fig. 2.53.
Straight line motion produced
by medium length cam

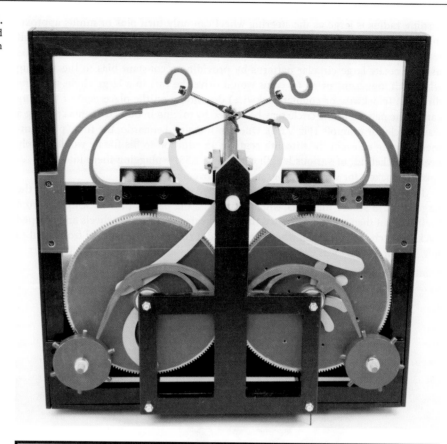

Fig. 2.54.
Pattern of the circle may be
altered by mixing in odd size
cams creating a wavy circle

turning radius is large as the steering wheel can only turn plus or minus approximately 20 degrees. The cart completes its program in approximately four and half feet of travel. This would seem to have little practical use however the cams may be used to create large circular patterns by providing a constant bias to the steering wheel. All long cams or all no cams would drive the cart in a large circle, with the direction (clockwise or counterclockwise) depending on the placement of the long cams. The pattern of the circle may be altered by mixing in odd size cams creating a wavy circle for example (Fig. 2.54). One can imagine Leonardo, the first "programmer" staging an event the fifteenth century. In addition to his file he would simply keep a pocket full of various length cams (Fig. 2.55)—plugging them into their respective sockets for various "programmed" movements!

The supreme thrill came when I had finished drilling evenly spaced holes in the large gears to secure the cams, which have a mating pair of pins sticking out from their bases. I then manually rotated the large gears via the drive wheels and stepped back to watch the cart's cam wheels rotate and turn the steering wheel from right to left. Leonardo's cart was executing its program for the first time in over 500 years.

Fig. 2.55.
Variety of cams

Leonardo's Knight

Tell me if ever, tell me if ever anything was built in Rome ...

Leonardo da Vinci, CA, f. 216 v-b [579 r] c. 1495

Carlo Pedretti was the first to discover the tell-tale fragments of Leonardo's Robot Knight in the Codex Atlanticus.[1] My effort to interpret and reconstruct Leonardo's Knight began with my book *Robot Evolution* and would lead me on an odyssey around the world. It would take me three generations to get it right, finally coming to me in, of all places, my local gym. The armored Robot Knight sat up; opened its arms and closed them, perhaps in a grabbing motion; moved its head via a flexible neck; and opened its visor, perhaps to reveal a frightening physiognomy. Fabricated of wood, brass or bronze and leather, it was cable operated and may have been built for a grotto similar to those built by Salomon de Caus (1576–1626)[2] perhaps with the accompaniment of automated musical instruments.[3]

What was the occasion for Leonardo's original Robot Knight? What patron required such a splendid demonstration of his wealth and power? Leonardo's project for the Robot Knight may have dated to the time of his work on the Last Supper and the decoration of the Sala delle Asse at the Sforza Castle, a period of some five years (1494 to 1498).

[1] Leonardo da Vinci, *Fragments at Windsor Castle from the Codex Atlanticus,* Carlo Pedretti (ed.), London, Phaidon, 1957, pp. 39–40, no. 12705. See also his later *Leonardo Architetto*, Milan, 1978 (English edition, London, 1986, and New York, 1991), pp. 319–323. In his edition of the Madrid manuscripts (New York, 1974), vol. III, Commentary, p. 76 note 13, Ladislao Reti mentions the robot sheets in the Codex Atlanticus as follows: "On fols. 366 r-b [1021 r] and 216 v-b [579 r] of the Codex Atlanticus, different armor parts are sketched. They do not belong to an actual suit of armor. The articulations are clearly shown, indicating that the project was for an automaton in the form of an armored warrior. Perhaps the armor parts shown belong to the same project." A reproduction of the central part of f. 366 (recto and verso) with the Windsor fragment RL 12705 in place, is given in the exhibition catalogue *Leonardo da Vinci, Studies for a Nativity* and the "Mona Lisa Cartoon," edited by Carlo Pedretti, Los Angeles, University of California, 1973, pp. 27–28, figs. 5 and 6. See also Pedretti's chapter on 'Anathomia Artificialsis' cit. in Chapter I, note 25 above, vol. II, pp. 868–871. I do not know of any other reference to Leonardo's robot studies. See, however, my own *Robot Evolution: The Developent of Anthrobotics*, New York, Wiley, 1994, pp. 12–20.

[2] Salomon de Caus, *Les raisons des forces mouvantes avec diverses machines tant gue plaisantes,* Frankfurt a. M., 1615. Cf. Bertand Gille, *Engineers of the Renaissance*, Cambridge, Massachusetts, MIT Press, 1964 (original edition in French, Paris, 1966), p. 236. See also the paper by Luigi Zangheri cited in note 17 below. Concordance as given by Ladislao Reti in his edition of the manuscript (as in note 1 above), p. 76 (CA, f. 36 r-a, b [100 r, 101 r] and v-a, b [102 r, 103i r]).

[3] See Leonardo's description of the garden planned for the suburban villa of Charles d'Amboise in Milan, CA, f. 271 v-a [732iii v], c. 1508: "With the help of the mill I will make unending sounds from all sort of instruments, which will sound for so long as the mill shall continue to move." Cf. Carlo Pedretti, *A Chronology of Leonardo da Vinci's Architectural Studies after 1500*, Geneva, Droz, 1962, p. 38. See also, by the same author, *Leonardo da Vinci. The Royal Palace of Romarantin*, Cambridge, Massachusetts, Harvard University Press, 1972, pp. 52 and 98, as well as the Richter *Commentary*, vol. II, pp. 29–31. Leonardo was certainly acquainted with late fifteenth-century examples of garden design, including those of Poggio Reale at Naples and the Rucellai at Quaracchi near Florence. It was for Bernardo Rucellai that he planned an ingenious water-meter for irrigation, as shown by a document that Pedretti discovered in Venice in 1951, namely the Golpaja Codex, that mentions a robot (a wooden man).

Fig. 3.1.
A map of medieval Milan the Sforza Castle, to the north east the park

In Leonardo's time, important political events called for impressive displays of pageantry. The years 1493 and 1494 were of special significance to the shrewd politics of Ludovico Sforza. The wedding of his niece, Bianca Maria, to Emperor Maximillian I forged closer ties between Sforza and the emperor, thereby ensuring a speedy recognition of Ludovico's title as Duke of Milan following the death of the young duke Galeazzo Maria Sforza at Pavia in 1494. In the same year, Ludovico instigated the French king, Charles VIII, to move down to Italy against the king of Naples. Any of these events and their associated celebrations could have provided an occasion for the appearance of Leonardo's technological wonder. As Carlo Pedretti has suggested to me, a suitable setting for the robot's first appearance could have been the park of the Sforza Castle. Embellished by Galeazzo Sforza, it was later abandoned and almost torn down before being restored by Luca Beltrami at the turn of the last century. The castle was constructed by Francesco Sforza as his residence and fortress, complete with moat, in 1450 (Fig. 3.1).

Access to the park from the ducal apartments was through Bramante's bridge, the ponticella, over the moat by the northeast tower of the Castle, where the Sala delle Asse is located. The park is best known for an elaborate pavilion at the center of a living labyrinth—a setting recorded by Leonardo himself, and was a place selected by him as a sort of testing ground for his inventions and experiments.[4]

The Sala delle Asse, a variation on the theme of the Renaissance grotto, is composed of a painted forest canopy on the ceiling and images of tree trunks lining the walls. The purpose of the room other than as an extension of the park, perhaps as a renaissance Tower of the Winds (see "Bell Ringer", below) providing both education and entertainment,[5] is long lost. It may have been intended as a man-made microcosm in which to display automata such as the Knight.

[4] It would be enough to mention the closing paragraph in the famous letter of Ludovico Sforza (CA, f. 391 r-a [1082r], c. 1482, Richter, §1340): "And if any of the above-named things seem to any one to be impossible or not feasible, I am most ready to make the experiment in your park …". See, however, for other pertinent reference to the park of the Sforza Castle, Richter *Commentary*, vol. II, pp. 31–32 and 186.

[5] Volker Hoffmann, "Leonardos Ausmalung der Sala delle Asse im Castello Sforzesco", in *Mitteilungen des Kunsthistorischen Institutes in Florenz, XVI,* 1972, pp. 51–62, for recent interpretations of the symbolism of the Sala delle Asse; John F. Moffitt, Leonardo's «Sala delle Asse» and the Primordial Origin of Architecture", in *Arte Lombarda*, N.S., nos. 92–93, 1990, 1–2, pp. 76–90; Dawson Kiang, "Gasparo Visconti's Pasitea and the Sala delle Asse", *ALV Journal, II,* 1989, pp. 101–109. See also Carlo Pedretti, *Leonardo. A Study in Chronology and Style.* Berkeley and Los Angeles, University of California Press, 1973 (2nd Ed., New York, Johnson Reprint Corporation. Harcourt Brace Jovanovich Publishers, 1982), pp. 76–77.

Fig. 3.2. Dungeon under the Sala della Asse

Leonardo's whole project inevitably included, perhaps even culminated, in the fashioning of a robot man. In his humanistic philosophy, man was the microcosm: the universe writ small. Leonardo's Knight, when viewed in a man-made microcosm such as the Sala delle Asse, would have embodied the Renaissance ideal of "man as the measure," the standard for which the world was designed. As an official reception space, the room might have been a *Wunderkammer*, or chamber of wonders, with the Robot Knight perhaps popping out of a rocky wall.

There it would have been one of the wonders that Ludovico could have displayed to impress important visitors like Charles VIII of France. According to French historian Albert Mousset, a "fully armed" warrior appeared at the Grotto of Perseus at St. Germain-en-laye, 20 kilometers from Paris, on the occasion of the Dauphin's visit during its construction on September 1, 1608.[6] The builder, one Francini, later known as Thomas de Francine, was a native of Florence. He left drawings of other grottoes of the complex, which date about 1600 and were also engraved. They betray knowledge of the Pratolino Grottoes. It is interesting that both grottoes and automata become more common in Europe at the approximate time that the Madrid manuscripts were transferred by Pompeo Leoni from Milan to Spain. Furthermore, the role of Juanelo Turriano in disseminating Leonardo's technological ideas in Spain is still to be fully explained. A native of Cremona, Italy, he was in the services of Charles V when, in 1533, he made a number of automata for his patron, though is best known for his grandiose hydraulic device for Toledo.[7]

A mechanical knight, one of a pair of jousters, was built in Germany in 1520 and is now housed in the Bavarian National Museum in Munich.[8] Could this have been inspired by Leonardo work? By the end of the sixteenth century, Leonardo's robotic ideas had come to full fruition. Thus in 1590 Lomazzo could record Leonardo's inventions, including the robot, stating that "all Europe is full of them."[9]

In 1997, bearing a letter of introduction from the Florence Science Museum, I made a field trip to the Sala delle Asse. Armed with facsimiles of Leonardo's notebooks from the period, I went to see if I could discover anything that might be useful for understanding his Robot Knight. I arrived at Milan's imposing fascist train station in a pouring rain that flowed out in torrents from the station's gargoyle downspouts. Making my way to the Sforza Castle, I made my introductions and was led off the beaten path to where no tourist was allowed to go—the dungeon. Now used as the museum's storage facility, it lies directly beneath the Sala della Asse (Fig. 3.2).

[6] Albert Mousset, *Les Francine. Crèatures des eaux de Versailles, intendants dex eaux et fountains de France de 1632 à 1784*, Paris, P. A. Piccard, 1930, as cited by E. Droz and A. Chapuis, Automata: A Historical and Technological Study, London, B. T. Batsford Ltd., 1958, p. 43.

[7] On Juanelo Turriano, his possible connection with Leonardo, and his work at Toledo, see Ladislao Reti, "A postscript to the Filarete discussion: on horizontal waterwheels and smelter blowers in the writing of Leonardo da Vinci and Juanelo Turriano (ca. 1565): a prelude to Besacle", in *Atti del XIII Convegno internazionale di Storia della Scienza*, Paris, 1971, pp. 79–82.

[8] Cf. Mary Hillier, *Automata and Mechanical Toys*, London, Bloomsbury Books, 1988, p. 25.

[9] Giovan Paolo Lomazzo, *Idea del Tempio della Pittura*, Milan, P. Gottardo Pontio, 1590, pp. 17–18. Cf. Beltrami, *Documenti*, p. 206.

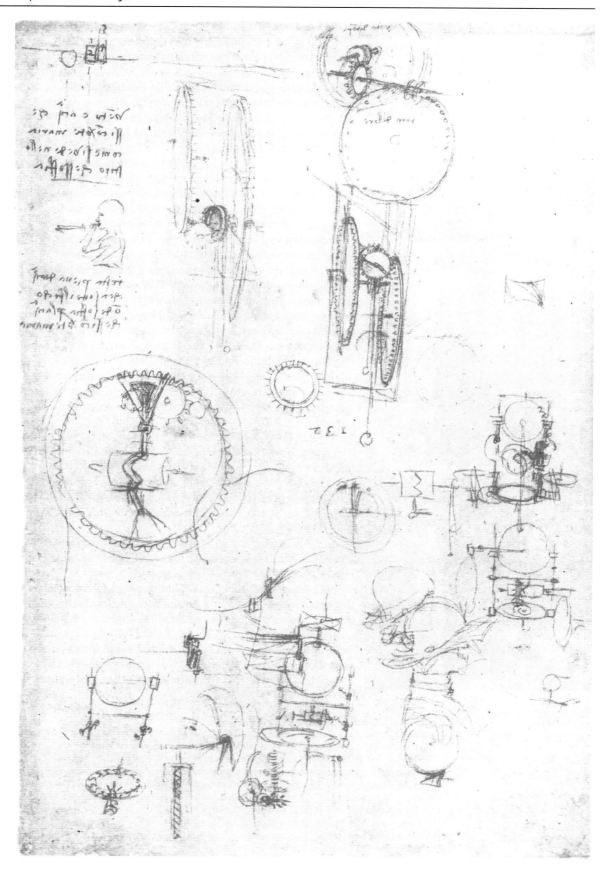

Ancient Roman tombstones were arranged in neat stacks on custom-constructed steel tables covered with plastic tarps. The cavernous room, with its large, Roman brick arches, seemed denuded of anything from Leonardo's time frame, with the exception of small stands built into the corners. In Leonardo's day these must have held torches. The moat had long ago been drained and is now a grassy ravine. At some point, perhaps centuries ago, windows had been cut into several of the meter-thick walls. However, my curiosity led me to the now-shuttered windows opening onto the long-gone moat. The first shutter I opened revealed—to my surprise—a giant snail, complete with probing eye stalks, slowly gliding across the window sill. Unable to stop myself, I opened another shutter and was startled almost to the point of falling backwards by a screeching cat, who arched her back in defense of her kittens. I would often think of these images as signs of things to come as I continued on my adventure into the world of Leonardo. The snail I would come to see as representing Carlo, his eyes wide open searching and probing for the truth, his gentle gliding along, so as not to disturb anyone, being well in keeping with the Renaissance motto *Festina lente* (hurry up slowly) that characterizes his approach to the study of Leonardo. And the cat guarding its kittens? The cat would be me struggling to protect my discoveries!

Pieces of the Puzzle

Four sheets of the Codex Atlanticus illustrate most of the elements of Leonardo's robot. Because a detail on one sheet might be explained or clarified by details on others, they must be considered as a group, not individually. I believe that these sheets must date from the same time, possibly closer to 1495 than to 1497, because of hints at their contents which are found in notebooks regarding the earlier date.[10] As a rule, I found that the more finished the sketch, the closer Leonardo is to finishing his thought. Leonardo in this time period draws in red chalk and then reinforces it in black ink. Finally, Leonardo's famous background slanting lines are added to put the figure in relief.

The left section folio CA, f. 388 v-a [1077 r] (Figs. 3.3 and 3.4) shows two small overlapping heads and one large head detailing the gorget (neck mechanism). The gorget's function is to protect the neck, provide secure attachment of the helmet, and still allow for flexibility. As applied to the robot, it conceals the mechanisms and protects the device from corrosion, which would have been an ever-present threat in a grotto. The gorget consists of three nested rings, or "lames," that create a flexible joint. This is detailed directly below the large head. In an actual gorget, multiple leather straps are riveted to the inside of the lames, holding the segments together while still permitting a degree of flexibility. In the large drawings of the head, the neck segments are inverted on the right. Some type of flexible central support is needed to prevent the rings from collapsing. The small tilted heads sketched in the center of CA, f. 366 v-b [1021 v] implies this (Figs. 3.5 and 3.6). Years later I would discover further neck/helmut drawings and perhaps even the face of the robot in Codex Forster

[10] A full discussion of the chronology of the three sheets in the pertinent entries of Pedretti's *Codex Atlanticus Catalogue* (as in note 22). The connection with two pages in Paris MS H, as discussed in the text above, may be taken to suggest an earlier date for the inception of Leonardo's studies for the robot mechanism. Carlo Pedretti agrees (oral communication) that Leonardo's first studies for the robot may date from c. 1494 at the time of a series of studies for musical instruments, mostly mechanical drums of a kind suitable for marching troops or individual soldiers, showing innovative ideas perhaps triggered by the French Army in transit through Lombardy in that year. This is the case with drawings of carriages and weapons in the same notebook as pointed out by Pedretti in his "The Sforza Horse in Context", keynote address at the symposium *Leonardo da Vinci's Sforza Horse. The Art and Engineering,* held at Lafayette College, Lehigh University in 1991, Bethlehem, Pennsylvania, Associated University Presses, 1995, pp. 27–39.

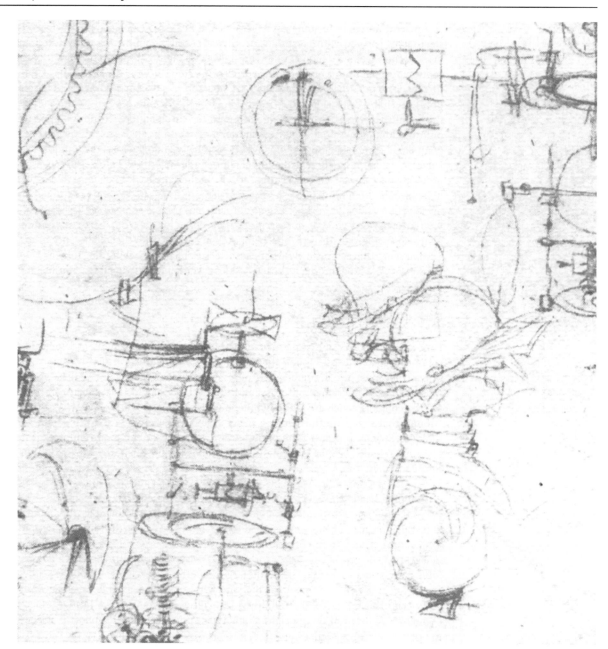

MS II,2, f. 65 r-v (Fig. 3.7). As Carlo described the striking similarity to the Codex Atlanticus drawings "they look like they were cut out of it." A drive train is also suggested by the cord diagram for the human neck on the *Windsor* anatomical sheet RL 19075 v (K/P 179 v) (Fig. 3.8) many years later.[11] Such cord diagrams, which duplicate every part of the human body, may have originated from Leonardo's robot studies, thus suggesting a new point of origin and practical application for his anatomical studies.

Fig. 3.4. CA, f. 388 v-a [1077 r] (left section). Helmut details

[11] For a date possibly as late as the French period, c. 1517–1518, see Pedretti's catalogue entry in the corpus of the *Anatomical Studies*, cit. (as in note 1 above), vol. II, p. 882. It was about 1508 that Leonardo introduced cord diagrams in his anatomical illustrations to explain the mechanics of the human body, apparently in view of constructing and anatomical model. Cf. Pedretti's chapter 'Anathomia Artificialis,' (as in note 1 above).

Fig. 3.5. ▶
CA, f. 366 v-b [1021 v]

Fig. 3.6.
CA, f. 366 v-b [1021 v].
Head details

Fig. 3.8. ▶
Windsor anatomical sheet
RL 19075 v K/P 179 v

Fig. 3.7.
Codex Forster II,2, f. 65 r-v
▼

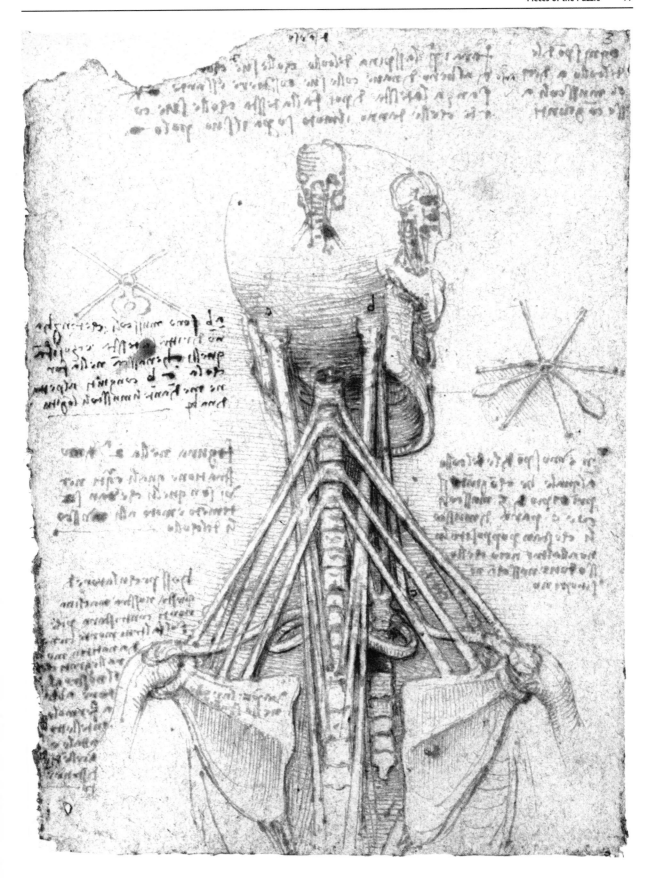

The three mechanisms drawn on the left section of CA, f. 388 v-a [1077 r] (Fig. 3.9) translate constant velocity (vertically-oriented rotary input) into a reciprocating rotary output at right angles. This could be interpreted as an escapement mechanism for a clock. Preliminary studies of this mechanism are in a notebook of c. 1494, Paris MS H, f. 113 [30 v] r – 112 [31 r] v, (Fig. 3.10) thus suggesting a date for this group of sheets.[12] The basic function of the machine is depicted schematically (Fig. 3.11): Two worms alter-

Fig. 3.9. CA, f. 388 v-a [1077 r] (left section)

[12] See note 10 above. Of particular interest and beauty are the red-chalk sketches on ff. 43 v and 44 r, showing the estimation of human muscular effort with the help of a dynamometer. As explained by Ladislao Reti, "Leonardo da Vinci the Technologist: The Problem of Prime Movers", in *Leonardo's Legacy*, edited by C. D. O'Malley, Berkeley and Los Angeles, University of California Press, 1969, pp. 72–73 and figs. 1 and 2, in the figure on f. 43 v, no less than six different cases covering the whole body are examined, while in the figure on the facing page Leonardo tries to compare the force of the arm in different positions and points of attachment. Between the last two drawings a diagram (not reproduced by Reti) shows the arm as a compound lever. As such, it shows how kinesiology was indeed for Leonardo the foundation to his experiments in robotics. Compare also Paris MS L, f. 28 r, c. 1498, as given in the Richter *Commentary*, note to §378.

Fig. 3.11. CA, f. 388 v-a [1077 r] (left section). Basic function of machine

Fig. 3.12. ▶
CA, f. 388 v-a [1077 r] (left section). Compacted version of machine

nately engage a large worm gear providing high torque, their motion controlled by the rotating drum cam. As far as I know this is the first time this mechanism has been studied. Another version of the clocklike device, which may be an attempt at a more compact design, is shown in the left section of CA, f. 388 v-a [1077 r] (Fig. 3.12).

My first impression was that the above was a rudimentary programmable controller for the robot. In that case, it could drive the arm's pulley and cable system. Making the robot arms move up and down according to the "program."

The right section of CA, f. 388 v-a [1077 r] (Figs. 3.13 and 3.14) shows a ratchet mechanism for producing vertical up-and-down motion by driving a paw that engages a toothed ratchet. The ratchet is detailed on CA, f. 366 v-a [1021 v] (Fig. 3.15). Perhaps this was for raising or lowering the Knight, assuming that a cable design was not used for the legs. A jack-like device hidden by the legs and connected to the torso could lift the Knight from behind. This would assume that the Knight was intended to be viewed only from the front, as would be the case if it were in a niche.

A wheel sketched, on the top left section of CA, 388 v-a [1077 r] (Fig. 3.16), is inscribed "rota dell' ore" (wheel of the hours), and another wheel is designated "rota del tempo" (wheel of the escapement),[13] thus showing that Leonardo is thinking of a clock mechanism, possibly in connection with the robot.

Fig. 3.14.
CA, f. 388 v-a [1077 r].
Detail of ratchet mechanism

[13] Carlo Pedretti, "Il Tempo delli orilogi," *Studi Vinciani,* Chapter III, Geneve, Droz, 1957, pp. 99–108.

◄ Fig. 3.15.
CA, f. 366 v-a [1021 v].
Detail of ratchet

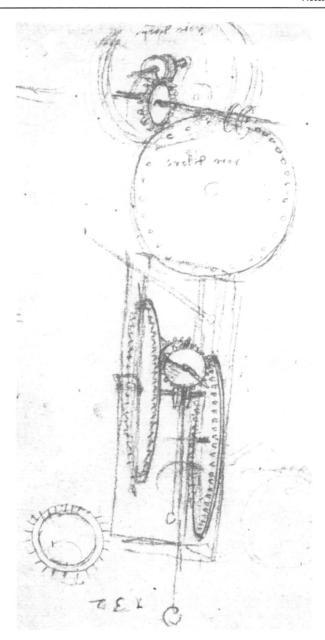

Fig. 3.16.
CA, f. 388 v-a [1077 r] (left
section). Clock sketch

This same detail shows a pulley system, this time driven by a counterweight. This is of particular interest in a context that includes clock mechanisms because of Leonardo's well-known tribute to the inventions of Nature as being superior to any human invention: "she does not involve counterweights when she makes organs suitable for animals."[14] Counterweights are also shown in the related mechanisms sketched in Paris MS H, f. 113 [30 v] r–112 [31 r] v (Fig. 3.10). The center group of drawings of CA, f. 216 v-b [579 r] (Figs. 3.17 and 3.18) (in red chalk partially gone over with pen and ink), show counterweights.

In the small helmet shown on the left section of CA, f. 388 v-a [1077 r] (Fig. 3.4), the visor appears both raised and lowered. The jaw must have been articulated, but is shown removed from the head. The nose and outline of the head can be clearly seen

[14] Windsor, RL 19115 r (C.IV.10 r), c. 1508–1510, given in the *corpus* of Leonardo's *Anatomical Studies* as 114 V, on p. 370. See also Richter, §837.

Fig. 3.18. ►
CA, f. 216 v-b [579 r].
Counter weights

Fig. 3.19. CA, f. 366 v-b [1021 v]. Nose and outline of head **Fig. 3.20.** CA, f. 216 v-b [579 r]. Italian Barbuta

on the top of CA, f. 366 v-a, b [1021 v] (Fig. 3.19) albeit upside-down. Two types of helmet are identified: a German Sallet (the two overlapping head figures) with laminated neckguard and visor pivoting high on the skull and an Italian burbuta, which resembles the Corinthian helmets of classical antiquity, as shown at the bottom of CA, f. 216 v-b [579 r] (Fig. 3.20).[15]

[15] Cf. John Paddock and David Edge, *Arms and Armor of the Medieval Knight*, New York, Cresent, 1988, pp. 94–135, 141–142, 177–182. See also Charles Ashdown, *European Arms & Armor*, New York, Barnes & Noble, 1995, pp. 213–264. The British refer to the period of Leonardo's suit of armor (1430–1500) as the Tabard Period, so named for the surcoat or Tabard, which was the most persistent element in this period. The Tabard Period saw a great deal of technological progress due to the innumerable conflicts of the time. International conflict was the perfect setting for technology transfer, producing an international style. By the time Leonardo's suit of armor was designed, the entire body was enveloped and protected by a flexible, articulated suit. Selection of a suit of armor for the robot also had the advantage of a limited range of motion and flexibility that would simplify the task of animation.

Fig. 3.21.
CA, f. 216 v-b [579 r].
Articulated joint

Fig. 3.22.
CA, f. 216 v-b [579 r].
Cable system

Fig. 3.23.
CA, f. 216 v-b [579 r].
Cable system

Fig. 3.24.
CA, f. 388 v-a [1077 r]
(right section). Cable system

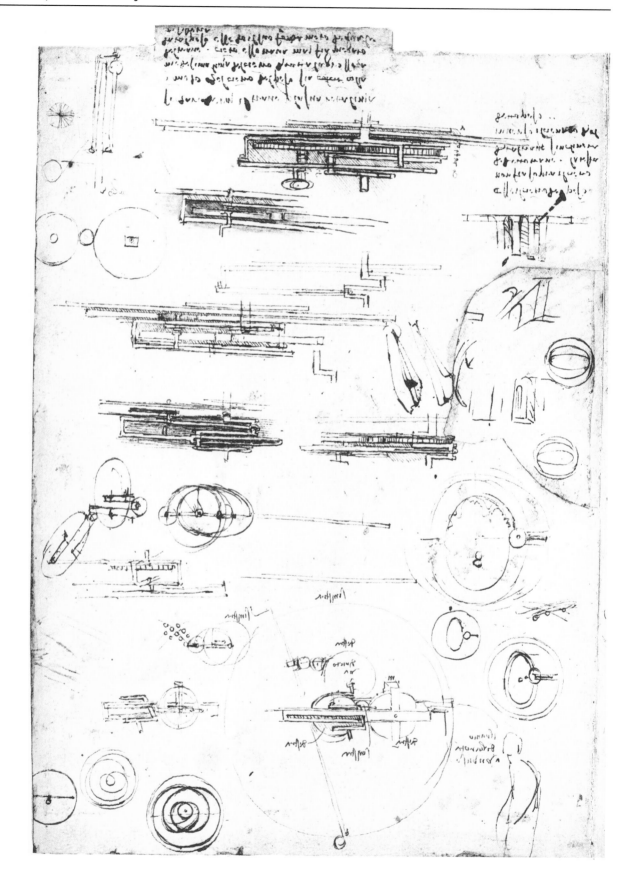

◀ **Fig. 3.25.**
CA, f. 366 r-a [1021 r].
Planetarium studies
and cable man

Fig. 3.26.
CA, f. 366 r-a [1021 r].
Close-up of cable man

Exploded above the Knights torso and shoulder is an articulated joint, detailing the sliding rivet that allows a degree-of-freedom (Fig. 3.21). The cable system for the arms is shown in several details on CA, f. 216 v-b [579 r] (Figs. 3.22 and 3.23). The perspective view of the cable system includes a pair of vertical lines to indicate the width of the torso. These probably were drawn as an exercise to roughly size the suit of armor. Another cable-driven mechanism is shown in the right section of CA, f. 388 v-a [1077 r] (Fig. 3.24). In CA, f. 366 r-a (Fig. 3.25) dominated by planetarium studies is an intriguing figure with cables in the locations of arms (Fig. 3.26).

The mechanical arm, CA, f. 366 r-a [1021 r] (Figs. 3.27 and 3.28), is probably similar to the leg, in which a pivot pins the upper and lower limb for a single axis joint. It is located alongside the planetarium design. Behind the elbow are two connecting right angle lines, which indicate an access panel for fastening a cable to the elbow joint or for facilitating cable routing to the hand. An arm socket appears on the side of the right small helmeted head CA, 388 v-a [1077 r] (Fig. 3.4). The hand is roughly sketched with a thumb, corresponding to a gauntlet in having all four fingers enclosed as a group.

The idea that some or all of the sixteen missing folios of Madrid MS I, i.e. ff. 37–42 and 55–56, contained finished drawings of the biomechanical studies and the robots was a compelling one. Nearly every one of the technological sketches unrelated to the robot projects on the *Codex Atlanticus* sheets (e.g. the lifting and transporting devices, as well as the epicyclical mechanism for a planetarium) is found in highly finished drawings in the Madrid MS I manuscript.[16] On two facing pages of this manuscript, ff. 90 v–91 r, the legs for studying lifting forces are shown. This gives a direct indication what Leonardo may have had in mind for the robot (Figs. 3.29 and 3.30).

[16] Concordance as given by Ladislao Reti in his edition of the manuscript p. 76 (CA, f. 36 v-a, b [102 r, 103i r] and r-a, b [100 r, 101 r]), (as in note 1 above).

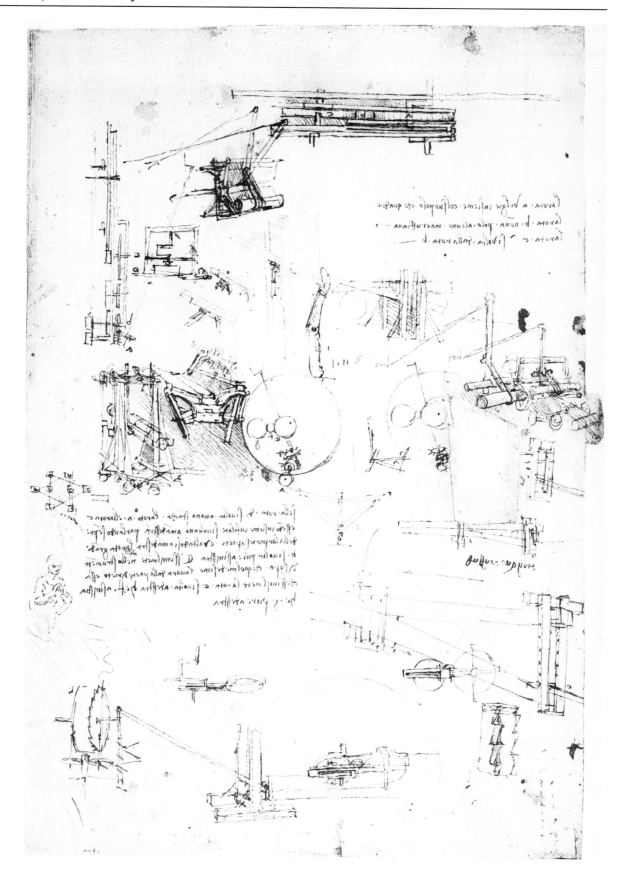

◀ Fig. 3.27.
CA, f. 366 r-a [1021 r].
Weight lifting studies and arm

The gaps left by the missing pages of Madrid MS I may be filled by the comparative study of Borelli as discussed in Chapter I. Because of the great similarity of theme and organization, these studies are the perfect foundation to build a robot. Indeed, Borelli's plate V, fig. 7 (Fig. 3.31) could very well represent Leonardo's intention for the Robot Knight's leg CA, f. 366 v-b [1021 v] (Fig. 3.32). The angle of the knee and the ankle is exactly as in the completed leg. Partially overlapping the foot is the genouilli'ere (a segmented cover) to protect the knee. More knee drawings are shown along with the jaw mechanism in Fig. 3.33. Significantly, on the same folio a mechanical knee is drawn next to a human knee (Fig. 3.34).

Fig. 3.28. CA, f. 366 r-a [1021 r].
Mechanical arm

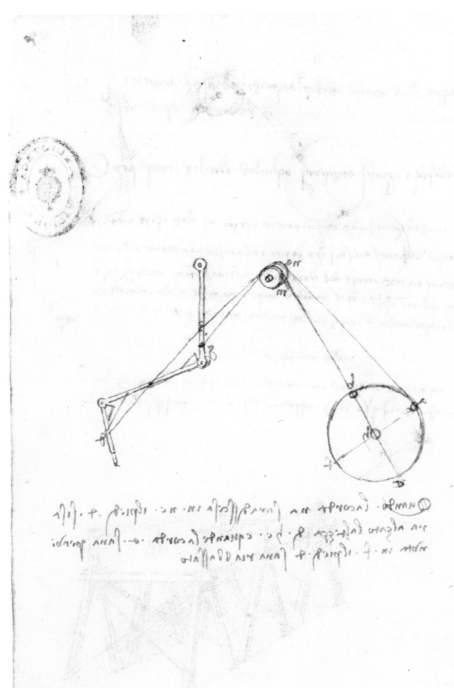

Fig. 3.29.
Madrid MS I, f. 90 v.
Mechanical leg

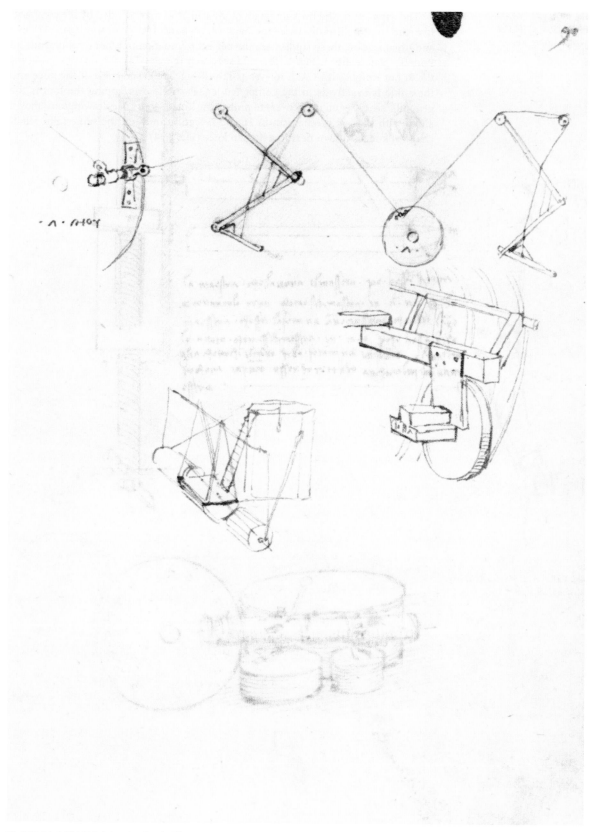

Fig. 3.30. Madrid MS I, f. 91 r. Mechanical leg

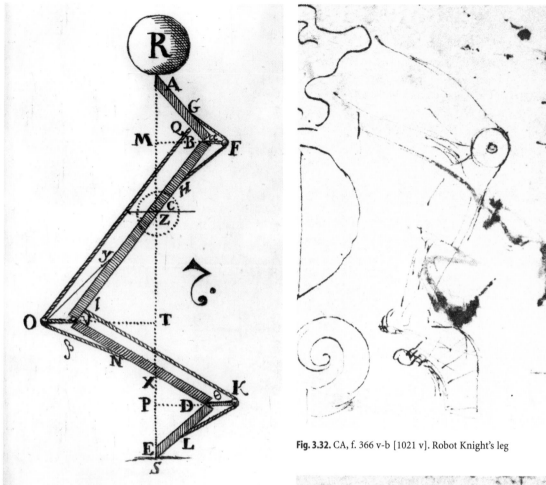

Fig. 3.31. Fig. 70. Borelli's leg, plate V, fig. 7

Fig. 3.32. CA, f. 366 v-b [1021 v]. Robot Knight's leg

Fig. 3.33. CA, f. 366 v-b [1021 v]. Robot Knight's knee and jaw

Fig. 3.34. CA, f. 366 v-b [1021 v]. Robot knee and human knee

142

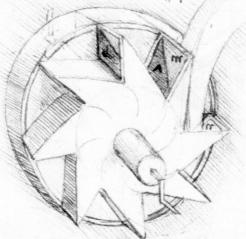

◀ **Fig. 3.35.**
Madrid MS I, f. 142 r.
Water wheel

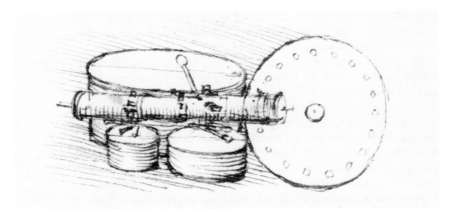

Fig. 3.36.
Madrid MS I, f. 91 v.
Automated drum

A water wheel with a description on f. 142 r of the Madrid manuscript (Fig. 3.35) is the same type as those later adopted by Bernardo Buontalenti, the architect of the Pratolino Gardens, and by Salomon de Caus.[17] This may have been the power source of the automaton. On Madrid MS I, f. 91 v (Fig. 3.36) following the diagrams of the leg biomechanical studies on the recto, are drawings of an automatic musical instrument which may have provided a military drum beat to accompany the knight as it made its appearance in a grotto. Paris MS H, the notebook of about 1484, also depicts numerous automated musical instruments.[18]

Reconstructions

To understand Leonardo's construction we must look to his teacher, Andrea del Verrocchio. According to Kenneth Clark, *Windsor Catalogue, sub numero*, "The decorated cuirass on the verso immediately suggest the workshop of Verrocchio, being of the same type as (though not identical with) that was worn by the two soldiers on the right of the silver relief of the beheading of St. John the Baptist in the Opera del Duomo, Florence."[19] In Milan, after 1482, he also came in contact with German craftsmen with expertise in armor construction.[20] Demonstrating his dissection knowl-

[17] See the drawing by Heinrich Schickardt, c. 1600, recording the mechanism of the water organ for Mons Parnassus at Pratolino (LBS, Cod. Hist. 4, 148 b) reproduced in every publication on Pratolino, e.g. Luigi Zangheri, *Pratolino. Il giardino delle meraviglie*, vol. II, fig. 69, Florence, Regione Toscana, 1979. Marco Dezzi Bardeschi, 'Le fonti degli automi di Pratolino', in Alessandro Vezzosi (ed.) *La Fonte delle Fonti. Iconologia degli artifizi d'acqua* (proceedings of a colloquium held at Pratolino on July 14, 1984), fig. 30, Florence, Regione Toscana, 1985, pp. 13–24. See, in the same volume, pp. 35–43, Luigi Zangheri, 'Salomon De Caus e la fortuna di Pratolino nell' Europa del primo Seicento', in particular fig. 3 on p. 36. See also Eugenio Battisti, *L'Antirinascimento*, vol. I, pp. 249–286, ('8. Per una iconologia degli automi'), text ill. on p. 270, Milan, Garvanti, 1989 (first edition, Milan, Feltrinelli, 1962).

[18] Emanuel Winternitz, *Leonardo da Vinci as a Musician*, New Haven and London, 1982, in particular on pp. 150–159, figs. 14–22. See also Richter Commentary, vol. II, pp. 215–216. For a through analysis and interpretation of their mechanism, see Marco Carpiceci, 'I meccanismi musicali di Leonardo', in *Raccolta Vinciana, XXII*, 1987, pp. 3–46.

[19] See the early drawings at Windsor, RL 12370 v, c. 1480. According to Kenneth Clark, Windsor Catalogue, sub numero, "The decorated cuirass on the verso immediately suggests the workshop of Verrocchio, being of the same type as (though not identical with) that worn by the two soldiers on the right of the silver relief of the beheading of St. John the Baptist in the Opera del Duomo, Florence". Compare also the famous profile of a warrior at the British Museum (Popham, pl. 129) also dating from about 1480. Cf. Mària G. Agghàzy, *Leonardo's Equestrian Statuette*, Budapest, Akadèmiai Kiadò, 1989, figs. 31 ff.

[20] 'Julio Tedesco' is mentioned in Forster MS III, f. I r, as having joined Leonardo on March 18, 1493 (Richter, §1459). He is also recorded in Paris MS H, ff. 105 r and 106 v, for mechanical work carried out for Leonardo in 1494 (Richter, §§1460 and 1462). Of particular interest is the note in Madrid MS I, f. 12 v, c. 1497: "Dice Giulio aver visto nella Magnja una di queste rote essere consummate dal polo m" (Giulio says to have seen in Germany one of these wheels become worn down by the axle m), in that it shows Leonardo's interaction with a foreign assistant.

edge, Leonardo built mechanical models of the muscles and joints.[21] His arm and leg-like designs for ornithopters attest to his full understanding of the mechanics of human and animal bodies.[22]

To get a picture of the overall exterior of the Robot Knight, I aligned the Knight fragments with the help of a photograph of Renaissance armor and had it redrawn (Fig. 3.37). Rivets on the sketch would even align with the photograph, indicating I was on the right track. At one time there must have been thick file folders containing beautiful, complete, assembled views showing the knight in multiple positions, as well as working drawings for fabrication. What have come down to us are the earliest conceptual doodles. But Leonardo, being Leonardo, naturally does even this very accurately and with surprising detail. Leonardo, in effect, saved his preliminary bar napkin sketches, perhaps along with more finished drawings in files. So although his final finished drawings were lost, it is possible to reconstruct his machines based on these fragments, stepping into his shoes as he put down his preliminary concepts. Indeed, as Pedretti has proven, entire lost sections of Leonardo's notebooks may be reconstructed in this way.[23]

Figure 3.38 shows my first reconstruction of the Knight's inner workings. The central drive pulley drives the looped cable through the arms to their drive pulleys. Idler pulleys maintain traction and direction of the drive pulley's direction. The legs may have been driven in a similar manner, as indicated by Madrid MS I, f. 90 v and 91 r discussed above.

However, in Madrid the legs are only capable of lifting, not pushing, most likely a part of a biomechanical experiment. To function for a robot, the legs require a second, antagonistically placed cable to protect the Knight from falling on his face, as shown in Borelli's leg studies mentioned earlier. The frame to support the pulleys and cables is the suit of armor itself, with integral bearings built into the elbows, knees, and shoulders. However, had Leonardo used a standard suit of armor, he would have likely built a skeleton to provide joints and support for the suit, as the frame is either missing or is unnecessary for a self-supporting suit of armor. Note that fifteenth-century armor is very different from the more familiar seventeenth- and eighteenth-century armor commonly on display in museums. Extremely thick and heavy, armor from the fifteenth century appears to be more like boiler plate from the few pitted examples I have seen.

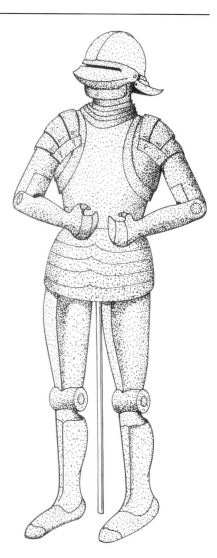

Fig. 3.37. Knight redrawn with Renaissance armor

On January 5, 1997, the Sunday Cultural Supplement of Italy's major financial newspaper, *Il Sole-24 Ore*, carried Carlo Pedretti's full-page review of my essay "Leonardo's Lost Robot" that he had just published in his journal *Achademia Leonardi Vinci*.[24] This was more than a review. It included my first generation Robot Knight reconstruction. Perhaps because he was applying fifteenth-century intellectual property rules, Carlo felt unconstrained by international copyright laws and published it with-

[21] See Pedretti's chapter on 'Anathomia Artificialis' as in note 1 above.

[22] The most striking example of this design is a highly finished drawing in CA, f. 341 r-c [934], c. 1508, reproduced in my *Robot Evolution* (as in note 1 above), fig. 1.13 on p. 17. Cf. Carlo Pedretti's *Codex Atlantics Catalogue* (New York, Johnson Reprint Corporation, 1978–1979), vol. II, pp. 193–194. Several preliminary studies are known, e.g. CA, f. 307 v-a [843], which includes details of the muscular legs of a nude standing figure.

[23] Carlo Pedretti, 1964. *Leonardo Da Vinci On Painting A Lost Book* (Libro A), Berkeley, and Los Angeles, University of California Press, 1964.

[24] See my "Leonardo's Lost Robot" in *Achademia Leonardi Vinci*, IX, 1996, pp. 99–110. Carlo Pedretti, "I robot secondo Leonardo", in *Il Sole-24 Ore*, no. 4, 5 January 1997, p. 23.

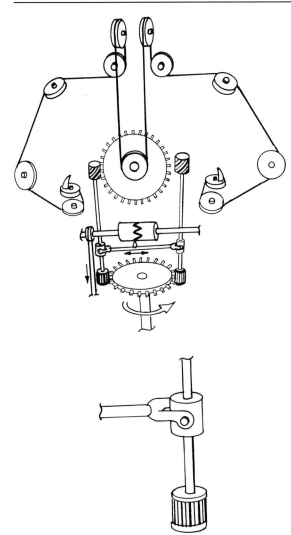

Fig. 3.38. First reconstruction of Knight's inner workings

out checking with me first. But as a quick and timely Machiavellian strategy, it was all for a good cause. It was to set in motion a chain of events that was to lead to my Vinci lecture of the year 2000.

As a first result of that press coverage I received a small contract in April 1997 from the prestigious Museum and Institute for the History of Science in Florence, directed by Paolo Galluzzi. This was for developing the CD-ROM for the Mechanical Marvels exhibit, which toured the world beginning at The World Financial Center in New York in October 1997, precisely at the site of the infamous Nine Eleven.[25]

On this, my first trip to Italy, I arrived in Rome taking in all the sights and sounds and caught the last train to Florence. The local train of Second World War vintage was quickly filled by natives grabbing all available seats, so I stood, talking to an Italian student who had traveled in the States. There was heated debate amongst the passengers about whether I should get off at Florence, and the discussion was ended when someone blurted out that if I didn't get off now, I would end up in Bologna!

Since it was now 2.30 A.M., my next problem was to find a cab in the dark, unknown city. To my eternal relief, when I left the deserted station and walked through a viaduct, I found cabs waiting. One of them whisked me to my little hotel, where I proceeded to wake the manager and crash on my little cot.

My first day on the job at the Museum began when I left my one-window garret hotel room, locking the door with a nineteenth-century skeleton key. As I walked down the ancient streets, through the Galleria degli Uffizi, I thought of how Leonardo himself may have walked these streets flanking the River Arno, nicknamed "the Blonde" for its yellow color caused by sediment.

At the Museum, I sat down with the draftsperson. Although we had a language barrier (she didn't speak English and I at that time didn't speak a word of Italian) we were still able to communicate though sketches. As we began to input my sketches, she quickly determined that my model was incomplete—how could the cables engage the driver pulley? With that sickening feeling that you have when arriving unprepared for a test, I headed out for escape and lunch. While ruminating on the problem, I hit upon the idea that Leonardo might be using idler pulleys to guide the cable around the drive pulleys, even though they were not shown in some of the most important figures. On my return to the museum, I seemed to verify this by plowing through all volumes of the *Codex Atlanticus* and found later examples of this treatment for canal locks in CA, f. 331 v-b [906 v] (Fig. 3.39), CA, f. 331 r-b [279] (Fig. 3.40) and 344 r-a [944 r] (Fig. 3.41). They depict idler pulleys wrapping cables around large drive pulleys.

[25] The exhibition, as planned by Professor Galluzzi in Florence, was first taken to Paris with the title "Les ingénieurs de la Renaissance de Brunelleschi à Leonard de Vinci" in 1995–1997. It was turned into Mechanical Marvels: Invention in the Age of Leonardo for the American venue to include a section on Leonardo's robot entrusted to me. Exhibition organized by Finmeccanica Istituto and the Museo Di Storia Della Scienza, Florence. See the exhibition catalog Mechanical Marvels: Invention in the Age of Leonardo, pp. 234–235 and my reconstruction of Leonardo's robot knight in the companion CD of the same name, Giunti Multimedia, Florence, 1997.

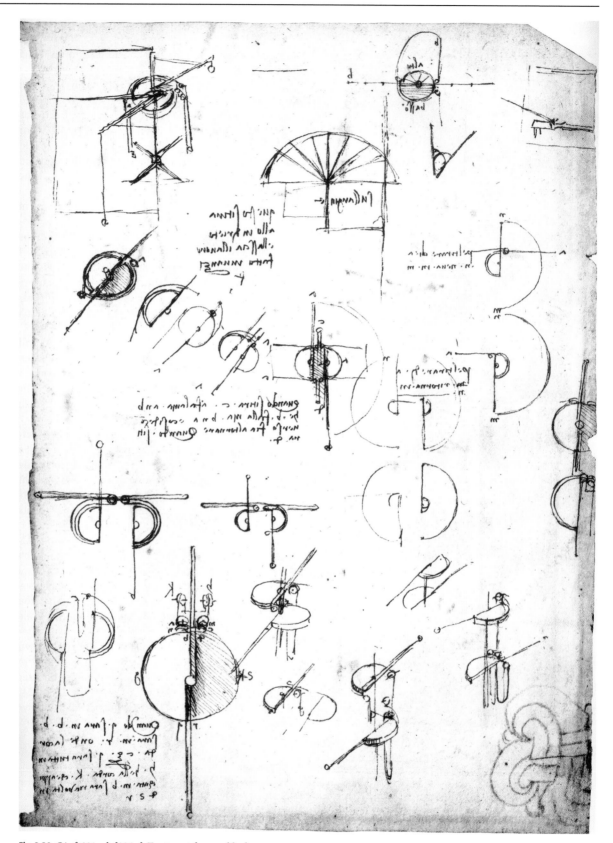

Fig. 3.39. CA, f. 331 v-b [906 v]. Treatment for canal locks

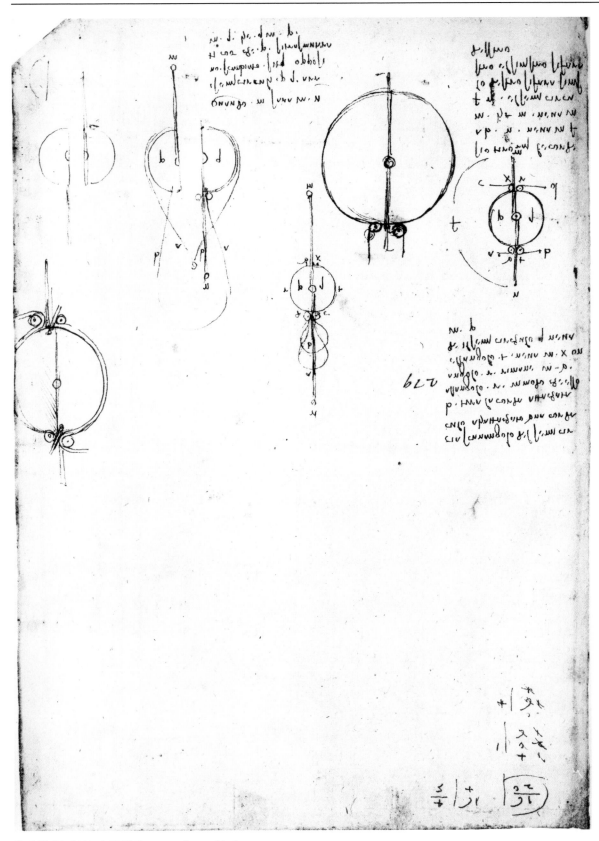

Fig. 3.40. CA, f. 331 r-b [279]. Treatment for canal locks

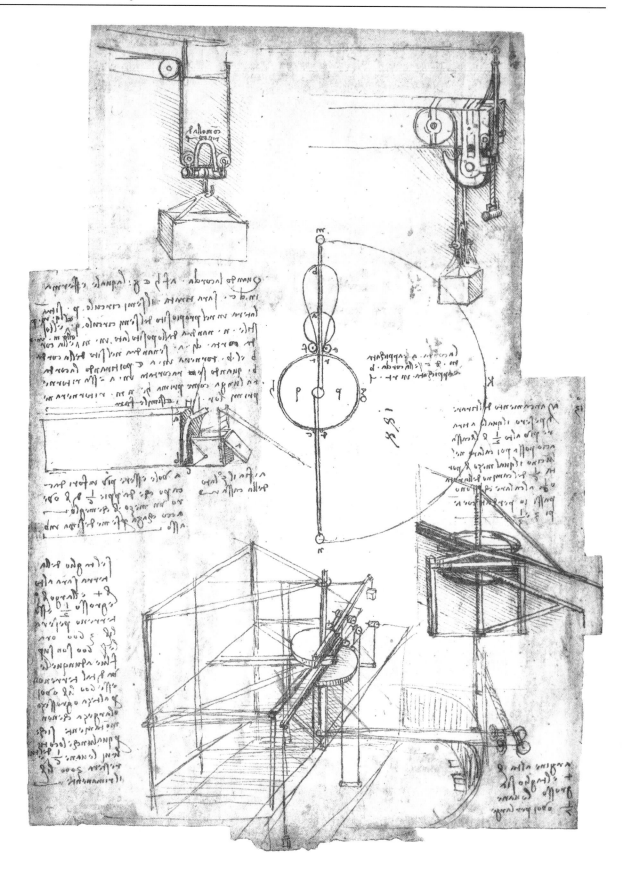

I then reexamined my preliminary drawings and reinterpreted them accordingly. I added the idler pulleys that I thought Leonardo must have left out. The single cable design would be maintained—gravity providing the restoring force to the arms. In this reconstruction the arms would always move in opposite directions i.e. one up and one down. Therefore the arms could have been made to beat a drum in a militaristic manner or to swing as the Knight walked forward. Possibly a clockwork controller drove the main drive pulley in the chest. I took a chance with this and added it to the reconstruction (Fig. 3.42). The clockwork mechanisms produced reciprocating motion so it seemed logical that it could drive the arms. Therefore it seemed to be designed for a reciprocating driver. For the first generation legs, I looked at the Madrid drawings.

Building Leonardo's Knight

In the spring of 2002, the BBC contacted me to film me building the robot Knight.[26] I flew to London November 2002 to build the Knight in a tight, compressed two weeks at the BBC Visual Effects workshop in West London. I modified the design somewhat to meet the needs and rigors of film work, making it simpler and more flexible. Also, a stock suit of armor was to be used in place of the dedicated suit that Leonardo indicated. I started by making a small Erector Set model in my basement, then began to design on paper while at the same time making a full size wood model of one side of the robot.

Forced now to resolve the drive train puzzle in actual hardware, I abandoned my first virtual reconstruction (the clockwork would have proved a daunting task) and

Fig. 3.42.
Second generation
reconstruction

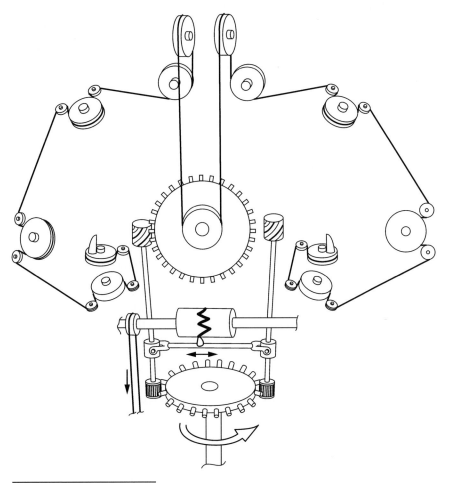

[26] BBC, Leonardo: program two, Dangerous Liaisons, airdate April 18, 2003.

began with my own, more comprehensive design, only to see it evolve toward Leonardo's as I strove towards a working full scale model. For economy, I chose a stock reproduction suit of armor purchased in advance and shipped to me for experimentation from England. The frame or skeleton design came from Madrid MS/Borelli and the upper body's ladder-like frame from Leonardo's many ornithroptor designs. Leonardo may have fabricated a custom suit of armor where he could have integrated pivots directly into the suit. The new BBC model would be fully functional, complete with cables and pulleys. Then, cringing at the thought of all the fees I would get from the airline for exceeding my weight allotment, I loaded nine cases, tool boxes, and a suitcase and boarded a jet to London. Still my design was not reconciled to Leonardo's drawings, although I have added more suspected drawings from the Codex Arundel, which at the time provided no further enlightenment.[27]

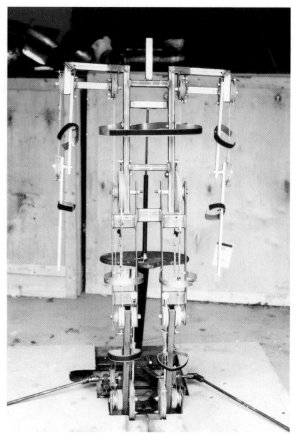

When I arrived, work began almost immediately with the help of a special effects expert Jamie Jackson-Moore who had recently built cars for the latest James Bond film. To meet the specification of the low ceiling in the grotto, I designed a base only four inches high. Housed in the base was a scissors-type car jack not unlike one Leonardo designed for his ornithroptor studies. The pulleys were originally fiberboard, but these broke and were replaced with harder beech wood. In my design the arms were to be driven independently by two separate cables that ran alongside the body, with idlers at the ankle, knee, hip and then up to the shoulders. They would terminate in pulleys driven by outboard driveshafts (Fig. 3.43). Not exactly Leonardo, but it was in his spirit, and it would guarantee a working model.

Fig. 3.43. Robot Knight reconstruction for BBC

The mad rush to finish this took us into the late hours of the night, with reinforcements of additional technicians needed to complete the overwhelming amount of detail. One vexing problem was the cables, which had to be terminated to the various parts of the frame (Fig. 3.44). Not only was the crimping tool needed to attach the cables, which were not working well, but we also ended up with slack in the system. Lots of practice led to reliable crimps at last. Using my wooden model, I determined that in terminating the cable to parts of the frame instead of to the pulleys changed the radius and therefore the mechanics of the system. Adding an additional cable wrap around the pulleys fixed that.

When late night fast food was brought in from Burger King, I amazed the shop foreman with my ability to consume three burgers. A black track suit was pressed into service to fill in the voids backed by foam rubber. At the last minute, on the day of transport to the BBC's grotto, the armorer showed up and completed the skirt and arm details, greatly improving the Knight's appearance. Since the armorer used ancient techniques, we hunted down an anvil in a back room of the shop. Then, as I held the pieces, he riveted them in place.

The grotto was located outside London, at Painshill Park, Surrey, and was a perfect setting for the Knight. Once part of a great estate, the mansion still stands, the grotto under its bridge on a man-made lake. The lake is configured to pass via a tunnel

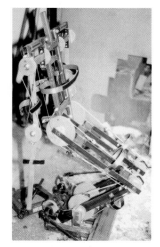

[27] Mark Rosheim, "L' automa programmabile di Leonardo," *XL* Lettura Vinciana 15 aprile 2000, Florence, Giunti. See figs. 41–44

Fig. 3.44. Robot Knight reconstruction for BBC. View from side

Fig. 3.45. Robot Knight reconstruction for BBC. Leg detail

Fig. 3.46. Robot Knight reconstruction for BBC

through the grotto, which has openings on two sides to form a canal through it. The canal is serviced by a parallel subterranean walking path. In order to reach the grotto, we had to take a punt, a traditional flat-bottomed boat. The producer, Oxford educated Tim Dunn, gave me a crash-course in punting with a fifteen foot-long punt pole. When we arrived at the lake, the assistant director George Williams was completing the onerous task of cleaning the punt of leaves and debris. I yelled to him, "What a connoisseur of edgework!" He held up his broom with both hands over his head, brandishing his implement in delight. Once in the punt, it was my job to transport Alan Yintob, the producer, narrator and head of BBC entertainment, by pushing a fifteen foot pole into the muddy bottom of the lake. To make my job trickier, the punt had a leak in its double-bottom construction and was wet and slippery. Thankfully, my nightmares of overturning the boat or knocking Alan into the lake with my punt pole failed to materialize. He even complimented me on my punting and we talked about his friend Orson Welles and why he had such a hard time finding funds for his movies. The answer was simple enough: Welles was hard to work with.

The Knight arrived in a big white panel truck and was set up in the grotto along with a flat-screen monitor perched on a shallow shelf in the cave. The thought of a four-thousand-dollar plasma screen falling and exploding was not pleasant. Then the producer directed me to change into my Cambridge boating costume for punting. My own little idea, it was inspired by my boyhood/adult hero, Patrick McGoohan, in his epic 1960's role as *The Prisoner*. The costume is a funny story. I had the pants already and bought the sweater on a late night shopping trip. However, the jacket had to be requested from BBC stores as we were told that it had to be exactly like the original. When the jacket arrived, we discovered the white piping was too narrow and the buttons were silver, not black. So we ordered one directly from the gift shop in Portmerrion, where *The Prisoner* series was filmed. Expecting perfection, we had a big laugh when it arrived and saw it was exactly the same as the one from BBC stores!

❖

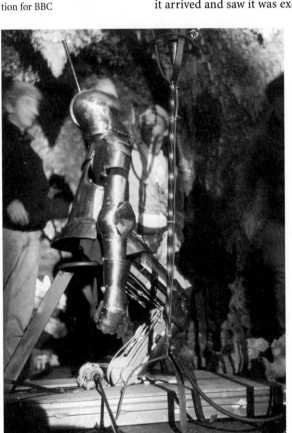

The robot as reconstructed is controlled by three drive shafts protruding from the base (Fig. 3.45 and 3.46). These are manually rotated by cranks, one for each arm, and a single crank for the legs, which move in unison. The arm cranks thread their cables through the ankle, knee, hip and shoulder, terminating in a drive pulley. The shoulder motion is phased together with the elbow via a single cable to double the motion. It was starting to look like Leonardo with the weight of the arms setting the preload of the cables. The ankles, knees, and hips are phased together to produce a scissors-like motion. One of the lessons I learned is that the Robot Knight is heavy: the jack and frame strain to lift the load. This was partly a function of the 4-inch platform, which created a very short lever with which to push with the jack. A very modern automobile air-shock was added to help the lift the Knight. Clearly, this was an area of further research and improvement. Knowing Leonardo, he must have had a simpler and more elegant solution.

One of the interesting things about my reconstruction is that as the design developed, it became closer to what is shown in Leonardo's drawings. For example, in my reconstruction sketch, the arm cable originally looped to form a double. This later became single, as practical experience showed that, just as shown in Leonardo's notes, gravity was more than sufficient to provide a restoring force to the cable.

Fig. 3.48. Codex Arundel 263, f. 42 r.
Detail of pulley system

◀ **Fig. 3.47.**
Codex Arundel 263, f. 42 r

Fig. 3.49. ▶
Codex Arundel 263, f. 42 r.
Detail of pulley system

Fig. 3.50. Codex Arundel 263, f. 42 r.
Multi-cable system

Because of the incomplete and fragmentary nature of Leonardo's sketches, it was impossible for me at that time to tell with absolute certainty what Leonardo intended. It is clear that it was cable driven, but the complete drive train is unclear, as is the question of whether it had a controller similar to that of the Robot Lion.

Only recently have I found the solution to the mysterious cable drawings in the *Codex Atlanticus* and more recently in *Codex Arundel*. Ironically, it would not be in Florence or London, but in my local St. Paul gym, while using the Cybex lateral pull-down machine, that I at last understood the upper body mechanics of Leonardo's Robot Knight. For when I looked at the cable system, I couldn't help but get the feeling I had seen it before (Fig. 3.22). There they were in the gym: the pair of flanking pulleys with the central pulley not rotated but *pulled* by a shackle connected to another vertical cable. It thus has dual function as an idler and as a drive pulley. As I pulled the two arm-like bars down, the central pulley went up, lifting the weights. So conversely, when the arms went up, so did the pulley. The arms could move independently for maximum flexibility. Eureka! I had it at last.

The central pulley shackle is what Leonardo didn't bother to draw in the bottom of CA, 216 v-b [579 r] (Fig. 3.22), and that is why it is so difficult to understand his intentions. One thinks of pulleys as something one rotates, but here it is suspended, free to be pulled down. In Codex Arundel 263 f. 42 r (Fig. 3.47) you can see Leonardo building his theoretical model. The upper portion of the page starts with several drawings of the upper body cable system. Below that, Leonardo builds his case from

left to right, starting with a simple pulley with a weight (Fig. 3.48). Next comes the basic system, with the center pulley being pulled by a cable and the two weights representing the arms. To the right of that is a drawing with two weights over pulleys that have no center pulley. Below, a similar series of drawings are shown below from right to left (Fig. 3.49). At the bottom are studies of weights being pulled by single and double pulleys. At the top right of Fig. 3.50 is a weight pulling nine lettered cables

Fig. 3.51.
CA, f. 330 r-a [903 r]

that are perhaps connected to the multi-pulley device at the center left. Similar drawings are shown in CA, 330 r-a [903 r] (Fig. 3.51) and CA, f. 330 r-b [904 r] (Fig. 3.52). and CA, f. 134 r-b [369 r] (Fig. 3.53).

The reoccurrence of the multiple pulleys arranged in a ring and cables indicates that there might have been an even more complex cabling system planned. What function this may have is still unclear.

Fig. 3.52.
CA, f. 330 r-b [904 r]

Operation

Fig. 3.53. CA, f. 134 r-b [369 r]

The operation of Leonardo's Knight is a model of simplicity and elegance, solving several design performance problems with a simple cable system (Figs. 3.54 to 3.56).

A central cable pulls or releases the center pulley, which passes over the flanking idler pulleys. These idler pulleys could be used to operate the Knight's visor by simply adding some additional pulleys to the visor pivots. The cable then extends down to the pair of facing idler pulleys and then over the shoulder, elbow and wrist pulleys. The shoulder pulley shaft must be connected to the upper arm. The lower arm mimics the upper arm when the arm cable is pulled taut. One interesting performance characteristic of this cable system is its differential motion. For example, if one arm is pulled down, the central pulley will move up, compensating for the motion without disturbing the opposite arm (Figs. 3.56). When the central cable is pulled, it lifts and separates the arms, and when it is released gravity provides the load to lower them.

Another benefit of the single central cable design is that it simplifies the routing of the cable through or adjacent to the legs. Assuming that the arms are only operating when the Knight is standing, the cable could simply hang down behind the legs. It could be threaded through one of the legs, as I did in the BBC Knight, but I now feel it simply ran vertically down to the floor, either passing through the floor or via a pulley horizontal with the floor.

The center of CA, 216 v-b [579 r] (Fig. 3.57) offers an alternative cable system design which I only recently determined is for whole arm grasp when the two indepen-

Fig. 3.54.
Robot Knight cable system
arms together

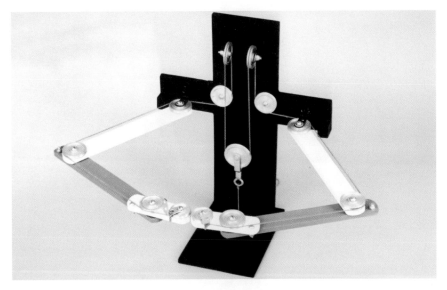

Fig. 3.55.
Robot Knight cable system
arms apart

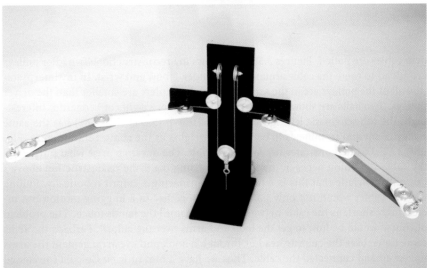

Fig. 3.56.
Robot Knight cable system
differential motion of arms

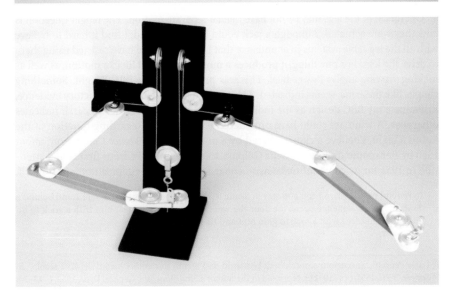

Fig. 3.57.
CA, 216 v-b [579 r].
Alternative cable system

dent cables are pulled. Figures 3.58–3.60 shows my reconstruction. Two idler pulleys are added to route the cable around the shoulder, elbow and wrist. In my interpretation all of the pulleys are in the same plane and the idlers are smaller than the driver pulleys. Two balls are shown representing the counterweights of Leonardo. Interestingly, the top schematic left figure of CA, f. 216 v-b [579 r] (Fig. 3.61) has the same pulley count and terminates in ball counterweights as the above central figure. Figures 3.62–3.64 demonstrates my reconstruction. The question arise what purpose is the cable stretching between the two arms? Using the same reconstruction above I can only conclude that this is a method for ensnaring a culprit robotically. Pulling the two cables would not only pull the arms together in a hugging motion but increasingly shortens the cable between the hands until the hands touch. The problem of course would be how to get the loop and arms over the culprit. Perhaps the arms came down over the culprits head or through a hook and eye arrangement the arms linked up and connected the cable. Thus we have a hint of what Golpaja (discussed below) may have been inspired by.

Operation of the legs may or not have been a separate motion. The bigger question is how they were actuated. Although a jack could have been used, I find it hard to believe with all the leg cable systems in abundance that Leonardo could have resisted using them to drive the legs. For one thing, it produces a more natural and lifelike motion, as well as making viewing angles less critical. This was proven with the BBC Knight. Something simple, like the arms, seems indicated. Therefore, for lack of any contradictory evidence, I nominate my BBC design as the most likely candidate until further research indicates otherwise. A windlass could have provided the drive force. Regarding function of the Robot Knight, I believe a clue is offered by a notation in the *Venice Codex* from about 1520 by Benvenuto di Lorenzo della Golpaja, to which Carlo Pedretti first called attention in 1951 for its copies of unknown Leonardo inventions. Golpaja notes to himself:

> To remind myself when I come to stay in Rome to make a wooden man who will stand behind a door, and when someone opens the door the wooden man goes to meet him with a stick to hit him on the head, or with a rope to grab him and tie him.[28]

[28] Carlo Pedretti, "Invenzioni sconsciute di Leonardo da Vinci in due codici inediti del XVI secolo," in *Sapere, XVII*, 1951, pp. 210–213, reprinted in the author's *Studi Vinciani*, Geneva, Droz, 1957, p. 23–33.

Fig. 3.58.
Alternative cable system
reconstruction arms apart

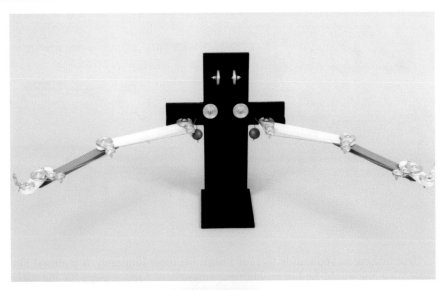

Fig. 3.59.
Alternative cable system
reconstruction arms together

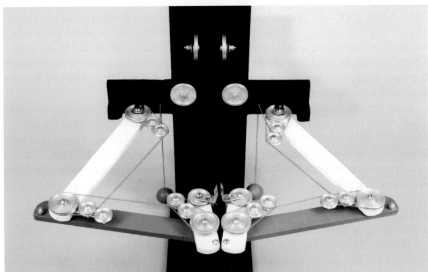

Fig. 3.60.
Independent motion of arms

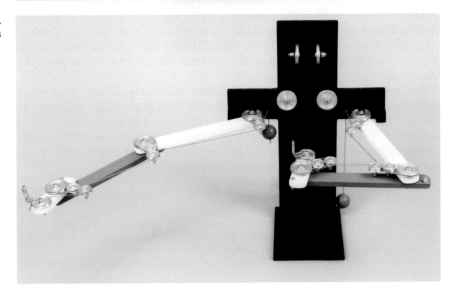

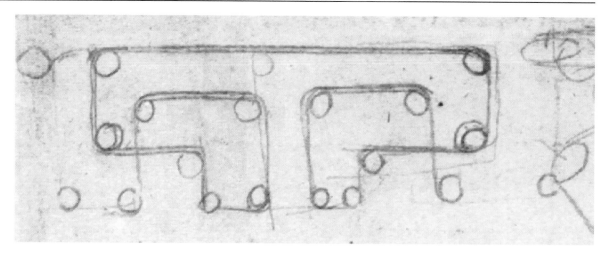

Fig. 3.61. CA, f. 216 v-b [579 r]. Second alternative cable system

Here we have an application that the Knight fits most admirably. It is almost like something one would find in an old time amusement park, a piece for the scary haunted mansion or tunnel of love—or a labyrinth, which was the 16th century equivalent. The Knight would be excellent at grabbing someone with its arms in a bear hug. The differential motion would automatically compensate for one of the arms being out of place. In the simple cable version it is not particularly dangerous, to escape the Knight's grip, one would simply have to overcome the weight of the arms. Perhaps the visor would rise, revealing a hideously contorted, sculpted face. And like the cart it would be controlled remotely via one or more cables.

However, one thing can be said with certainty about the lost drawing(s) as works of art—they must have been beautiful beyond compare and perhaps were the centerpiece of Madrid MS I. Someday the missing drawings may surface. They could have been stolen at any time, perhaps by Borelli himself, or even in recent times. They could have been separated and rebound in a separate book now hidden in some cavernous and clandestine library where at this very moment it is being gazed upon by some unknown collector. It could well be the book we know as Madrid MS I was mutilated by unknown hands, or that Leonardo himself rearranged the sheets, for he mentions on a sheet of anatomical studies from around 1508–1510 at Windsor, RL 19009 r: "Arrange it so that the book on the elements of mechanics with its practice shall precede the demonstration of movements and force of man and other animals, and by means of these you will be able to prove all your propositions."

Leonardo's Robot outwardly appears as a typical German-Italian suit of armor of the late fifteenth century. Built into its chest is an elegantly simple differential pulley/cable drive system. The cables exit the robot from the back or base. Power for the robot to move its arms and stand or sit came from manual operation or perhaps a waterwheel.[29]

Perhaps the great mystery surrounding this lost robot of Leonardo can be summed up by the master himself in the giant scrapbook known as the *Codex Atlanticus*. In the sheets for this project, we read an incomplete sentence with which Leonardo tried out his pen: "Tell me if ever, tell me if ever anything was built in Rome ..."[30] Leonardo may be expressing his frustration and anxiety about a project near and dear to his heart that because of external pressures could not be born.

[29] This seems to be implied by the sketches in Paris MS L, f. 28 v, and CA, f. 164 r-a [444 r], though the context shows that Leonardo is analyzing the mechanical problem of pulling a weight uphill. Cf. Reti, op. cit. (as in note 12 above), p. 82–83, fig. 15.

[30] Cf. Richter *Commentary*, note to §1360, where all such sentences are reported, though never again with a reference to Rome.

Fig. 3.62.
Second alternative cable system
reconstruction arms apart

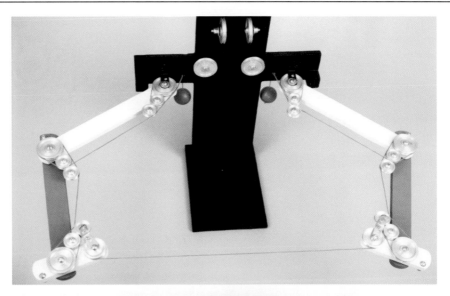

Fig. 3.63.
Second alternative cable system
reconstruction arms together

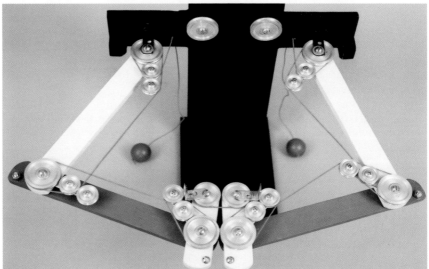

Fig. 3.64.
Differential motion of arms

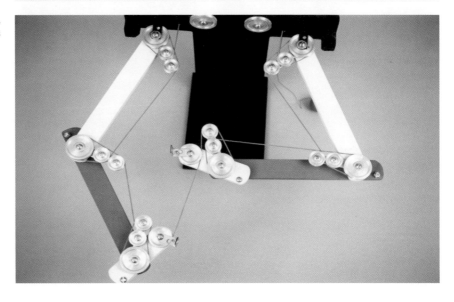

Leonardo's Bell Ringer

Duke of Buckingham: Why let it strike?
Richard III: Because that, like a Jack, thou keep'st the stroke Betwixt
thy begging and my mediation.

Shakespeare. *King Richard the Third*, act IV, scene II, 116–118

Leonardo's Bell Ringing Jacquemart (c. 1510) represents the last and most highly developed of his automata. In what follows, we see how Leonardo's project to design a hydraulic clock that rang the hours relates to earlier renditions of hydraulic devices, fountains and water clocks.

Ancient Models

Leonardo's major source of information about hydraulic devices in antiquity would certainly have been Heron of Alexandria of the first century, an author made known by the humanists, and whose *Book of Pneumatics* greatly appealed to him, particularly for the so-called Heron Fountain. The latter was first described by Alberti, illustrated by Andrea del Verrocchio, and applied many times by Leonardo in his hydraulic devices, such as in the beautiful table fountains at Windsor (Fig. 4.1). Heron's *Book of Automata*, best known in Bernardino Baldi's 1589 edition, includes a number of theatrical devices as well.

There is another great hydraulic achievement of antiquity that must have appealed to Leonardo. This is the Tower of the Winds, located in the Agora in the center of Athens (Fig. 4.2). Constructed by Andronicus Kyrrhestes of Macedonia during the Roman period in the second quarter of the first century B.C., it was one of the few structures from antiquity to have survived intact. Built of marble and octagonal in shape, it is 43 feet (13 m) tall. It was a marvel of antiquity, boasting complex sundials on top; a frieze on each of its eight sides; and according to one ancient account, a weathercock at its pinnacle in the form of Triton, son of the sea god Poseidon; clepsydra; a planetarium and possibly automata. Leonardo was certainly acquainted with the Tower of the Winds through Vitruvius and other sources[1]. In the middle 1960s, Derek De Solla Price reconstructed the clepsydra under a grant from *National Geographic* magazine[2]. It represents the state-of-the-art of ancient water clock technology, or "horologion"—an "hour indicator." The following description of the clock is based on Price's reconstruction.

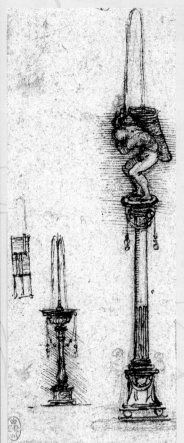

Fig. 4.1. Table fountains, Windsor, RL 12690

[1] Derek De Solla Price, *Gears from the Greeks: The Antikythera Mechanism. A Calendar Computer from ca. 80 B.C.*, New York, Science History Publications, 1975, pp. 51–62. As Price relates: "The Tower of Winds, located in the Roman Agora in the heart of Athens, was built by Andronicus Kyrrhestes of Macedonia about the second quarter of the first century B.C. It was a monument designed in accord with the science of the day with an especially complicated sundial on each face of its octagonal tower, a wind vane and a frieze of the gods of the prevailing wind above that, and a whole series of marvelous astronomical and probably other showpieces inside. It was a sort of Zeiss planetarium of the classical world".

[2] Derek De Solla Price, Athens' Tower of the Winds. *National Geographic*, CXXXI, no. 4, April 1967, pp. 586–596.

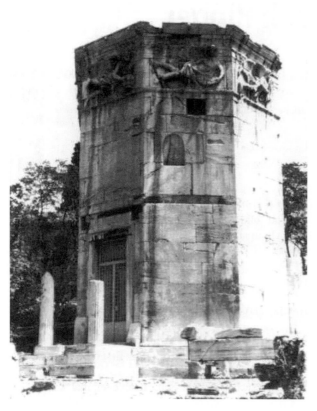

Fig. 4.2. Tower of the Winds

Fig. 4.3. Tower of the Winds mechanism

The Tower of Winds Water Clock was designed along the lines of Ctesibus about the middle of the third century. It appears to be the first to introduce a float into an inflow vessel. In Ctesibus' design, an indicator rod is carried by the float which shows the time by its position above the vase. A large tank (Fig. 4.3) is fed constantly by an outside pipe from a brackish spring located high on the Acropolis.[3] The lower pipe pours a constant stream of water that slowly raises the float in the smaller container. When fully raised, the float releases a chain, which is wrapped around a pulley and terminates in a counterweight. Gradual descent of the counterweight rotates the clock disc. The clock disc, Price speculates, was made of bronze and depicted "a model of the universe moving in harmony with reality. Among Andromeda, Perseus, and the figures of the zodiac, a golden sun, pegged into the proper hole for the time of year, moved behind a wire grid which indicated the hours of day and night and the lines of the horizon and meridian". The wire grid, perhaps held by Atlas or Hercules, is accented by three fountains fed by the middle overflow vertical pipe running along the same channel as the chain.

Every two days, the attendant would reset the sun peg into its new location. No doubt the same attendant would reset the clock every 24 hours by emptying the small tank via a square opening in the floor, starting afresh the clockwork universe. Thus started, the bronze clock disc rotates clockwise, as have all of our clocks for over 2 000 years.

[3] Derek De Solla Price, op. cit. in note 2 above, p. 591.

Fig. 4.4.
Arab water clock

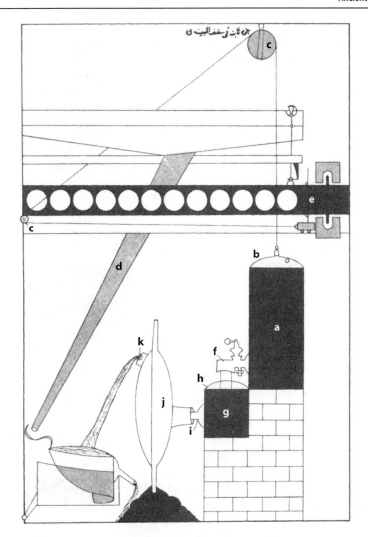

The Hellenistic tradition of water clocks and automata was preserved after the fall of the Roman Empire by the Arabs (Fig. 4.4). An entire book of these devices was written by al-Jazarī in the thirteenth century, whose *Book of Knowledge of Ingenious Mechanical Devices* illustrates and describes several clocks with automata, some of extreme complexity, utilizing the same siphons, floats, valves and reservoirs that Leonardo would later use.[4] In one mechanism, a reservoir tank is filled with water *(a)*. A float *(b)* suspended by a cable over pulley *(c)* slowly sinks as the water flows out of the reservoir. The cable slides the pointer *(d)* across the 12 holes indicating the hour. The water pours out of valve *(f)* filling a smaller container *(g)*. In it a second float *(h)* has a ground stopper which automatically turns off the tap above it when the smaller container is full. When the float sinks, the valve is re-opened. Therefore, the water in *(g)* flows under constant pressure via pipe *(i)* located near the base of *(g)* into the circular shaped container *(j)*. The water exits through an overflow port *(k)*, which should be at the same level as *(g)* at its highest position (it is illustrated incorrectly). By rotating the vessel *(j)* along the axis of pipe *(i)*, the rate of outflow could be varied and thus the length of the hours.

[4] Donald R. Hill, *The Book of Knowledge of Ingenious Mechanical Devices by Ibn al-Razzaz al-Jazari*, Boston, D. Reidel Publishing Company, 1974, pp. 42–50.

Chinese influences may have played a part in the technological development of Arab fountains. Su Sung (1020–1101) was a Renaissance man hundreds of years before the European Renaissance. Astronomer, mathematician, diplomat, and naturalist, he produced a classic *Pen Tshao Thu Ching* (*Illustrated Pharmacopeia*) on pharmaceutical botany, zoology and mineralogy. A consummate civil servant who mastered the available technical knowledge and applied it to the benefit of the state, Su Sung wrote another classic, *Hsin I Hsiang Fa Yao,* or *Horological Engineering.* His astronomical clock tower (Fig. 4.5) was not created by trial and error but was the product of careful written technical proposals followed by small wooden models and then a full-scale one against four types of clepsydra. Only after four years of trials was the casting completed. This explains why the complex drivetrain worked and was able to rotate the armillary sphere of some 10–20 tons and a bronze celestial globe 4.5 feet in diameter.

Fig. 4.5. The Su-Sung astronomical clock tower built c. A.D. 1090

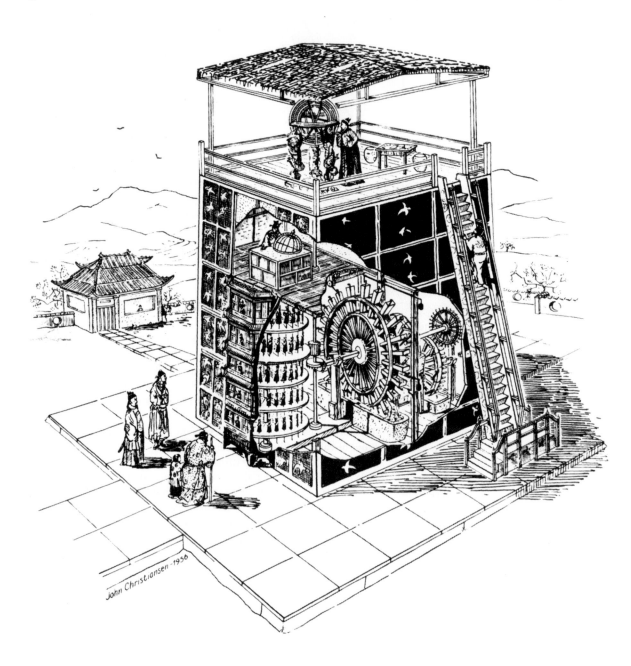

Fig. 4.6.
Fountain at Rimini

The 11-foot diameter great water wheel was driven by water from a constantly fed tub that supplies water to the paddle wheel buckets. The buckets are of particular interest as they were articulated in such a way as to form the first escapement mechanism—hundreds of years before escapements were reinvented in the West—with an accuracy not obtained again until end of the sixteenth century.[5] As Needham states in his classic *Science and Civilisation in China*, "Its peculiar interest lies in the fact that it constitutes an intermediate stage or 'missing link' between the time-measuring properties of liquid flow and those of mechanical oscillation".

A bronze armillary sphere was located on the roof, and the celestial globe was recessed in a cabinet on the floor directly below, creating an artificial horizon. They were also powered by the waterwheel via gearing. Automata, rotating on a five-level turntable, appeared in openings of the pagoda-like façade and performed by striking bells, gongs, or perhaps even drums announcing the night watches and their divisions. The turntables were six to eight feet in diameter, suggesting the jacks, which were clothed in different colors, were quite large.

A major source of inspiration for Leonardo was the Pigna Fountain (Figs. 4.6–4.8) at Rimini, on the northeastern coast of Italy. Leonardo fell in love with the harmony of the waterspouts radiating out of its diameter when he passed through Rimini's medieval Piazza Cavour in 1502. He even wrote a note to himself about it: "let a harmony be made with different falls of water, as you saw at the fountain of Rimini on August 8, 1502".[6] During the reign of Paul III (1534–1549), it was crowned with a statue of the prelate's likeness, but this was replaced in the nineteenth century by the "Pignà" (pine cone) that gives the fountain its present name. Of ancient Roman origin, the fountain was originally fed by aqueduct. In 1543 it was damaged by fireworks set off in the tub to celebrate the high prelate whose likeness it bore. Giovanni Carrari from Bergamo restored it, forming its present shape while still reflecting the original, ancient plan. Recently restored,[7] it appears to have inspired Leonardo's project for a building-size water clock or clepsydra powering a bell-ringing Jaquemart.

[5] Joseph Needham, Science and Civilization in China, vol. IV: 2, London, Cambridge University Press, 1965, pp. 435–481.

[6] MS L, f. 78 r, Richter, §1048.

[7] Carlo Pedretti, "Rimini. Una fontana per Leonardo", introductory text to the exhibition catalogue *Leonardo. Machiavelli. Cesare Borgia. Arte storia e scienza in Romagna, 1500–1503*, (Rimini, Castel Sismondo, 1 March–15 June 2003), Rome, De Luca Editori d' Arte, 2003, pp. 11–21.

Fig. 4.7.
Fountain at Rimini
side view section

Fig. 4.8. Fountain at Rimini top
view section

Leonardo's design antedates automata that would appear in grottoes in the late sixteenth and early seventeenth centuries, and may have been their inspiration.[8] The celebrated park of Pratolino near Florence, full of such technological wonders dating from the 1570s and much admired by visitors and technicians from all over Europe, has been shown as a possible example of Leonardo's ideas first applied to garden architecture. His projects for the suburban villa of the French governor of Milan, Charles d' Amboise, included a mechanical bird for a theatrical performance.[9] The fashion of garden technology and water displays was soon to spread all over Italy, particularly to Rome, as if to recreate the wonders of classical antiquity. Such amusing water displays can still be seen all over Europe.

Leonardo's bell-ringing Jaquemart appears on several sheets of the *Codex Atlanticus* and in the *Windsor collection*, dating from about 1508–1510, the time of Leonardo's activity as an

[8] Michelangelo Buonarroti the Younger, *Descizione delle felicissime nozze della Cristianissima Maesta' di Madama Maria de' Medici Regina di Francia e di Navarra*, Florence, Giorgio Marescotti, 1600, p. 10, describes a mechanical lion produced at a banquet and acknowledges the Leonardo antecedent. Cf. Pedretti, *Leonardo architetto*, Milan 1978 (English edition, London 1986, and NY 1991), pp. 319–322, figs. 506 and 507. For an overview of late sixteenth-century robotic devices applied to a natural setting, see the special research conducted by Professor Marcello Fagiolo of the University of Rome, *Natura e artificio. L'ordine rustico, le fontane, gli automi nella cultura del Manierismo europeo*, Rome, Officina Edizioni, 1979, particularly for the second part on pp. 137–258 on 'Il giardino: la grotta, l'acqua, gli automi'.

[9] The play staged might have been Politianus' *Orpheus* or an adaptation of it. Cf. Pedretti, *Leonardo architetto*, Milan, 1978 (English edition, London, 1986, and New York, 1991), pp. 293–295. See also Richter *Commentary*, note to §678.

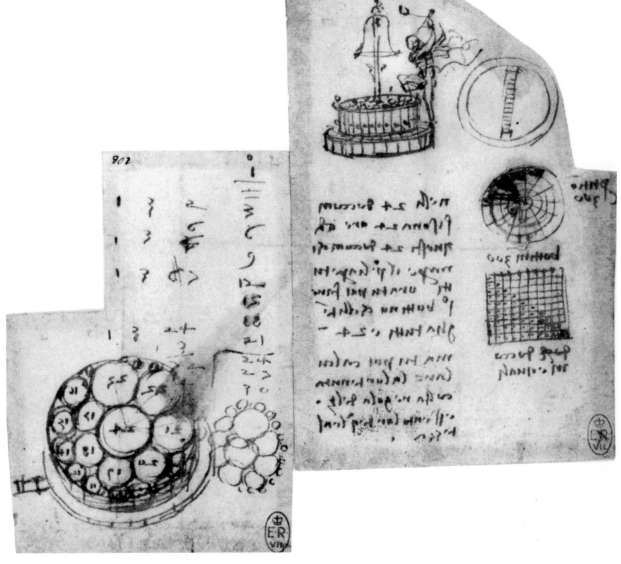

Fig. 4.9. Jaquemart from Windsor, RL 12716 and 12688

architect in the service of Charles d'Amboise in Milan. Shown in Windsor, RL 12716 and 12688[10] (Fig. 4.9), the Jaquemart is an example of a robotic device for telling time, ringing every hour on the hour and striking the bell with the corresponding number of hours. One version may have been designed to fit within its own custom building. If constructed on such a large scale, it would be similar to the great clock tower in the Piazza San Marco, in Venice, where two giant, roof-mounted human figures have been striking the single bell with mallets hour by hour since 1497 (Fig. 4.10). During the writing of Madrid MS II, f. 55 r, in 1503–1504, Leonardo describes a water organ "with many concords and voices" and his plan to make it portable as well. Both of the above influences would form the foundation of Leonardo's Jaquemart, or Bell Ringer.

[10] In addition to a fragmentary sheet at Windsor reconstructed by Carlo Pedretti with fragments 12716 and 12688, the bell ringer project has survived in several sheets scattered throughout the *Codex Atlanticus*, e.g. f. 65 v [20 v-b], which in turn is the parent sheet of Windsor fragments 12480 and 12718 r. Cf. *Leonardo da Vinci, Fragments at Windsor Castle from the Codex Atlanticus*, Carlo Pedretti (ed.) London, Phaidon, 1957, pp. 38, 41, and pl. 2. See also my paper "Leonardo's Lost Robot", in *Achademia Leonardi Vinci, XI*, 1996, pp. 99–110, in particular p. 100 and fig. 2.

Fig. 4.10.
Clock tower in the Piazza San
Marco, Venice

In the mid-fifteenth century Florence Leonardo's teacher Andrea del Verrocchio constructed what must have been an early inspiration to his talented pupil. The story is related by Vasari (III. 375):

> It is also by him the *putto* for the clock of the New Market place [in Florence], a figure with articulated arms, so that, by raising them, it strikes the hours with a hammer—a device that was then much admired as a beautiful and whimsical thing).[11]

In February 2003 I began to reconstruct Leonardo's Bell Ringer by gathering up the material that scholars-historians rather than engineers have attempted to identify as possibly related to it. And so I went back into Leonardo's notes for unidentified material. With the surviving operational descriptions, I worked out how I would solve the problem myself. This I call the "top-down approach". My second method is to try to fit the pieces of the puzzle together more or less on their own. This "bottom-up approach" is the way scholars and engineers have traditionally attempted to solve the riddle of Leonardo's notes on projects. The problem with this is the extremely fragmentary nature of the legacy—the gaps are too big to be filled in.

To close the gaps, I apply my "mortar", derived from the "top-down approach". In thinking like Leonardo I'm aided by my engineering, history, and art background, which utilizes sketching in notebooks to solve problems. Having a natural talent for complex, three-dimensional visualization, I also have little formal schooling, so I do not have the typical engineering background of my age with its mathematical theory emphasis and loss of craft practices. This is one way in which my thought processes

[11] Vasari. *Lives of Seventy of the most Eminent Painters, Sculptors and Architects by Giorgio Vasari*, vol. II, p. 255. New York, Charles Scribner's Sons, 1896. Cfr. *Achademia Leonardi Vinci*, X, 1997, pp. 273–274.

are different from those of scholars and engineers. For better or for worse I am a Renaissance man. My own sketching was based on Leonardo's technique so when I work the same problem I produce similar preliminary drawings to his. In short, I am his student. Also, through the study of Leonardo's drawing style, I "weigh" his drawings based on the level of detail in the execution, recurrence, etc. and assign them a value accordingly. I also keep in mind that Leonardo's solutions are simply brilliant, requiring the minimum number of components to get the maximum number of functions, so I try to look for the simplest, most elegant solution, which forces me to abandon complex, "Rube Goldberg" contraptions in favor of straightforward designs.[12] The problems Leonardo was solving, together with the many obstacles to understanding his solutions, means that I am not able to reconstruct his intentions in one attempt; the Robot Knight, for example, required three before I was satisfied with the results. Having the luxury of making models rapidly accelerates the process.

Of course, it is critical that the final reconstruction is just that, a reconstruction of Leonardo's intention, not a Mark Rosheim invention. So throughout the reconstruction process Leonardo's drawings are constantly cross-checked against my progress until full agreement is reached.

The Bell Ringer is unique in that, compared to the other unreconstructed projects by Leonardo, it has a large amount of related text with which to work. Although most of the text would prove to relate to an earlier version of the device, it proved critical in understanding the more advanced version.

Pieces of the Puzzle

I began my hunt for the Bell Ringer by collecting all the drawings related or suspected to be related to the Bell Ringer. Of course I utilized the references as mentioned in my tomes, but I also paged through all twelve elephant folio volumes of the Codex Atlanticus with little more thought to the effort than I would if paging through a paperback book, allowing interesting images to present themselves to my eyes. For the task of reconstruction, I needed to have these images at my fingertips, not easy to do with the Codex Atlanticus, in which the drawings are scattered and also occur on both sides of the pages. In need of a way to view the pieces conveniently, I hit upon the idea of scanning the images from the elephant folios into my scanner. This was awkward—they're not called elephant folios because they're lightweight—so I laid my scanner up-side-down on the relevant pages and scanned them into my computer. The machine protested with a grinding of gears, but once the pages had been scanned, I could zoom in or out, rotate, and print.

At the same time, I started sketching the basic design and daydreamed how I would solve the problem myself. As in the Robot Knight, I had little more to go by than groupings of figures with notes regarding dating. Many of the drawings had been already identified long ago. Even Carlo could offer no help, not even a hint—I was in uncharted territory.

Two pages that have survived started me on my path. Windsor, RL 12688 that Carlo had first shown to have been originally joined to RL 12716 (the Bell Ringer fragment), depicts a large cylinder containing 24 tightly packed containers. These cylinders are labeled 1 through 24 and are arrayed in a convoluted spiral formation

[12] CA, f. 206 v-a [549 v], c. 1497: "When you wish to produce a result by means of an instrument do not allow yourself to complicate it by introducing many subsidiary parts but follow the briefest way possible, and do not act as those do who when they do not know how to express a thing in its own proper vocabulary proceed by a method of circumlocution and with great prolixity and confusion": Quando voi fare uno effetto per istrumento, non ti allungare in confusione di molti membri, ma cerca il più brieve modo; e non fare come quelli che non sapendo dire una cosa per lo suo proprio vocabulo, vanno per via di circuizione e per molte lunghezze confuse".

Fig. 4.11.
Containers arranged in spiral
formation

(Fig. 4.11). The cylinders become progressively larger, with the largest and last, 24, in the center of the figure. Faintly drawn lines radiate out from the center of the figure. A perspective drawing of the lower cylindrical portion forms the base and corresponds to the upper left figure of 12716. What might be a segmented supply or drain pipe protrudes from the base on the left. To the right of the main figure a cruder version is sketched. Above the figures are columns of numbers relating to the "rule of three" which Leonardo used to determine the diameter and capacity of the containers. The rule of three relates to the formula for the volume of a container: $V = \pi r^2 h$.

In Windsor, RL 12716, the upper figure, drawn in perspective, shows the entire system comprising a bell on a post attached to a stepped cylindrical base. The base is proportioned similarly to the fountain at Rimini and includes what might be radiating water spouts, represented by small circles around the diameter of the upper cylinder. However, if this were the case, there would be approximately twice the number of spouts as the Rimini fountain. The circular target like figure (lower right) bears a striking resemblance to the top view of the Rimini fountain and appears to have fourteen radiating lines corresponding to the Rimini supply lines. To the right Leonardo writes "Partitions 300" and below it "Bottini 300." Significantly, a grid like drawing on the bottom is labeled "Bottini all a-like."

A humanoid figure—The Ringer—is climbing the fountain. His right leg is bent to place his foot on the upper level. Like a knight about to make the down-stroke with his sword, the ringer's left arm is wound up over his head. As Carlo Pedretti has noted,[13] the ringer's hammer cannot strike the bell by simple rotation of the base as the hammer and bell are in separate planes.

The text of 12716 reads: "In 24 containers there are the 24 hours, and the one of these 24 containers that opens the first then opens all of them. Now you can make a

[13] Personal communication.

Fig. 4.12.
Windsor, RL 12627 v K/P 4 v.
Section of leg

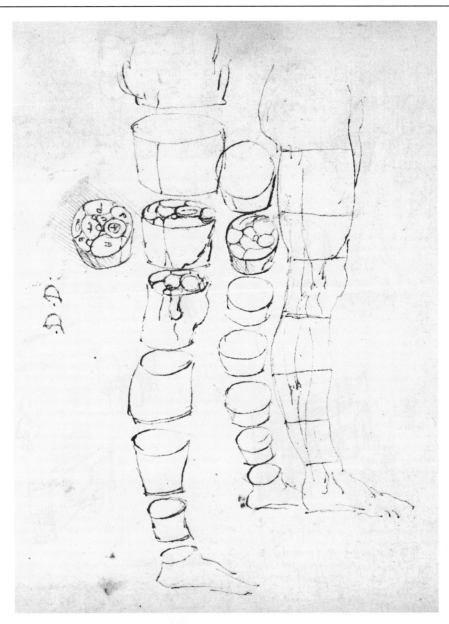

drum-like well ["bottino"] that keeps all the 24 containers". Then Leonardo adds, "but you can calculate their volume by the rule of 3 since they are of equal height". In other words, Leonardo has designed a system with 24 containers, which allows him to pack them in a drum-like well. The 24 containers hold the "24 hours." They all have equal heights, so he can easily calculate their volume by the rule of three. As Leonardo put it, the 24 chambers, each of a different capacity, empty their water in a predetermined sequence. The sequence is initiated by the first container. Compactness is a goal: as in a comparable cross-section view of the muscles of a leg as shown in early anatomical drawings at Windsor, RL 12627 v K/P 4 v (Fig. 4.12).

Other drawings depict the components and provide hints on their operation. Let us begin with f. 20 v-b [65 v] of the Codex Atlanticus as reconstituted by Carlo Pedretti with two Windsor fragments back in 1957 (Fig. 4.13). The upper left figure depicts a perforated bowl-shaped object in the bottom of a cylinder, possibly a strainer. To the right of it are geometrical studies. Several building sketches with float mechanisms appear in the center and below. Similar structures appear under the face and statue

at right. A detailed drawing in the lower center depicts the actuator/valve assembly (Fig. 4.14). Upper and lower floats (Leonardo calls them "*baga*)" are shown mounted on a helical column. A lower float is guided by pair of flanking guide rods mounted to the inside wall of the cylinder. A valve stem with an upper and possibly two side ports are shown with a container sketched above them. The text describes the operation:

> When the 24th hour strikes, then all the containers can come to be filled up, and so through the "spiral siphon" ["cicognola"] they all empty themselves at once and shut those above, which get to be filled up according to the preestablished order.
>
> See to it that the float [the "life saver"] may be so much heavy in descending as it is light in raising. Thus it will have to have one degree of weight in its descent and two of levity in its ascent. One of them resists to the weight and the other is left free in rising.

From this, I could understand the basic operation—the float rises when filling—but what was the upper float, the "spiral siphon", and that diagonal link across the helix? A sequence is described, but what does it mean? Does the "preestablished order" refer to the sequence in which the containers are filled? I focused on what was before me—the mechanism—and turned to the closest similar drawing that might help me to understand it.

◀ Fig. 4.15.
Windsor, RL 12282 v K/P 125 r.
Actuator/valve assembly

Fig. 4.16.
Windsor, RL 12282 v K/P 125 r.
Actuator/valve assembly

In Windsor, RL 12282 v K/P 125 r (Fig. 4.15), several variations are shown of actuator/valve mechanisms. The top figure (Fig. 4.16) shows a multi-port valve with a float release latching mechanism actuated by a small float on top. This is for releasing the "*baga*" or donut shaped float at the base. Below this figure, several drawings show the related linkage release mechanism of CA, f. 20 v-b [65 v] (Fig. 4.17). They are particularly significant because they explain why, for example, there is a diagonal link overlaid on the helix drawings with a pivot in the center. It is as if Leonardo were drawing it in as an afterthought rather than planning for it by showing the figure in section and showing it clearly. That is why you see the diagonal link—a minimal reminder Leonardo makes for himself. Also, if you look very carefully at the same drawing, to the bottom right of the helix you can just see the companion release tip.

It is also interesting that the scissor-like linkage of the "bottini" is very similar to scissor-like linkage used as cam followers for the cart in Chapter II. That linkage is driven by rotating cams to turn the cart's steering wheel. Indeed, this linkage, also used for control, does the same job for the "bottini" transferring motion from the "upper baga" to release the lower "baga" and thus producing valve stem rotation. See page 157 and Fig. 4.51 below for further information.

In the center of Windsor, RL 12282 v K/P 125 r head/neck and a portion of shoulders are shown superimposed on the actuator/valve mechanism (Fig. 4.18). To the right is a human stomach and esophagus (Perhaps Leonardo is drawing an analogy between the "baga" rising up and the action of the esophagus muscles. These sketches may

Fig. 4.17.
Windsor, RL 12282 v K/P 125 r.
Linkage release mechanism

Fig. 4.18.
Windsor, RL 12282 v K/P 125 r.
Head and neck overlaid over
actuator/valve assembly,
stomach and esophagus

Fig. 4.19.
Windsor, RL 12282 v K/P 125 r.
Helix formed by perforated tube

also be clues for the automata perhaps using the same valve/actuator technology. To the right (Fig. 4.19) is a helix formed by a simple perforated tube. Below a drawing of a costume are geometrical studies possibly relating to the helix angle of the screw.

I could now see how the actuator/valves operated. Two floats are slipped over the hollow shaft the lower one engaging the helical groove with two lugs. Both floats are in their lowest positions. The upper container is full and the lower container is empty. The lower float is held in place by the tong release mechanism. Water fills the container to the upper float. The upper float lifts and trips the tong release mechanism releasing the lower float. It rises rapidly through the water rotating the helix and turning the valve above it. This valve releases the water stored in the upper container, simultaneously shutting off the water to the lower container and opening a passage for the water to pass to the next unit. Now that I had the basic operation of the two floats, including the snap action timer function, my attention turned to how they were used as a system for the Bell Ringer hydraulics.

Folio 362 v-a [1011 r] of the Codex Atlanticus (Fig. 4.20) is an important drawing for understanding the operation of the Bell Ringer's hydraulics. The upper group of figures shows a series of valve stems with containers above them (Fig. 4.21). Below these figures the text reads:

The containers of the hours must always have their bottoms lower on the front side and higher on the back, so that the water will always be able to flow away from the containers.
Vases with water: a b c d- good invention.
When the bringer turns himself to give water at the 23 vases, the bringer turns rapidly their 23 keys a b c d, which turns for a quarter of arc [90 degrees], and so it closes them all. Then they open one by one when needed.
Device for automatic opening and closing:
This opens the key while going up and closes the key when it comes back.

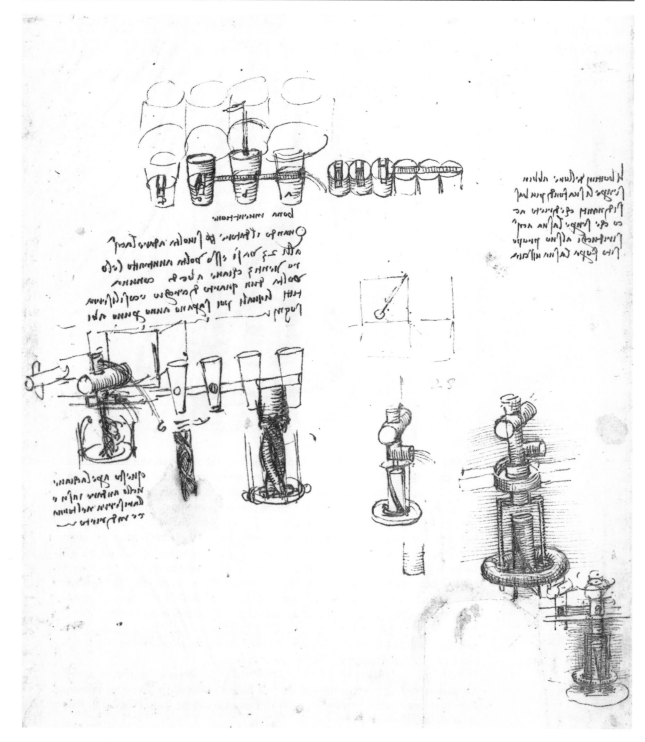

From this we can see the construction of the "container of the hours" and the operation of the "Bringer" and how it functions with the 23 keys, the word Leonardo uses for valve stems. Also, we learn that turning the keys 90 degrees serves to close them. Drawn in the middle of the page and continuing down to the right are what I now see as early versions of the actuator/valve assembly, which automatically stops and starts the flow of water through it and the container above.

Fig. 4.20. CA, 362 v-a [1011 r]. Hydraulics

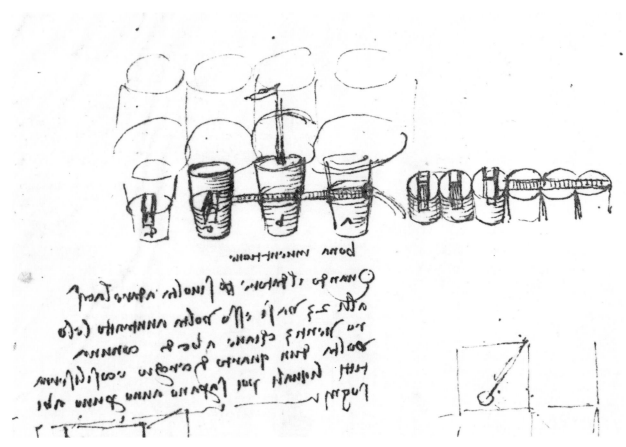

Fig. 4.21. CA, 362 v-a [1011 r]. Valve stems with containers

But what was the "Bringer?" Folio 343 v-a [943 r] of the Codex Atlanticus (Fig. 4.22) shows an array of valves with vertical pipes, additional valves and valve stem arrays. To the right is an illustration of water pouring into a vessel. The "Bringer" is shown in the central, elaborately detailed figure (Fig. 4.23). The right is an overview of the "Bringer": Below, left is the "Bringer's" faucet in multiple positions. The bottom figures are variations on the latching mechanism that restrains the "baga" or donut shaped float. The wildly complex "Bringer's" operation is detailed in the last paragraph of this sheet. Almost a robot in itself, the Bringer's main float is unlatched when water reaches to the level of the upper float. It immediately begins to rise and trips a valve mechanism to its right and then starts rotating. It begins to engage levers on the left, turning the faucet-like spout to various fill points, which are the "Container of the Hours"—the containers that power the alarm bell.

The text is interesting for its construction and operational descriptions. The upper notes relate to wineskins, so it maybe be deduced that this sheet belongs with CA, f. 373 v-b [1042 r] (Fig. 4.32), which shows leather bags rather than actuator/valves as key components. I believe that the "leather version" represents an earlier conception, for the wineskins lack the durability of the final actuator/valve concept and may be a more literal representation of Leonardo's thinking about the mechanism. Indeed, all of the following Leonardo sheets in this section may be linked either to references to leather or to the "Bringer", making them all part of this particular design effort.

Another passage on CA, f. 343 v-a [943 r] gives an interesting construction detail: "These pipes will be made of thin clay and cooked for very long, until they become glass". Operational information is also given: "Vases of the hours. The first opens and then the water of the second, when it opens, move through the first and this way it keeps going". Leonardo then poses the question of how to close them and answers

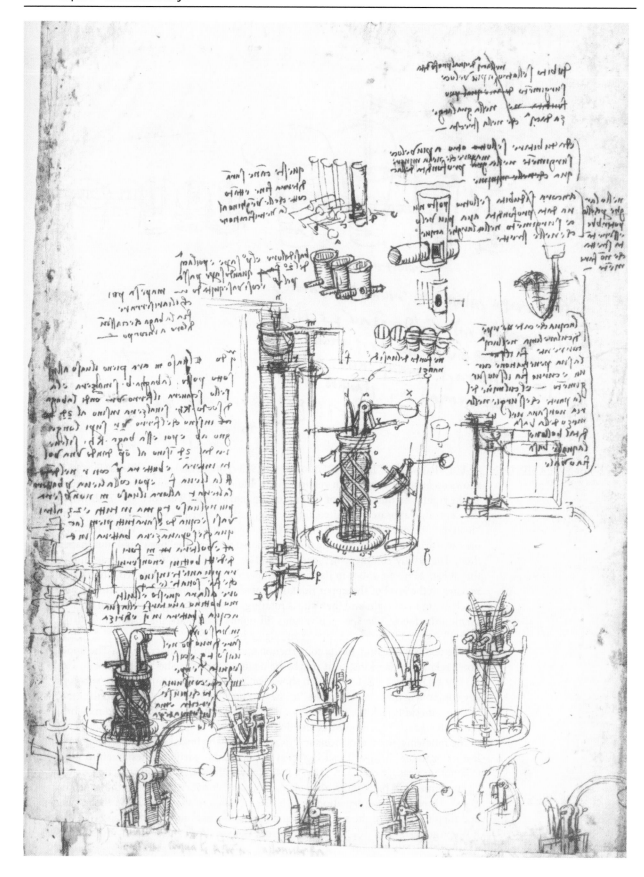

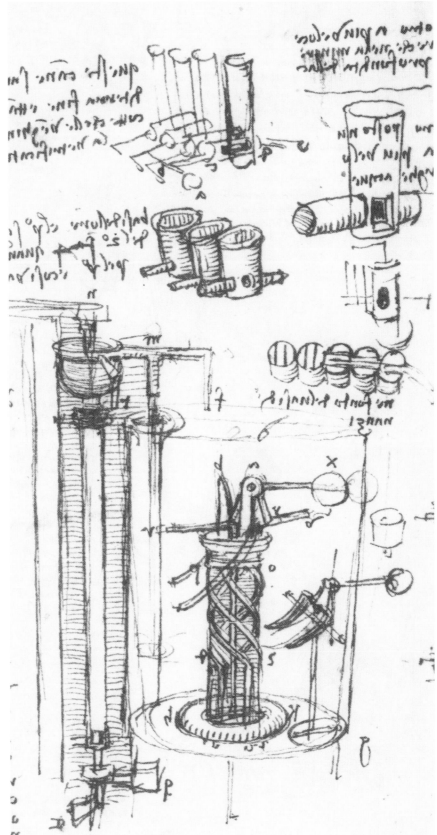

◄ **Fig. 4.22.**
CA, 343 v-a [943 r].
The bringer and accessories

Fig. 4.23.
CA, 343 v-a [943 r].
The bringer and valve array

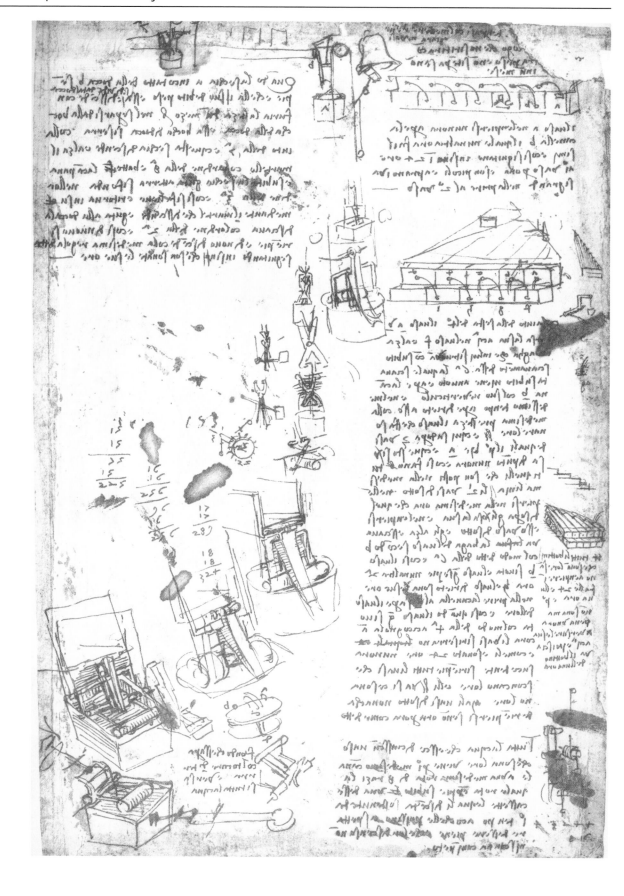

◄ Fig. 4.24.
CA, 343 r-a [941 r].
Alarm clock

himself: "But then think about what it will be that will have to close them. It will be the 'baga' that each of those has inside". On f. 343 r-a [941 r] of the Codex Atlanticus (Fig. 4.24), the top figure shows an actuation scheme for the bell. When the bucket fills, a hammer controlled via the pulley and cable system hits the bell (Fig. 4.25). Lower figures (Fig. 4.26) relate to a container that, when filled with water, raises a

Fig. 4.25.
CA, 343 r-a [941 r].
Bell actuation

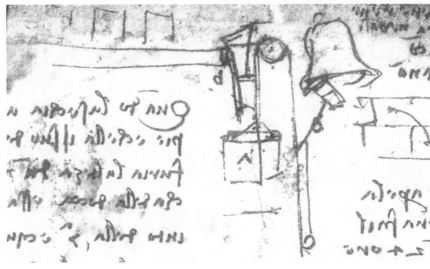

Fig. 4.26.
CA, 343 r-a [941 r].
Float operated door

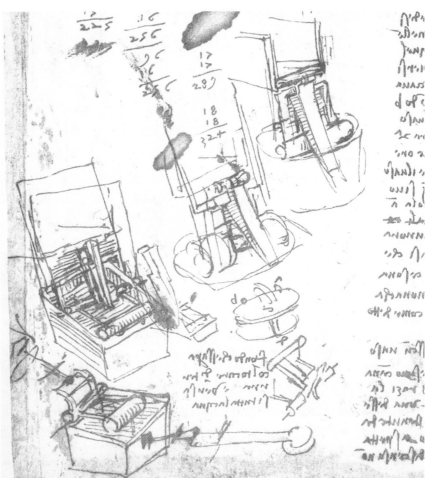

Fig. 4.27.
CA, 343 r-a [941 r].
Cascading water alarm clock

float that lifts open a door—a predecessor of the actuation/valve mechanisms. "Cicognola", a spiral siphon, is mentioned as in CA, f. 20 v-b [65 v].

I looked at the operation information from a distance, unsure whether this was directly related to the Bell Ringer or to an earlier or later project. Various drawings of cascading reservoirs (Fig. 4.27), shown on the upper right of this sheet, are reminiscent of ancient Roman and Chinese clepsydra of the compensating tank type.[14]

Leonardo relates: "The *a* vase, while filling up in one hour, opens the little pipe *b*, which in another hour does the same; and they proceed this way for 24 hours, one

[14] Joseph Needham, *Science and Civilisation in China*, vol. III, London, Cambridge Universtiy Press, 1959, pp. 315–329.

Fig. 4.28. ▶
CA, 288 v-a [782 v].
Studies for alarm clock

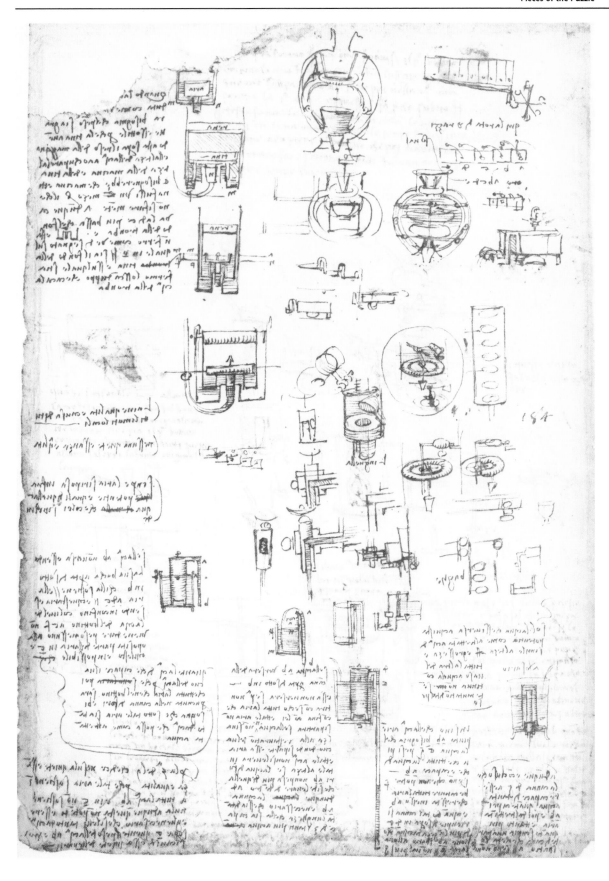

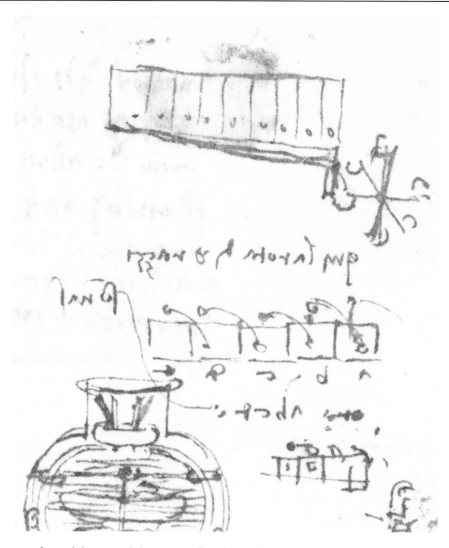

Fig. 4.29.
CA, 288 v-a [782 v].
Paddle wheel with spokes

vase for each hour. And they are small and open the large vases while opening to the second vase". This was helpful because I could see the sequencing described and opening of the valves. And it indicated dumping the contents of the large vase, at the same time opening a passage to the second small vase.

Because the "baga" is mentioned, another interesting passage is:

> With the help of the sixth proposition of the fourth book, the $a\ b$[15] vase pours its water in the f vase and lifts the "baga" that is inside it, with straight away unlocking of such sixth. And this, once unlocked, immediately comes to the surface and opens the b pipe with its "reverticulo"[16] and at the same time with the same speed it opens behind itself the vase that rings the hours.

Clearly, Leonardo is describing a two-part system: the vase with the "baga" and the vase that rings the hours, which is located behind the "baga" vase. The nomenclature and functionality was very similar for both the ringer and its predecessor. What was different obviously was the valve/actuator mechanisms.

[15] Ms. "v": note 3 of the transcriber of the Leonardo's text (Augusto Marinoni) informs that Leonardo writes "v" when 'b' is obviously meant.

[16] Curved pole.

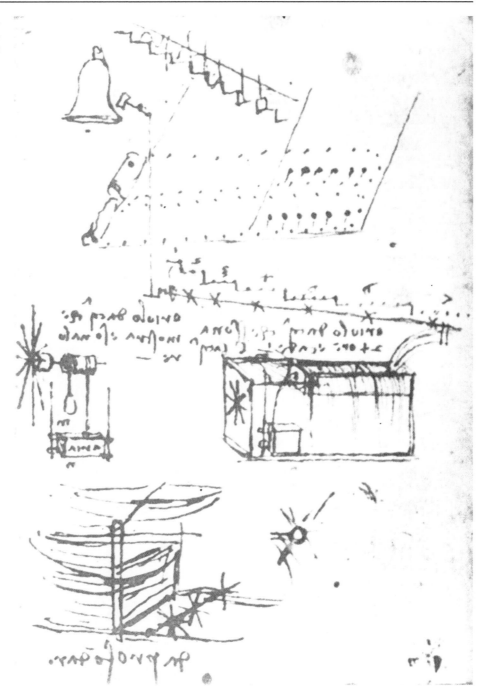

A paddle wheel with "razzi", or spokes, is shown as an actuator for the bell on a number of these sheets perhaps best represented by CA, 288 v-a [782 v] Fig. 4.28 and 4.29.

The small pocket notebook MS L also contains early conceptions of the water clock and it gives evidence that this project occupied Leonardo while even on the move. Folio 23 v of this notebook (Fig. 4.30) states: "Water clock that strikes twenty-four hours and drops one-half braccia of water". And: "Water clock that shows and strikes the hours". This is followed on f. 27 r in the same notebooks (Fig. 4.31): "Water clock. Governing ["temperia", meaning regulation of the "tempo", i.e. clock escapement] of

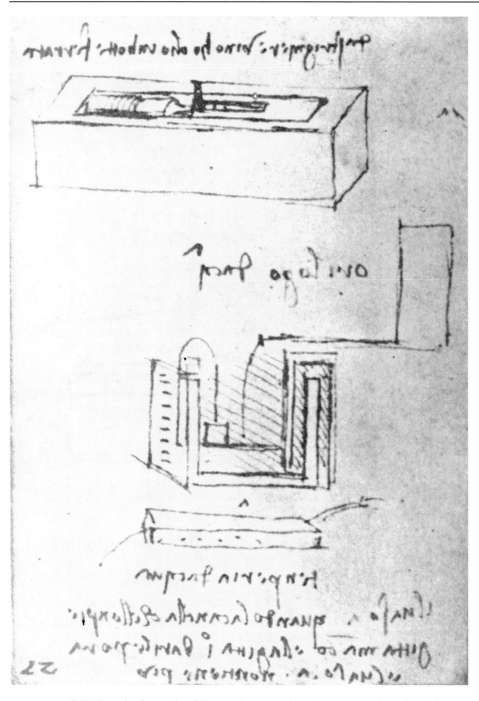

Fig. 4.31.
Paris MS L 27 r.
Studies for water clock

water". "When the faucet that fills vessel a spouts less, it spouts one barrel each hours, and vessel a will hold no more".

Finally, I needed to reconstruct the operation of the hammer hitting the bell. Folio 373 v-b [1042 r] of the Codex Atlanticus (Figs. 4.32 and 4.33) seems to be an early conceptualization of an alarm clock, not the Bell Ringer. The concepts for float actuated valves use leather bags and doors in place of actuator/valve assemblies used in the Bell Ringer. A canal is mentioned that was no doubt the source of water for the clock. The mention of leather bags ties this mechanism to CA, f. 343 v-a [943 r], CA, f. 343 r-a [941 r] and indirectly to CA, f. 288 r-a, v-a [782 r, 782 v] through the "Bringer".

Fig. 4.32. ▶
CA, f. 373 v-b [1042 r].
Studies alarm clock

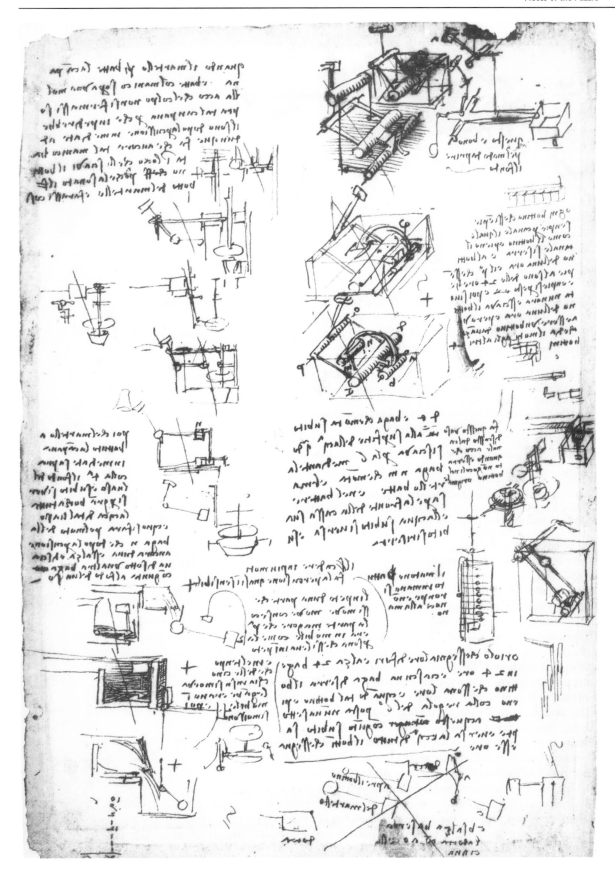

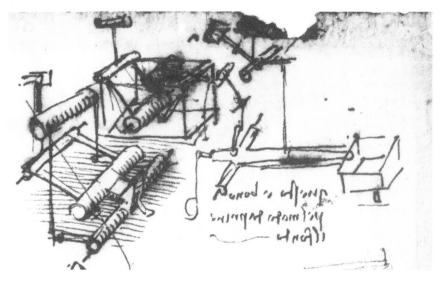

Fig. 4.33.
CA, f. 373 v-b [1042 r].
Float operated door

The latter sheet, CA, f. 288 r-a [782 r] (Fig. 4.34), seems to be a preliminary version of CA, f. 343 v-a [943 r] since it has a similar operational description in its text and therefore may be connected to it and others in the series. The problem of uninterrupted time is dealt with in the first paragraph:

> If the hour 23 has rung, the first "bottino" is to be unlocked and to receive water for 2 hours and have the way out for two hours without ringing one, and then in the second hour it will ring the first hour. And this is done because, as soon as the 24 hour rings, the one hour begins and if in such time one had to start to fill the "bottino" that then has to pour water in order to make the one hour "bottino" strike the hour, and would be interrupted time.

The second paragraph relates to the problem of when 24 (the end of the series) is reached:

> When the hour 24 has rung, then the same water is to evacuate the "bottino" and open the original pipe, that is the source which fills the first "bottino" and when the "bottini" are all full, then the original source of water is to be closed.

The last paragraphs describe the Bringer in more detail. Leonardo relates a plan to prevent interruption of time by starting the first hour after hour 23 has rung. To compensate for the extra hour, he gives the first container the capacity of 2 hours. He also discusses a rotating faucet, allowing it to contain "a jug of water" so that the friction is kept to a minimum. An entire automatic cycle is related.

On the top center of CA, f. 288 v-a [782 v] (Fig. 4.28) are two early versions of the Bell Ringer's bottino assembly in an earthenware vessel (Fig. 4.35). The tong-like linkage, *baga*, and conical float are nested inside. A second version (Fig. 4.36), below and to the right, is more like the final version from CA, f. 20 v-b [65 v] (Fig. 4.14). The valve stopper, which is also a float, is actuated by a "baga" float above it. Various floats and valve combinations are shown as well as a version of the actuator valve assembly in the center. On the right are cascading systems for a water clock that is not the Bell Ringer. This is evident because the upper right corner has a paddle wheel that uses the output of the cascading chambers. The rest of the pages consist of sectional views of valves, siphons, and float valve mechanisms. These sheets connect to the previous drawings in this series through the recto drawings of the "Bringer".

The problem of uninterrupted time is dealt with again in these pages. The complex "Bringer" appears again, with details on the rotating faucet, what it fills, and its interaction with the little barrels and finally the water of the 24 and its flow patterns. Maddeningly complex, the "Bringer" must be an early conception, for its construction, tuning and adjustment would have left little time for Leonardo to do anything else!

Fig. 4.34. ▶
CA, f. 288 r-a [782 r].
Studies for alarm clock

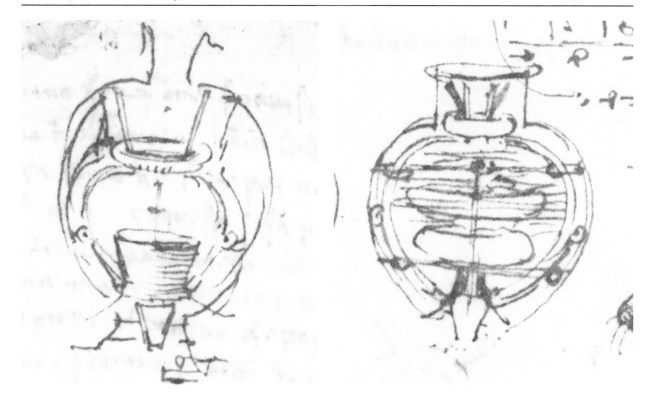

Fig. 4.35. CA, f. 288 v-a [782 v]. Earthenware bottino

Fig. 4.36. CA, f. 288 v-a [782 v]. Earthenware bottino

Reconstruction

Even though the material seems scant, there is a great deal of information present. Beginning with the Windsor drawings, I could see that Leonardo was striving toward compactness and perhaps self-containment. As this was my most complete fragment of the overall system and the only one to depict the automaton, I gave it a high value. I started to see a separate earlier project—the alarm clock—and I used its operational information to glean clues for the more advanced system.

Using my "top-down approach", I set about to see how I would solve the problem, the first order of business being the automaton. Based on my technical knowledge I knew that Jacks had to be simple in order to operate through the high number of cycles demanded of them by a clock. Also, I knew that Leonardo, being Leonardo, might try to one-up the state-of-the-art by doing something more sophisticated.

One possible reconstruction that would fit the surviving sketch is to have the upper body mounted on a skew-axis bearing (Fig. 4.37). The Jack could be powered by a rotating shaft passing through its left leg. The shaft could terminate in a bevel gear, which in turn drives another bevel gear connecting to the upper torso. Thus the ringer starts with the mallet above his head and swings down along the axis to strike the bell. This could be driven by a vessel that would receive and dump the water, causing the gear work to rotate the torso and then return to its original position. The more water, the more times the bell would ring.

Perhaps a small paddle wheel was driven by the measured water being dumped from the containers, as shown in CA, f. 288 v-a [782 v] (Fig. 4.29): the more water, the more turns of the paddle wheel and thus the greater number of strikes by the Ringer. Or perhaps the wheel was driven by the bucket cable system shown in CA, f. 343 r-a [941 r] (Fig. 4.25). I suggest the simple tip bucket arrangement Leonardo shows in the upper left of CA, f. 288 r-a [782 r] (Fig. 4.38) that is found in Japanese gardens. The water fills the bucket until it becomes unbalanced, dumping its water and caus-

Fig. 4.37.
Upper body mounted on a skew
axis bearing

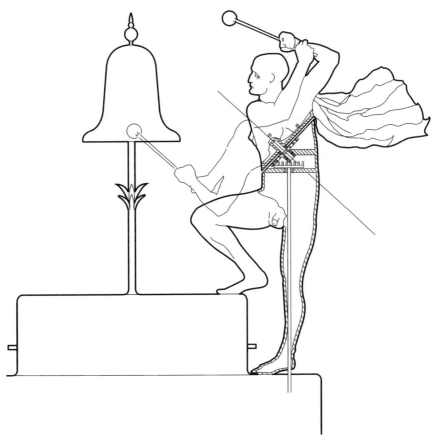

Fig. 4.38.
CA, f. 288 r-a [782 r].
Tip bucket detail

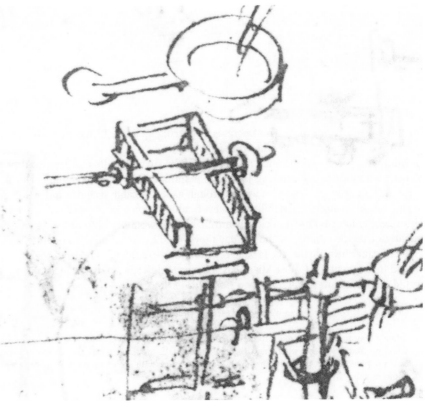

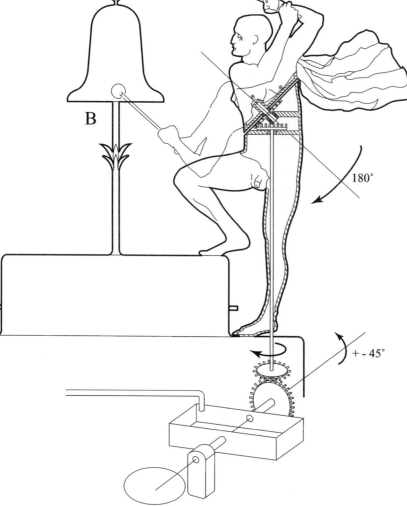

Fig. 4.39.
Bell ringer with tip bucket

ing the ringer to strike once. This operates by gearing up to the Ringer, resetting with every tip of the bucket for another ring (Fig. 4.39).

Another reconstruction which may better fit the surviving illustrations would be to use hydraulic actuation of the Jack with a similar float-type arrangement in its torso that is fed by an "artery" of water through its leg. A cable system similar to that of the Knight is another possibility. However, cable systems (especially with materials of Leonardo's day) are notoriously unreliable and would tend to break down frequently, given the number of times a day they would be called upon to operate.

As I further investigated the Jack, to my mounting excitement I realized that it was spread throughout the Codex Atlanticus. Leonardo describes how the Jack-like man would deliver a blow in CA, f. 352 v-a [975 v] (Fig. 4.40):

Of the Use of Force By a Man Who Would Strike a Great Blow

When a man prepares to make a forceful motion, he bends and twists as much as he can in the direction contrary to that where he wishes the blow to fall, and thus he prepares a force as great as is possible for him, which he then brings together and, with a compound motion, launches upon the thing struck.

Fig. 4.40. ▶
CA, f. 352 v-a [975 v].
Motion study

◀ **Fig. 4.41.**
CA, f. 352 r-b [975 r].
Device to lift water

This is preceded by a fragmentary note on the mechanical principle inherent in the delivering of a blow, thus confirming the suspected reference to the Bell Ringer device:

> Why an impetus is not spent at once [but diminishes] gradually in some one direction? The impetus acquired in the line *a b c d* is spent in the line *d c* but not so completely but that some of its force remains in it and to this force is added the momentum in the line *d c* with the force of the motive power, and it must follow than the impetus multiplied by the blow is greater that the simple impetus produced by the momentum *d e*.

Significantly, on the opposite side of the sheet, CA, f. 352 r-b [975 r] (Fig. 4.41), next to architectural studies for a church, Leonardo shows a device to lift water from a well by means of counterweights and alternating buckets, along with notes on the amount of water lifted per hour. Carlo Pedretti relates these studies to the project for the church of St. Maria alla Fontana in Milan, which was founded by Leonardo's French patron Charles d' Amboise in 1507 on the site of a miraculous spring of water. In his catalog Carlo also notes, "a sketch of a vase, perhaps for a fountain."

An even more exiting discovery was in store as I traced the Bell Ringer through Leonardo's siphon studies. In Windsor 12641 (Fig. 4.42) we can see along side his studies of siphons are several studies for the Bell Ringer. They are depicted in two figures with hammer overhead, and one wound up like a baseball player (Fig. 4.43). Another figure is obscured from an ink smear, but may show a swing similar to that of a baseball player. Of particular interest is the trumpet blower, which may have been an alternative to the Jack ringing the bell (Fig. 4.44). It certainly would have had

Fig. 4.42. Windsor, 12641. Studies for bell ringer

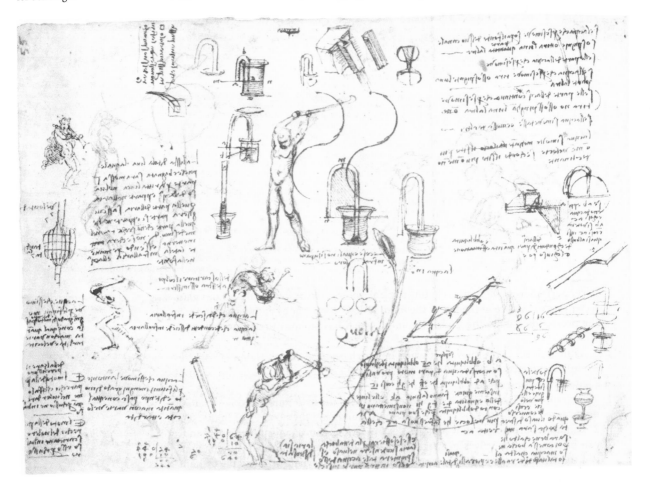

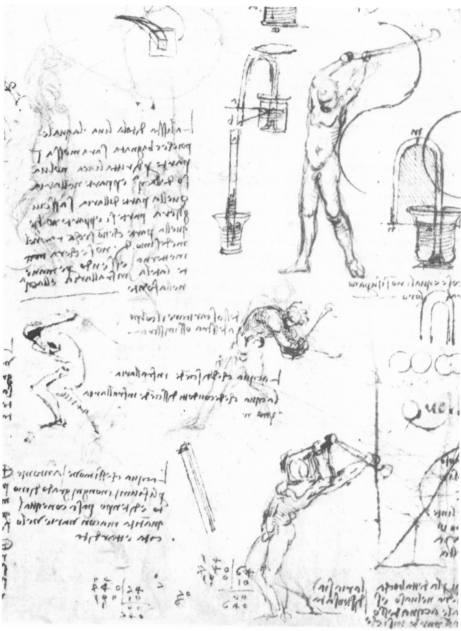

Fig. 4.43.
Windsor, 12641.
Bell ringer figures

Fig. 4.44. Windsor, 12641. Bell
ringer blower

▼

fewer parts. Several siphons including a spiral siphon are shown. A simple hour glass
water clock is shown at the top of the folio. Indeed, the siphons allowed me to trace
the project directly to the Codex Hammer, which has siphons drawn on folios 3 v,
30 v and 34 v.

Little did Bill Gates know that when he purchased the Codex Hammer for over
30 million dollars, that he was also purchasing a document linked to the birth of
digital computing concepts!

A more complex problem is the reconstruction of the hydraulic controller that not
only caused the bell to ring on the hour but also to ring the number of hours. The
24 containers are clearly shown in Fig. 4.9, but lack any mechanism that would indi-
cate interconnection, valves, or a sequence generating mechanism. So my first thought
was to use the text as a specification and build a mental image of 24 simple contain-
ers to see if I could make them work as indicated in Leonardo's notes. I thought it

would be something like the cascading systems that have been used in Roman times,[17] as shown in CA, f. 288 v-a [782 v] (Fig. 4.29) and CA f. 343 r-a [941 r] (Fig. 4.27). This broke down because the timing of the hour and the ringing of the hours are two separate operations. So I looked to what I felt were the most closely related drawings for inspiration. Looking at CA, f. 20 v-b [65 v] (Fig. 4.14), I could see the mysterious actuator/valve, but most importantly, another container lightly drawn above it. This would simply contain the unique quantity of water required to ring its hour. Looking at CA, f. 362 v-a [1011 r] (Fig. 4.21), I saw again the lightly drawn containers above the valves. Leonardo did not bother to detail them as they are simply containers. This would also explain why you see only circles within the main housing in the Windsor drawings no. 12688 and 12716 (Fig. 4.9)—there is nothing more to see.

The next step was to understand how the actuator/valve mechanism fit into the overall scheme of things—it was a key component, and perhaps it would teach me how the containers were interconnected. As described above, I could see clearly how the mechanism in CA, f. 20 v-b [65 v] (Fig. 4.14) functioned. I understood that when water filled the container the pair of floats would work together in perfect harmony. Leonardo's trigger concept—connecting the upper float by a scissor-like linkage inside the hollow helix to the lower float—was a model of economy. Once the container filled, the "handles" of the scissors would be squeezed by the ascent of the upper float. This would cause the restraining "blades" to move inward to release the bottom float, allowing it to ascend, and thereby rotating the helix and turning the valve (see *Operation* and *Building Leonardo's Bottino* below for more information).

I then connected these in series as indicated in CA, f. 362 v-a [1011 r] (Fig. 4.20) and the top of CA, f. 343 v-a [943 r] (Fig. 4.22) and could see them keeping time in one direction. Was the dreaded Bringer needed to reset this system? The prospect of costs (to say nothing of the mental anguish of reconstructing the Bringer) was so dreadful that it provided an excellent incentive to find an alternative—as it may have for Leonardo as well. Also, why did it not show up in Windsor drawing RL 12688, which clearly shows a top view? Surly he would have detailed the rotating faucet mechanism. Also, I figured that a dump valve must be used at the bottom of the lower containers, but none was shown in key drawings. So again, how are they emptied and what was the spiral siphon? Could this be a clue?

Searching on the Internet to learn more about siphons, I saw a remark about how more reliable they are than other means of draining tanks. Well, reliability would be critical in this system. Also, the translator's preliminary word for *cicognola* is "stork", not "spiral siphon". The image of a stork made me think of a more conventional siphon, which is a long straight tube bent in half, and then it hit me: once the siphons got going, they would operate on their own—they would not interrupt the sequence of time and could be used to reset the entire system. I could use the water flowing from container 24 to pass a port connected to the siphon line. The resulting pressure drop would start the siphons. Although the idea has been attributed to Johann Bernoulli [1667–1748] I assume that Leonardo and even the ancient Romans knew the basic principle. Leonardo would have been well acquainted with siphons and their theory of operation from the introduction to Hero's *Pneumatica*,[18] which even included an early example of the scientific method. Leonardo was also seeking Archimedes treatise and must have located it as his notebooks illustrate his work on siphons.

How all this would come to be assembled was another issue. Thanks to the siphons, no plumbing would be required at the bottom of the containers. They could just sit there in the bottom of the fountain. Piping of the siphons, ringer line and siphon starting line could be routed down between the cylinders and connected together in the lower base, either through a common manifold or through a circular

[17] Joseph Needham, op. cit. (as in note 14 above) plates XLIV and XLV.

[18] J. G. Landels, *Engineering in the Ancient World*, Berkeley, University of California Press, 1978. There is an excellent description of Archimedean siphons on pp. 192–194.

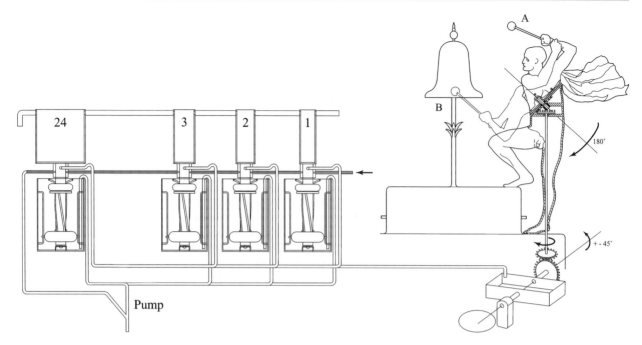

pipe tapped with little "T"-blocks. I assumed the plumbing would be lead tubing and would be soldered or perhaps glued in place with asphalt. The upper containers would likely be removable to enable access to the plumbing below. Although ceramics are mentioned for constructing some elements of the system, I think that the upper and lower containers were most likely soldered brass or bronze because they are easy to work with, rugged and corrosion resistant.

All this occurred to me by flipping through my pile of Leonardo drawings over and over again, sketching version after version, building my mental image of how it functions. Locking down the understanding of a subsystem here, another there; loading dozens, maybe hundreds, of images into my subconscious; flipping faster and faster, I watched until, as in an antique peephole kinetoscope, I saw the individual frames begin to flicker and start to move. An image appeared—a beautiful image—of what had been lost and what was again, at last, brought forth to the light of day. Finally, I had it—after nine months of research, thought, and above all sketching, I had a solution (Fig. 4.45).

This key discovery of how the valve/actuator functioned not only solved the operation of this component, but also showed me that the valve/actuator was a sequencer of the hours and would be identical for all 24 hours. Now I understood what Leonardo meant when he wrote in Windsor 12688 (Fig. 4.9) "bottino all alike." This would have been an important consideration, not only for reliability but also for cost effectiveness—a small assembly line would have been set up to fabricate the actuator/valve assemblies.

Operation

From the diverse descriptions of at least two different designs, I arrived at a general theory of operation (Fig. 4.46). In all versions, Leonardo indicates that this is at minimum a two-part, or "binary" system using 24 containers—the "container of the hours"—that is, the unique quantity of water that will reproduce the required number of bell strikes. Below are the "bottini", or "little barrels" containing float mechanisms that actuate overhead valves. The little barrels provide sequencing and control the flow of water from the "original source". Each barrel fills in one hour (in one version), then releases the "container of the hours", each one a quantity of water that will generate the proper number of bell strikes. All container of the hours flow out through a common line. The top of the "container of the hours" may be seen in the

Fig. 4.45. Overview bell ringer system

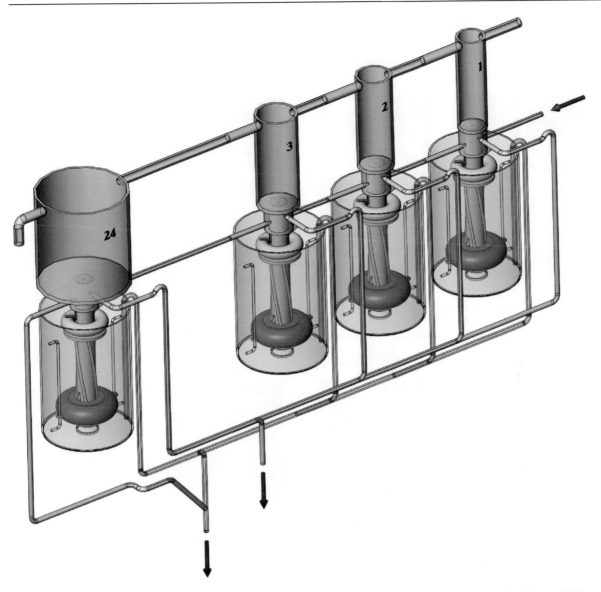

Fig. 4.46. Bell ringer computer

Bell Ringer illustration on Windsor, RL 12688 (Fig. 4.11), with the "little barrels" lo-
cated below them.

In brief, water is admitted from the canal. It is directed by valve number 1 to fill
the little barrel. When the little barrel fills, the upper float rises and unlocks the lower
float via its linkage (Fig. 4.47). This float rises rapidly, rotating the helix and thus
turning the upper valve stem. The valve releases the water in the upper container to
actuate the Ringer, simultaneously opening a port to allow water to flow to the next
unit—repeating the cycle.

When the twenty-fourth hour is reached and the upper container is dumped, the
water flows to the common dump line, creating a pressure drop that starts all the
siphons, which are connected by a common line. When all the lower containers are
drained, the floats return to their original positions, resetting the system. The con-
tainer of the hours could all be refilled while hour 1 is filling (it must fill in that time)
via its valve by adding another port to admit water to the upper container. Another
method would be let the additional port open into the main fountain housing, flood-
ing the entire fountain with the water spilling over and into the containers. This would
agree nicely with the principal Windsor drawings RL 12688 and RL 12716 (Fig. 4.9).

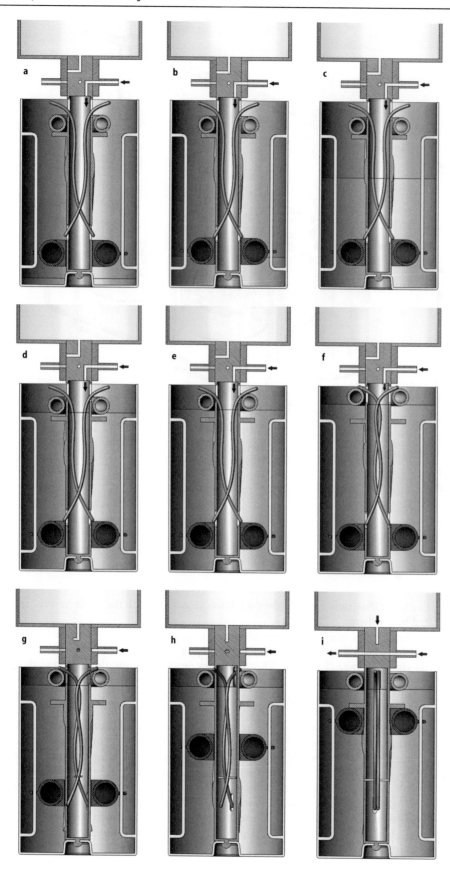

Fig. 4.47.
Bottino sequence of filling

Building Leonardo's Bottino

To prove that my reconstruction of Leonardo's Bottino was valid I set myself the task of building a single working Bottino. The helix and valve stem seemed the most difficult to build so I started there and let the components define the rest of the system.

Initially my Bottino container was an antique battery jar but as the reconstruction evolved and looked better and better I splurged the big money on a foot of Plexiglas tubing. Also, in my only successful departure from Leonardo's original design, I screwed the guide rods directly into the wooden end cap tying them to the top cap with wing nuts. This, with the help of some very modern O-rings, would make a very rugged and watertight Bottino.

Fig. 4.48. Working model of bottino

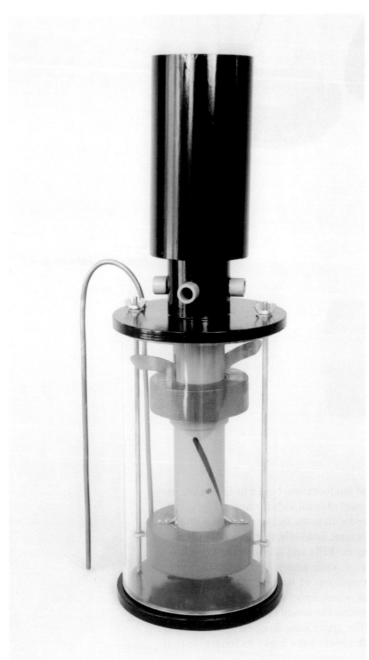

I carefully chose my materials from my stockpile of bits and pieces I keep stored under my work benches. I made the linkages out of brass and tried to do away with the upper wings of surplus material Leonardo had designed. To my surprise I quickly realized that they were for creating a bias to force the lower baga restraining tabs outward. So much for redesigning Leonardo! Great care was needed in choosing the material for the lower baga as they had to rise and descend with enough forces to set and reset the upper valve. Day by day and hour by hour the bits of wood, plastic and metal began to resemble Leonardo's creation. Once the components were assembled I started to fill and putty in all the voids and imperfections, sanding and re-sanding the filler until I had a smooth-as-silk surface. Layer after layer of primer was sprayed and sanded until at last I could apply the final coat of paint. I chose a barn-like red, oil-based paint for the baga, as it recalled the paint I saw in the Life of Leonardo episode where the sphere was being fabricated to cap off the Florence Cathedral's dome. I painted this and the other parts by hand, not by spraying, to give the model a more antique look (Figs. 4.48–4.50).

A few feet of copper tubing from my local hardware store and a bending guide and presto! I had a siphon! The upper container of the hours I made out of a simple piece of tubing. In an actual system the container of the hours would be larger than the Bottino. As discussed above the scissor linkage of the Bottino and the scissor linkage of the programmable automaton of Chapter II were very similar (Fig. 4.51). Apparently, Leonardo would reuse certain design elements in his robots. At last I had my finished machine. But … would it work?

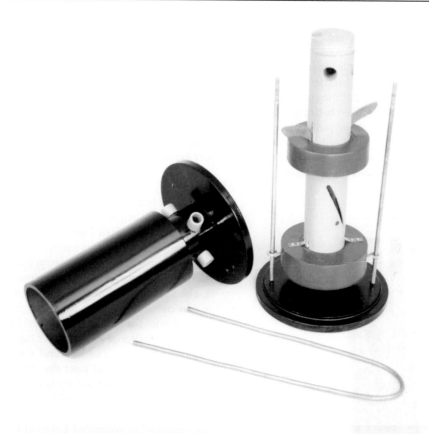

Fig. 4.49.
Disassembled bottino

Fig. 4.50.
Floats, helix, and valve stem

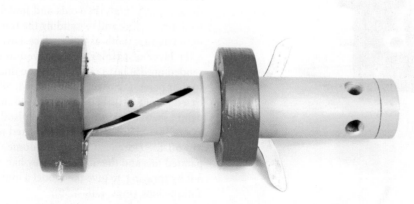

To test my Bottino I set it on a small stand outdoors and began to fill it with my garden hose (Fig. 4.52). Slowly, the container started to fill with the lower float standing still. Finally, the upper float was also covered with water and started to rise. Would it work? Would the upper float release the Bottino? Suddenly, the upper float jerked up (Fig. 4.53) and the lower baga rose, turning the helix and spinning the brass linkage counterweight wings. The valve now rotated, water gushed forth from the upper container, and the supply water was free to pour out of the left port (Fig. 4.54). I could only think of the line from Moby Dick when, upon sighting the great white whale, the lookout cries, "She breaches!" To reverse the action I sucked on the siphon to prime it and watched with satisfaction as the upper baga dropped with the water level to its stop, resetting the linkage. Then the lower baga began its longer descent

Fig. 4.51.
Bottino trigger linkage (*left*)
programmable automaton
linkage (*right*)

Fig. 4.52. Lower container filling

Fig. 4.53. Lower float released – helix turning

finally pushing down and in the linkage tabs. Once past them they snapped out relocking the baga for its next cycle. I had seen with my own eyes the first digital logic element.

In this section we have looked at the ancient forebears of Leonardo's Bell Ringer as well as the Ringer itself. Utilizing Leonardo's legacy of fragments, we grouped them into two projects. Applying my "bottom-up approach" and creative engineering for the "top-down approach", we reconstituted the Bell Ringer for the first time in centuries. Even in Leonardo's day, a water clock was an anachronism. But no doubt pressed by a demanding patron, Leonardo rose to the challenge and produced a fascinating, modular, compact, and reliable clock that anticipates modern, computer-like functionality.

The key difference between Leonardo's clock and those of his predecessors is the modern conception of modularity and compactness. The Chinese water clock could tell time, too, and likely rang the hour, but it required a building to house it. Its predecessor, the Tower of Winds, also could tell time, but lacked the chiming of the hours function. Always sought after, but seldom achieved, were ease of maintenance, reliability, and manageable cost. Like his followers centuries later, Leonardo realized that in a digital system individual components do not have to be made precisely if they are representing only two states i.e. 0 or 1. Leonardo's accomplishment marks the first occurrence of a sequence controller in the modern sense of a simple, dedicated computer that performs its job for telling time and entertaining those who saw it.

Fig. 4.54. Valve actuated: upper container and line water streaming forth

Epilogue
Leonardo's Legacy and Impact on Modern Technology

Leonardo's life-long career as a roboticist would bridge the fifteenth and sixteenth centuries. Leonardo's relationship with his teacher Verrocchio was doubtless the foundation of his work with robots. Perhaps Leonardo even sought to outperform his mentor, striving for even greater technological glory. Not surprisingly, it would take exactly that type of teacher/student relationship in our modern time to reassemble Leonardo's lost robots. Obviously in love with the technological challenges of mechanisms, Leonardo at an early age shows an astonishing grasp of how to integrate multiple subsystems to accomplish his goal of a self-propelled, compact programmable automaton, perhaps located in the base of a mechanical lion, which would follow a prescribed pattern. In mid-life, he would create an animatronic knight, also for entertainment purposes. Towards the end of his life, he would invent a hydraulic clock in homage to the clepsydras of the ancients but with very modern concepts of components and packaging.

Fig. 5.1.
Spenser lathe

In the Programmable Automaton, with its beautiful nested subsystems and dual spring power supply, we see the foundation of the first programmable machine tools, to say nothing of the first Autonomous Ground Vehicle (AGV) that would become common on the twentieth century factory floor for moving manufactured components and subassemblies. Flexible programming is provided by removable cams for steering and actuating additional subsystems—dare I say subroutines? The spring return cam followers actuate stop and start functions and steering. This is a clear anticipation of the nineteenth-century cam-operated machine tools. In 1893, Christopher M. Spenser filed his patent on a "Fixed Head Type of Automatic Lathe for Making Metal Screws Automatically." Controlled by curved plates on rotating drums, it was very similar to Leonardo's some four hundred years earlier. Leonardo's machine is a direct anticipation of the technology that fueled the industrial revolution, with the same use of rotating cams to control machining operation (Fig. 5.1). Spenser's would be the prototype for countless cam-controlled automatic machine tools. From these numerically controlled machine tools would evolve machines controlled by punched tape and eventually modern software.

In the Robot Knight, with its remote control potential and anthropomorphic physique, we see the birth of animatronics, or entertainment robots. No doubt designed for a fifteenth-century amusement park, it must have shocked and amazed visitors who came upon the mechanical apparition standing up and outstretching its arms. That the unique differential cable drive system for the arms would be reborn 500 years later as an exercise machine shows Leonardo's wonderful cleverness in designing multi-functionality using a few simple components. Animatronics would in the twen-

Fig. 5.2. Robotic surrogate proportions of robot

tieth century be made famous by Disney and developed further by myself for NASA (Fig. 5.2). These twentieth-century inventions would continue to fulfill the need for entertainment, at the same time leading to modern anthropomorphic robots for space and hazardous duties. They show an amazing similarity to their 1950s science fiction counterparts made famous in countless B-grade movies. Perhaps someday they will become our domestic servants.

Perhaps the most futuristic of all of Leonardo's robots is the controller for the Bell Ringer. Here we see the advent of digital logic elements and the harbingers of electronic circuitry. Leonardo invented what in the twentieth century would be called "Fluidics," utilizing pressurized fluids for control and actuation. This technology would be made obsolete with improvements in computers, controllers, and electric actuators but their function would remain the same. Logic elements, those ubiquitous, highly repetitive devices, would for the first time be produced by Leonardo's tightly packed "bottini." In the nineteenth century, rows and columns of gear wheels (Fig. 5.3), then twentieth-century vacuum tubes (Fig. 5.4), and most recently, transistors, would become the modern art of our technological age. We see Leonardo striving for "com-

Fig. 5.3.
Babbage difference
engine no. 1

B. H. Babbage, del.

Fig. 5.4.
Attanaoff Berry computer

Fig. 5.5.
Micro-chip

pactness" of his elements, just as modern designers continue to pack more transistors into every nanometer of microchip. Leonardo would also pack his "bottini" elements in as tight a circular cluster as possible, not unlike silicon wafer manufacturers that strive to squeeze the maximum number of transistors into every chip (Fig. 5.5).

The technology would go full circle with modern micro-processor based controllers driving modern day fountains with articulated jets synchronized with popular music by an underground vault full of electronics, computers, and software. Just as with Leonardo's Bell Ringer, every hour on the hour, the fountain performs its feat to the entertainment and delight of modern visitors who applaud at the end of each cycle. These circles of water jets could very well be the same number as in Leonardo's fountain (Fig. 5.6). This modern day fountain recalls Leonardo's own words, "let a harmony be made with different falls of water, as you saw at the fountain of Rimini, as you saw it on August 8, 1502." The circle is complete—Leonardo's vision again reaches beyond the horizon to guide us into the future.

Fig. 5.6.
Ross-Hime Designs, Inc.
Omni-Wrist articulated fountain,
Los Angeles, California

Appendix 1
Leonardo on the Bell Ringer Water Clock

All the Leonardo texts on sheets of the Codex Atlanticus pertaining to his project for a Bell Ringer Water Clock are here translated into English for the first time. The translations by Translatia are from Italy's National Edition of Leonardo da Vinci, *Il Codice Atlantico della Biblioteca Ambrosiana di Milano*. Trascrizione diplomatica e critica di Augusto Marinoni, Firenze, Giunti Barbèra, 1975–1980, 12 volumes of text and 12 volumes of facsimiles. Texts marked by an asterisk are those that Leonardo himself crossed through as evidence of having elaborated or transcribed them somewhere else, normally in manuscripts now lost. The presentation in English follows exactly the Italian by Marinoni, including his descriptions of each sheet as well as his notes, to which the translator has added his own indicating them as such. Occasional bibliographical references given by Marinoni in abbreviated form in his comments are only two, as follows:

Beck = Theodor Beck (1906) Leonardo da Vinci (1452–1519). Vierte Abhandlung: Codice Atlantico. *Zeitschrift des Vereines deutscher Ingenieure*, L, pp 524–531, 562–569, 645–651, 777–784

Clark-Pedretti = Clark, Kenneth and Pedretti, Carlo (1968/1969) The drawings of Leonardo da Vinci in the collection of Her Majesty the queen at Windsor Castle, Second edition. Phaidon, London New York, 3 volumes

Folio 782

Recto

Formally 288 r-a; 300×212 mm; very transparent paper, narrow columns at intervals of 22 mm; central watermark ('snake'); to be compared with ff. 65, 941 (whose ancient numbering is contiguous to the one of the current sheet) and 1042 due to the identity of paper and topic. This one consists of the plan of a water clock with alarm (see Beck, pp. 651, 530). The tear of the upper margin has damaged the text.

- On top

 … If the hour 23 has rung, the first "bottino"[1] is to be unlocked and to receive water for 2 hours and have the way out for two hours without ringing one, and then in the second hour it will ring the first hour. And this is done because, as soon as the 24 hour strikes, the one hour begins and if in such time one had to start to fill the "bottino" that then has to pour water in order to make the one hour "bottino" strike the hour, and would be interrupted time.

- Towards the center; The probable overall view of the machine, followed by

 This is open by the vase of the 24 hour

[1] "Bottino" = little barrel. However some introductory remarks in the folio 941 point out that "bottini" are actually cylindrical containers used to contain water. I therefore decided to leave the original lexeme throughout the text. [translator's note].

- On the right, "bottini" system

 When the hour 24 has strikes, then the same water is to evacuate the "bottino" and open the original pipe, that is the source which fills the first "bottino" and when the "bottini" are all full, then the original source of water is to be closed.

- Detail of the Instrument

 4 finger[2] high. It empties in one hour.

- Similar illustration with: a

 This is to have a half lid so that when it is full, no water of the channel will drip on it.

- At the bottom, Instrument with: n – m

 * The vase m will be ¼ braccio[3] above the openings of the "bottini" and it will contain about a jug of water, so that it is light when it turns, since it is sufficient that it is half way full for it to provide water to several places; it is given to it by n; when the one hour "bottino" is full, m is turned to a place that provides water to all the "bottini", which are filled at the same time; then, being full, the water that remains forms a channel under m and folds m outside each "bottino", until the water of the 24 flows again under m and gives it back to the vase of the first hour as before. This way it keeps going.

- Illustration above the preceding one

 * A round motion on a flat surface with no wheels or cogs is to be given[4]

- Illustration with: m[5]

 * The vase m will be ¼ braccio higher than the vases of the hours.
 * The water of the hour 24, if[6] it happens to turn the water giver to one hour "bottino", which[7] flows underneath the "bottino" of the hour 2, it turns the giver away from every "bottino", all …
 * Little vase with the capacity of one jug. In order for it to be light, it is enough that it is half full to provide water to different places, and the 24 hours will make it turn in the way you see it filling just this vase, and when it is full, the float that comes up like a screw, will turn the lip of the vase elsewhere, namely to fill the other 23 "bottini", which, once they are full, the vase, thanks to the "baga" that will raise out of one of the 23 filled "bottini", will turn the giver of the water out of each vase, until the 24 rings, and the giver with its "baga" will come back to this first site.

Verso

Formerly 288 v-a; ancient numbering 184 (the f. 941 has the number 183 on it). One of the illustrations in the upper right corner is more thoroughly developed and ex-

[2] Dita = fingers [translator's note].
[3] A unit of measurement. Braccio = arm [translator's note].
[4] Round motion = "Circumvolubile per piano".
[5] The two illustrations marked with the letter m effectively represent the same machinery and the relative captions say the same thing with minor variations.
[6] Hard to read stained word, as others are in this paragraph.
[7] Referred to the water [translator's note].

plained in the f. 941 as a complex of "bottini" that measure and signal the hours of the day. Various other drawings are reminiscent of those in the front, but most of the space is dedicated to different shapes of small tubs that fill and empty out, mostly represented in the longitudinal section.

- Right column, following the first illustration

 Here the wheel of 8 spokes.

- Five "bottini" with: e d c b a

 a b c d e are vases

- Under the illustration in the center

 Little tongue

- Little illustration with five little circles

 Floats

- Double cylinder inside a vase, with: Adversary

 Only the water that is poured, gains power like an equal amount of water of similar height and thickness, and all the other in the vase continuous to that does not feel any variation of such weight.

- Illustration of a cylinder inside a vase and pipe allowing the water to flow out, with: a d – b e – c – f – g

 Until the water has filled *a b*, it is necessary that the water *e g* be heavier than the water of capacity *a b* – if this weren't the case it could not remove all the air remaining in *a b*; and when this pipe fills above in *d* and for a length which is more than the space available in *a b*, then the water *f g* does not count any more.[8] It is therefore concluded that the pipe *d g* must be able to contain as much water as the capacity of *a b*, and later the same amount of air, and even more than a part of the pipe is filled that is from the space *a b*; otherwise, it does not hold.

- Similar illustration, with: a – aria – p n – m – b

 If the *a b* water will pour from the open pipe to *b* underneath. —It will not pour, if it first hasn't dragged along all the air that borders with it; and such air won't leave, if the water *n* does not raise high enough to the restoration of the vacuum, from where such air will leave, and such water won't raise to such an height, if the water outside *a b* won't be heavier than that which has to be leave from inside. Therefore the pipe *a b* has to be of such length that its capacity is such that it can contain 3 times more water than the capacity of the air vacuum[9], because, after the water that is in the "bottino" will have moved in the pipe outside, it is necessary that under such air there is an amount of water, whose power equals an equivalent amount of water.

[8] Following "più" a vertical line (read "f" by P.) is used in the MS to separate from this text the "g" that follows which belongs to the illustration.

[9] Ms. "acqua" (water).

Left hand column, from the top

- Three illustrations of small tubs, with: aria – m n; rena – tina – n(m) – p m; rena – m m a – f p n

When the ... [duta] like ... [ra], it is necessary that the weight be heavy and thin, because since the vat has to stay on top of the weight of the millstone and the height of the water has to occupy the height of the millstone and of the vat, it would be necessary that vat and millstone a half braccio, and that would be nothing to be done. Finally empty the lowest root that the bottom of the "tromba"[10] (*small illustration*) make an iron, as you see marked, on which in *p*[11] be the bottom of the vat and on which the scanduppo[12] stay steady, which forces the water into the tromba. The inequality is the cause of all the local motion. No quiet is without equality. The air always rests among equal powers of that water that is enclosed with it.

- Cylinder inside a vase, waste pipe with: d – a – f c a – b

If the *a b* water is not pouring, being its opening open below in *b*, what is it that sustains it? It is the air *a d c*, and such air, bordering with the water level of the "bottino" *a c f*, does not provide any weight at the opposite side of the air in *c*. And this is impossible for the fifth proposition of the ninth book, which says: "no quiet is without equality", because such air sustains in *a* all the water *a b*, and in *c* it doesn't sustain anything. Therefore, being this impossible, it is necessary that there raises above *c* as much water as the weight of the water *a b*, and then such quiet of the parts is obtained.

Folio 941

Recto

Formerly 343 r-a; ancient numbering 185; 297 × 199 mm; transparent paper, very weak little columns, 22 mm from one another; tear in the margins with mutilation of texts and drawings; sheet to be considered together with ff. 65, 782, 1042. Notes and drawings are about the construction of a water clock with alarm (see Beck pp. 650–651). The right column studies mainly the system of drawers or "bottini", the left one the devices used for their emptying and the alarm. Arithmetical operations: the squares of 15, 16, 17, 18 corresponding to 225, 256, 289, 324.

- Right column

... Regulate "temperare"[13] by putting sand or gravel in the vases.[14]
... clock[15] which does not go back against the weight and does not need to be adjusted that once a month.

[10] tromba = trumpet [translator's note].

[11] Ms. "o" with the first part of a little descending sign interrupted by the underlining of the letter. On the other side of the illustration the letter "p" is present, but "o" is not.

[12] Scanduppo = stantuffo [= piston, translator's note] appears several time in da Vinci's writings. According to Tommaseo the term is found for the first time in the "Pirotecnia" by V. Biringuccio (Venezia 1540) in the form "standuffo", and later in Galileo as "stantuffo". It is likely to have originated from German "Stampfe" (merged with "tuffo") whose affricate "pf" would have been rendered by Leonardo as "pp" and by the others as "ff". As to "c" in lieu of "t" one might hypothesize a dissimilation.

[13] "Temperare" could either mean "mix in the right proportions" or "to build, forge". This latter usage of the word is attested in Dante's writings (XIV^th Century Italian) [translator's note].

[14] See the vases loaded with sand in the f. 782 v [288 v-a].

[15] Ms.: [...] og<i>o", i.e. "orologio" (clock). We don't know whether in the missing part of the paper there existed a drawing as well or just words. In the latter case between "con" and "tra peso", between "se non" and "n un mese" there might have been letters of syllables now lost.

- Row of "bottini", with: b a

The *a* vase, while filling up in one hour, opens the little pipe *b,* which in another hour does the same; and they proceed this way for 24 hours, one vase for each hour. And they are small and open the large vases while opening to the second vase.

- Similar illustration, with: e d c b a – i h g f

With the help of the sixth proposition of the fourth book the *a b* vase[16] pours its water in the *f* vase and lifts the "baga" that is inside it, with straight away unlocking of such sixth. And this, once unlocked, immediately comes to the surface and opens the *b* pipe with its "reverticulo"[17] and at the same time with the same speed it opens behind itself the vase that rings the hours.

And in this case 3 vases are to be used, the first of which is *a,* and this is poured precisely in one hour, and all the others that are on the same line will do the same. The second vases below, while filling up in the same hour in which those above them pour the water into them, and as the vase below fills up, it raises and unlocks the baga of the second vase *b* in the way described in the sixth. And this way the *b* vase empties and the *g* vase fills up in another second hour, and the vase behind rings its hours. In the process of opening the pipe for *b,* the vase of the hours gets opened as well and this way, when the *g* vase empties the way of the fourth "a siphon"[18], the vases close again, and after 24 hours have rung, in the hour that follows all the vases that strike[19] the hours and those that ring the hours have to be filled. But the vases below only happen to fill hour by hour, as stated.

- Illustration with smeared ink: wheel, shafts and rotating cylinders, with: (4) 3 2 4 4 – 8 16

All the water coming out of each that strikes the hour vase, flows through one and the same channel to one and the same wheel with 8 "spokes",[20] and such wheel immediately fills one of the boxes, which move down sustained by one time[21] so that they can wait to be full and their moving down does not occur forcefully.

Right margin

- Little illustration, with: og

- Overall view of the bottini

All the bottini that ring the hour have to be filled between the 24 and the one hour; and the first does not ring but for an hour to pour his[22] water and then it unlocks the one hour bottino.

[16] Ms. "v".

[17] Curved pole.

[18] "Cicognola" means spiral siphon. In current Italian; "cicogna" = stork [translator's note].

[19] Ms. "sconcano", but see the f. 782 r [288 r-a]. where the verb "scoccare" is repeated: here it looks like "scoccare" the hours [= strike the hours, translator's note].

[20] This wheel is clearly depicted in f. 782 v [288 v-a].

[21] Hard to read: the last lines of the writing are quite confusing due to a hand moving over the fresh ink. The first letter of "tempo" (?) [= time, translator's note] doesn't look like a "t" and the box cannot be sustained by the time, but perhaps "per un tempo" [= all at once, translator's note], unless it is turns out that "tempo" has to be substituted by another word.

[22] Ms. "le", perhaps "le sue acque" [= the (plural) his (plural) waters, (literal translation, translator's note)].

Left column

- Shower that pours in a bucket hung to a pulley: seventh

- Same thing and a bell, with: b–a

As the bucket a in contact with the shower b fills up and gains the weight it ought to, it separates from the shower and moves very quickly one half braccio down. While separating from the opening of the shower, such opening of the shower closes with the help of the seventh proposition, and such bucket moves down and lifts the hammer with the order of the eighth and hits the bell, and immediately, the bucket, that has reached the ground, establishes itself in the order of the third and moves back up thanks to the hammer moving down and once it has reached the shower, it unlocks it with the order of the second, and this way it fills again and it again moves down with the same aforementioned rule, and it keeps going until its hours have rung.

- Small wheel with cogs, with: 1/3 – 25 – 25

- Bottom of a box, with: a – b – c – d

Bottom that has to open as d touches the ground; and releases all the water.

- Arithmetical operations

15	16	17	18
15	16	17	18
75	256	289	324
	96		
15	16		
225	256		
(225)			

Verso

Not visible before restoration, with no writing or drawings.

Folio 943

Recto

Formerly 343 v-a; ancient numbering 26 (in pencil) p; 259 × 196 mm.

Right column

* I wonder whether the float in equally deep water will come up to the surface quicker in wide water or in narrow water
* One has to wonder whether the float will come up to the surface quicker in deep water or in shallow water
* Moreover one has to wonder whether the float put at a certain depth will come up to the surface quicker in wide waters than in narrow ones.
In the wide ones, because it could be so narrow that it would produce no effect[23].

[23] Written in the margin, it is the answer to the preceding question.

- Illustration of water falling into water

 The water that falls in a perpendicular line into running water, makes its penetration curve and curve will also be its coming up. The peak of the part that surges into the air, will not be in the middle of the "base"[24] of such boiling effect[25], and such "basa" will be oval.

Middle Column

- Cylindrical vases, with: b c d – a

 These pipes will be made of thin clay and cooked for very long, until they become glass.

- Group of five vases

 At the bottom of the vase place in front.

- Group of three vases

 Vases of the hours. The first opens and then the water of the second, when it opens, moves through the first and this way it keeps going. But then think about what it will be that will have to close them. It will be the "baga" that each of those has inside.

- Large illustration in the center, with: n – m – t f – l – b a x – r y v – p o – d S – h K – g – q – e

 * When the vase m will have filled the vase under it, the "baga" b will raise and the saddle[26] will unlock the piece of iron $v\ r$, so that the "baga" under $K\ h$ will move up as far as the Sd, until the piece of iron vr moves beyond the device ab and then such "baga" $K\ h$ will move away from $S\ d$ as far as $o\ p$, making a whole turn, and it will first hit with r the lever f and then with the lever v it will hit the lever t. At this stage the vase m won't be pouring any longer in the vase $t\ g$, but it will in all the other 23 vases; and when they will all be full, the water that will come forward will hit e and will drive m outside such "bottini" and won't be of any use, up until the 24 hours will have rung. Then this will be the last "bottino" to empty out and its water will hit q and will reposition the m vase straight so that it again pours in the vase $t\ g$, and this way it keeps going, until it is worn out; it is such that one can use it a lot and never needs to be adjusted.

 Drawing of water clock … etc.

Verso

Not visible before restoration with no writing or drawing.

Folio 1011

Recto

Formerly 362 v-a; old numbering 28 (in pencil); little columns spaced 24 mm; for the gap at the bottom cfr. Clark-Pedretti III 49. Studies for a Water Clock, for which cfr. The ff. 65 v, 782, 941, 943, 1042.

[24] If I understand the context correctly it might refer to the round concentric circles produced by an object falling in the water [translator's note].

[25] P. "bottino" unjustified: the water jumps into the air starting from a sort of own boiling.

[26] Ms. "la | sello"; the illustration shows a saddle shaped groove, on which lays the iron piece "v r".

- Right Margin

 The containers for the hours must always have their bottoms lower on the front side and higher on the back, so that the water will always be able to flow away from the containers.

- Vases with water: a b c d—good invention

 When the bringer turns itself to give water at the 23 vases, the bringer turns rapidly their 23 keys a b c d, which turns for a quarter of arc [90°], and so it closes them all. Then they open one by one when needed.

- Device for automatic opening and closing

 This opens the key while going up and closes the key when it comes back.

Verso

Not visible before restoration, with no writing or drawing.

Folio 1042

Recto

Formerly 373 v-b; ancient being 29; 300 × 205 mm; transparent paper with a homogenous mixture. Construction of a water clock with ringer, cfr. ff. 65, 782. According to Beck, p. 650, this sheet contains the first ideas about this device.

Right column

- Figure, with: a

 This is good for the way of opening the bottom.
 Every container that fills itself, it fills by canal. The canal, when the container is full, closes, and the container of the first hour is the first that fills at the strike of the 24 hours, and it fills very soon, and then it takes an hour to empty and unload the container of the one hour, but there must be a first container that starts the other 24 containers.

- Figure of "container" with floating and hammer, and with: – d – n – p m a – e b

 There is a leather bag that rises immediately to the surface of the water, when it unloads for the sixth time through the leather bag that rises, and the hammer strikes, striking it then opens the front of this box and the water immediately flows and straight after it closes.

- Towards the border, "container"

 Make this vase is away from the canal, so that when it is closed, it doesn't drop in the original container.
 The brick struck in the hand breaks, and doesn't hurt the hand.
 The falling in many times makes the impression almost non existent.
 The momentum of one part that moves, carrying a bigger part that wasn't moving before, just like the person who rises rapidly and while he was rising with his upper body the legs stood still, and then they move.

- Group of figures

 Clock that strikes the hours and rises 24 leather bags in 24 hours and each leather bag opens the container that rings the hours, and when that container is full, with the rule of the sixth, the leather bag is put in a little vase close to the container, and it opens immediately and flows the water of all the container which marks the hours.

- * Lower margin, group of figures, with

 o – a – b – c shower – opens the recipe – of the hammer – shower
 * c b rises, b a closes the shower with a o and unloads it.

- Left column

 When the hammer strikes the bell, and touches with the handle a spring, so that the hammer doesn't stop over that bell, because it would stop the sound after the strike.
 So it makes possible that the handle beat when the container unloads, since the hammer beat its strike; and so it goes on *(associated figures follows)*.

- Two figures, with: n ; c

 After the hammer has beaten the bell, immediately the bottom of the vase opens by the fourth proposition and immediately flows all the water who was within the vase. And this will be made with the movement of the leather bag n that after the strike still rises and unloads downside another leather bag united to the bottom of the vase.

- Column of numbers

10	6
5	
2	
1	
12	
1	
1	
1	
36	6

Verso

Not visible before the restoration, with no writing or drawing.

Appendix 2
Electronic Representation
of the Clock Operation

A fascinating way to study the Bell Ringer is in terms of modern electronics. Leonardo's Bell Ringer is hydraulic (it is driven and controlled by water under pressure), but more specifically it resembles a fluidic device. "Fluidics" was very popular beginning in the 1960s, the advantage being that power and logical operations could be combined in a single, fluidic, electroformed "circuit board." Even fluidic gyros had been developed. Advances in electronics and interfaces, to say nothing of the messiness of hydraulic fluid, brought about the demise of this technology by the late 1970s. Nevertheless, most electrical systems can be modeled as hydraulic or fluidic systems, and vice versa. Think of the following analogies:

1. Water is guided via pipes or hollow tubes which conduct water easily and provide containment via an outer wall. Electricity is guided using metal wire, which conducts it easily and is contained by a non-conducting (insulating) outer wall.
2. Water is forced to flow by a pump or other source of pressure. Electricity is forced to flow with pressure, i.e. voltage from an electrical pump such as a generator or battery. Voltage is the pressure upon the electric "fluid," that forces it to flow.
3. A fixed amount of water can be measured. Similarly, we can specify a fixed amount of electricity or electric charge. One coulomb is a precise amount of electricity, just as a liter is a precise amount of water.
4. Flowing water is analogous to current. When flowing, water may be measured in gallons per minute (GPM). Electrical current is measured in coulomb per second or amperes.
5. Given the above, pressure and flow are the basic measures of both water and electrical systems.
6. The amount of flow for a given amount of pressure is determined by the resistance of the system to flow. In a water system, the resistance depends on the size of the pipe, the smoothness of the inside walls and valves which may be present, etc. In an electrical system, resistance is often determined by "resistors," which would be analogous to a constriction in a pipe.
7. Valves (a kitchen faucet is a form of valve) turn on or off the flow of water. Specialized valves can open and close several different sources of water. The electrical analog to a valve is the switch, such as a simple wall switch that turns a light on or off. Transistors are electronic switches that, upon receiving a voltage, cause a circuit to open or close.

A more complex switch is an "AND GATE," which is a basic building block of logic circuits used in computers. Leonardo's "bottino," the fluidic version of an "AND GATE," is perhaps the most fascinating part of his Bell Ringer components. The logic equation for an AND GATE is $Z = AB$ (Fig. A.1). In other words, to produce the output Z, two simultaneous signals, $A + B$, are required. If either A or B is missing, no Z output is produced. Leonardo's A signal is the line pressure; his B signal is the rising "baga," which turns on the "bottino's" valve. The single output Z is the pressurized fluid exiting the valve to enter the next "bottino".

The AND operation will be signified by AB or A·B. Other common mathematical notations for it are A∧B and A∩B, called the intersection af A and B.

Fig. A.1.
AND gate

A	B	Out
0	0	0
0	1	0
1	0	0
1	1	1

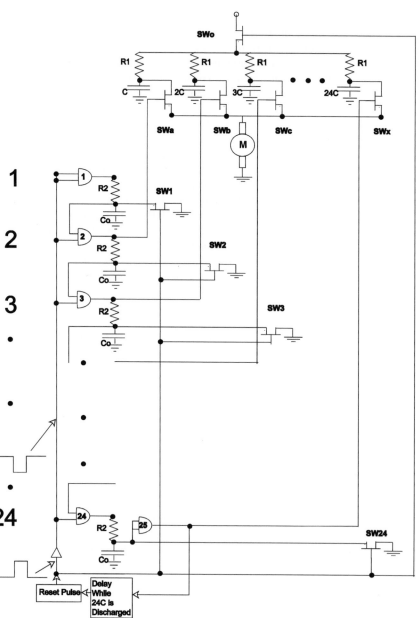

Fig. A.2.
Bell ringer electronic equivalent

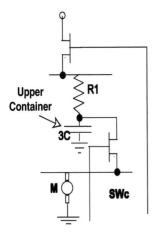

Fig. A.3. Bottini, capacitors

There are many ways to represent electronically the operation of the clock. For example, a single microprocessor could be used and programmed to perform all the functions of the clock. The example presented here uses discrete electronic components to represent the various components of the clock.

Figure A.2 shows one electronic version of the clock that depends on analog components. The bottini, illustrated in Fig. A.3, are represented by capacitors, C_0, and the restriction in the flow of water into these containers is represented by resistors, R_2. The 24 "container of the hours," shown in Fig. A.4, are represented by capacitors C, 2C, 3C, …, 24C. Here the value of the capacitor nC is n times the value of C and holds n times the charge that C holds. Here again the restriction in the flow of water into these containers is represented by **R1**. We choose component values such that the time to fill capacitors C_0 is much much longer than that needed to fill capacitors nC, i.e. the time constant $R2 \cdot C_0 \gg R1 \cdot n$C.

Last, but not least, the Bell Ringer is represented by a motor **M**.

Operation

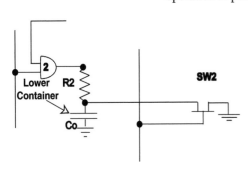

Fig. A.4. Container of the hours, resistors

The reset pulse begins the operation. During the pulse, **AND GATES 1** through **24** are turned off and no voltage is applied to the $R2C_0$ networks. At the same time, all charge on capacitor C_0 is drained off by switches **SW1** through **SW24**. These switches are **MOSFETs** (Metal Oxide Semiconductor Field Effect Transistors) and are used because they require very little current to turn them on. It is the electrical field from the voltage applied to the gate that controls the current through the switch. One last operation is performed during the reset pulse. Switch SW_0 closes and fully charges capacitors **C** through **24C**. After the reset pulse the clock operation begins. **AND GATE 1** is turned on and charges the first C_0. When the level of charge reaches a certain level two things happen. **AND GATE 2** is turned on and charges the second C_0. At the same time, switch **SWa** is closed and drains the charge from capacitor **C** through the motor **M**. The motor **M** is designed to do work proportional to the electrical charge going through it. That is, if n times the charge flows through the motor, then the motor performs n times the work. The operation continues in like manner until all capacitors, C_0, are charged. At this point **AND GATE 25** is turned on, which causes (1) switch **SWx** to close, which drains the charge from **24C** through the motor **M** and (2) the reset process begins.

Index

Note: Page numbers in italic refer to figures. Bibliographic entries in italic refer to pages with full citations of corresponding references.